STEAM
AROUND HARROGATE
& THE DALES

STEAM

AROUND HARROGATE
& THE DALES

MIKE HITCHES

AMBERLEY

First published 2013

Amberley Publishing
The Hill, Stroud
Gloucestershire, GL5 4EP

www.amberley-books.com

British Library Cataloguing in Publication Data.
A catalogue record for this book is available from the British Library.

ISBN 978 1 4456 0764 1

Typeset in 10pt on 12pt Sabon.
Typesetting and Origination by Amberley Publishing.
Printed in the UK.

CONTENTS

INTRODUCTION

Gateway to the Yorkshire Dales, Harrogate developed as a spa town thanks to mineral springs which had been discovered at the end of the sixteenth century. By the mid-nineteenth century, it had become fashionable to 'take the waters' in the town and several large hotels and hydros were built to serve those Victorians who visited Harrogate to benefit from the mineral springs here as they believed that they were good for their health. With such potential traffic from these visitors, it was no surprise that the new railways took an interest in reaching the town. The first company to arrive was George Hudson's York & North Midland Railway, via its branch from Church Fenton and Wetherby to Brunswick in 1847, just six weeks before the Leeds & Thirsk Railway reached nearby Starbeck.

The Leeds & Thirsk Railway, later to become the Leeds Northern Railway, issued its prospectus in 1844 shortly after the Great North of England Railway, whose line had opened in 1841, had considered approaching Harrogate from its main line at Pilmoor, via Boroughbridge and Knaresborough, with a branch to Ripon. At the same time, the Y&NMR supported a line from Bolton Percy to Harrogate. However, the population of Harrogate did not favour the Y&NMR proposal, as it could ruin the chances of a better route from Leeds, and managed to have it rejected. While these proposals were being discussed, the Leeds & Thirsk pressed on and, in 1845, the company deposited its Bill, at the same time as the GNER deposited one for its own line from Pilmor, now planned to be extended to Leeds. As the two Bills were being debated, George Hudson leased the GNER and had that company's Bill withdrawn, leaving the Leeds & Thirsk with a clear run, obtaining its Act on 21 July 1845. At the same time, the company was authorised to make two spurs to connect with the Leeds & Bradford Railway at Bramley and at Holbeck; a curve to connect with the GNER at Thirsk; and two short branches at Starbeck which would lead to Harrogate and Knaresborough. On the same day, the Y&NMR received its Act for a line between Church Fenton and Harrogate, via Wetherby.

The Leeds & Thirsk Railway's direct entrance to Harrogate was obstructed by Almscliff Bank so the line took an easier route, via the Crimple and Stonefall Valleys to Starbeck, but that left the railway without a station in Harrogate itself. Although Harrogate was well served from Leeds, the Leeds & Thirsk line was shorter than that of the Y&NMR, whose line was rather circuitous, but it meant changing trains at Starbeck to reach Brunswick in the centre of town. The two lines to the south crossed at Crimple, the Y&NMR over Crimple Viaduct and the Leeds & Thirsk on the valley floor. When the North Eastern Railway was formed in 1854, the opportunity was taken to unify the situation and, on 8 August 1859, an Act was obtained which sanctioned the construction of three connecting lines and a new central station in Harrogate. The three lines approved were as follows:

1. From the original Leeds & Thirsk line a mile north-east of Pannal station to connect with the former Y&NMR branch at the southern end of Crimple Viaduct.
2. From the line leading to Brunswick, through the centre of Harrogate, to connect with the Leeds & Thirsk a mile north-west of Starbeck.
3. From a point a mile north-east of the new Harrogate station, at Dragon Junction, to join the Leeds & Thirsk at Starbeck.

The new station was built on the section between Brunswick and the north-west of Starbeck and, along with the three new lines, opened on 1 August 1862.

A final link was the short connecting curve at Starbeck between the Leeds Northern Line (the ex-Leeds & Thirsk) and the Knaresborough branch, which was authorised in 1863, probably opening the following year. However, the line had been disconnected at the eastern end by the beginning of the twentieth century.

Other companies also operated trains to Harrogate in the years prior to the First World War, including the Lancashire & Yorkshire Railway, who ran trains between Liverpool and Harrogate from 1897. Between 1897 and 1901, NER locomotives took charge of these trains between Leeds and Harrogate but, from 1901 until 1915, when the service became a wartime casualty, L&Y locos worked right through. The Midland Railway ran trains to St Pancras from 1902 until 1928. The MR had arrangements with the NER for access to Harrogate, York and Newcastle, which is no real surprise as George Hudson, chairman of the Y&NMR, also held directorships in the North Midland Railway, among others, and was influential in the formation of the Midland Railway in 1844. Therefore, there would always be friendly relations between the NER and MR.

The first sod of the Leeds & Thirsk Railway was cut on 20 October 1845 at a time when the company was contemplating extending its line to join the Stockton & Hartlepool Railway at Billingham and powers were requested from Parliament in 1845/46. The route was planned to run direct from the L&T at Melmerby, passing under the GNER at Northallerton and on the west side of Yarm by means

of a long viaduct. George Hudson, however, applied pressure on the L&T and it was finally agreed that the company's trains would run over GNER metals between Thirsk and Northallerton, the Melmerby–Northallerton proposals being withdrawn. This second Leeds & Thirsk Act was passed on 16 July 1846 which, along with the extension, authorised the company to make junctions with the Stockton & Hartlepool, the Stockton & Darlington and the Clarence Railway at Billingham, Eaglescliffe and Stockton respectively. At the same time, permission was given to divert one of the proposed spurs to the Leeds & Bradford Railway (the St Helen's Mill or New Laith branch) and also to extend the proposed Knaresborough branch across the River Nidd and through the town.

On 9 July 1847, deviations at Thirsk and in the Crimple Valley were authorised, followed, on 22 June 1848, by three further Acts which gave the company powers to extend from Melmerby to Northallerton, with a connection to the York, Northallerton and Billingham, and from Harrogate to Pateley Bridge and to alter the proposed junction with the Stockton & Darlington Railway at Eaglescliffe.

While plans were still going through Parliament, sections of the L&T were being completed and opened. The first of these was the section between Ripon and Thirsk, opened to freight traffic on 5 January 1848 and formally opened to all traffic on 1 June. The section between Weeton, Starbeck and Wormald Green was opened on 1 September 1848, and from Wormald Green to Ripon twelve days later. Completion of the line south to Leeds was delayed by the work involved in construction of Bramhope Tunnel, which was 3,761 yards long. Problems were caused by an inrush of water, estimated at some 1,563 million gallons, which had to be pumped out. Several men were killed during the tunnel's construction and a memorial to them stands in Otley churchyard. On 9 July 1849, the whole line was opened and three trains, carrying some 2,000 shareholders, travelled from Leeds to Thirsk and back. When the L&T first opened, a temporary terminus was established in Wellington, Leeds but the company soon went to Leeds Central station, shortly afterwards going to the Midland Railway's Leeds Wellington station until the joint North Eastern Railway and London & North Western Railway Leeds New station was opened in 1869.

The L&T connected with the Great North of England Railway at Thirsk, whose line ran from Tyneside to York, via Darlington, and is now part of the East Coast Main Line. The GNER was based on an idea by Joseph Pease, a major figure in the development of the famous Stockton & Darlington Railway, who envisaged a railway to connect Tyneside with the proposed York & North Midland Railway at York. A survey of the proposed line between Gateshead and Croft, just south of Darlington, was started in 1835 and it was soon realised that this section would be more difficult to construct than that across the Vale of York. Thus, it was decided that powers would be obtained for the northern section first and powers for the southern section would be applied for in the following session of Parliament. This difference of a year would allow both sections, from the Tyne to York, to be ready for opening at the same time. Although the GNER had proposed a line south to Ripon – thence branching off to Wetherby, Tadcaster and Leeds

– while the other line ran via Easingwold to York, supporters of the project in York for a direct route to Newcastle felt that traffic in the city would become secondary to that of Leeds if these proposals went through. Thus, the GNER was persuaded to change its mind and the Bill deposited was for a line from Croft to York only. This second Act received royal assent on 12 July 1837, the first Act incorporating the company and authorising the line between Croft and the Tyne having been granted a year earlier.

The first sod for the line south to York was cut near Croft on 25 November 1837 and, after several delays in construction, the line was opened to mineral traffic on 4 January 1841 and to passengers on 30 March. On opening day, there were GNER stations at Shipton, Tollerton, Alne, Raskelf, Sessay, Thirsk, Northallerton, Cowton and Croft. Junction stations were opened later at Dalton (Eryholme from 1901) and Pilmoor, to serve the Richmond and Boroughbridge branches respectively, and Danby Wiske (opened in 1885). Shipton was renamed Beningbrough in 1898 and Croft had 'Spa' added in 1896. Only five years after the GNER main line had opened the company was taken over by the Newcastle & Darlington Junction Railway, changing its name to the York & Newcastle Railway from 27 July 1846. Eight years later, the Leeds Northern Railway, the Y&NMR and the York & Newcastle Railway were merged to form the North Eastern Railway from 31 July 1854.

The new NER inherited very attractive branches through the Yorkshire Dales. The first of these was to Richmond, which gave access to Swaledale. There were several schemes which offered access to the dale but nothing ever came of them. The GNER gained authorisation, by an Act of 21 July 1845, for a line of 9¾ miles from Dalton (Eryholme) to 'Back of Friars' at Richmond, on the opposite bank of the River Swale. A year later, the company obtained powers for another three branches, from Pilmoor to Boroughbridge, Northallerton to Bedale and Dalton to Malton. Now under the auspices of the Y&NR, the first branch to be completed was the 6-mile line to Boroughbridge. The second branch was that from Northallerton to Bedale, which became the first section of a line extending some 34 miles to Hawes (where a connection would eventually be made to the Midland Railway's Settle–Carlisle line) at the head of Wensleydale. Although the GNER gained authorisation on 26 June 1846, the line was opened by the York, Newcastle & Berwick Railway in 1848. The line on to Leyburn was built under the Bedale and Leyburn Act of 4 August 1853, local landowners providing much of the capital. This section was opened to freight on 24 November 1855 and to passengers on 19 May 1856. The NER took control of the B&LR to prevent infiltration from competitors on 1 January 1858 and, in 1865, the Hawes and Melmerby Act gave powers to build a line from Hawes to Wensley, with a connection from Finghall to the ex-Leeds Northern line at Melmerby, but a lack of funds meant that it was replaced by a cheaper scheme to connect Hawes with Leyburn, a distance of 16 miles, authorised on 4 July 1870, opened to goods traffic on 1 June 1878 and to passengers in September. As if to compensate for the loss of the Hawes–Melmerby line, the NER built a branch from Melmerby

(on the Leeds Northern line) to Masham, with an intermediate station at Tanfield, authorised on 13 July 1871 and opened on 9 June 1875. Authorised by an Act of 1848, the Leeds & Thirsk proposed a branch to Pateley Bridge, but this was allowed to lapse. The NER decided to revive the idea and received powers for the branch on 21 July 1859, the line opening on 1 May 1862.

By the late Victorian period, the railways around Harrogate and the Dales were now well established and the system would now enter a 'golden period' with smartly turned-out locomotives hauling comfortable passenger coaches and the lines busy with freight traffic. This period continued until the outbreak of the First World War, which changed so many things. During the war, the famous Catterick military camp was established and a 4-mile single-line branch was built, which left the Richmond line at Catterick Bridge. During the war, troop trains were run to and from the camp's terminus and, on one occasion, a train full of soldiers ran away, became derailed and wrecked. After the war and until the outbreak of the Second World War, the camp line was used as a siding but, from 1939, large influxes of soldiers meant that the LNER ran unadvertised passenger services. Eventually, three trains a day operated to the camp from Darlington in the early hours of Monday morning so that soldiers returning from weekend leave could be back with their units in time for their duties.

Heavy use of the railways during the First World War left them run down and lacking in maintenance. Although the companies were promised proper compensation, the government were slow to pay them and did not provide enough money to allow the system to be brought back to pre-war standards. In this immediate post-war period, there were calls for the railways to be nationalised, the state having taken control of the network during wartime and in the early post-war period. The government of the day did not favour state control during peacetime but investigated the possibility of mass amalgamations of the railway companies, culminating in the 1921 Railways Act which allowed grouping of the over 100 companies into four groups. Thus, in 1923, the North Eastern, along with the Great Northern, Great Central and some Scottish railways were grouped to form the London & North Eastern Railway, just at a time when road competition for freight and some passenger traffic was increasing and the economy was heading towards depression, putting thousands out of work. The downturn in the economy and reductions in coal and steel output in the North East led to a huge decline in freight traffic for the LNER. Passenger traffic held up quite well but this was largely due to substantial discounts on ticket prices, which would erode revenue further. Lack of passengers and reductions in freight traffic led to closure of local branch lines and the Dales lost its Melmerby–Masham branch to passengers from 1 January 1931.

By the end of the depression years of the 1930s, Britain was once again at war with Germany and the railways came under state control for the duration. Its first role was to undertake evacuation of children from the major cities to safer, more rural areas, lessons having been learned from the Spanish Civil War when German bombers bombed open cities in support of General Franco, the fascist dictator

of Spain. The Yorkshire Dales was one such safe area and children from cities like Leeds were sent there to protect them from the likelihood of air attack. With the outbreak of war on 3 September 1939, the railways were very soon involved with movement of large numbers of troops to the Channel ports for the British Expeditionary Force to go to mainland Europe. Wartime measures in the Dales included the closure of Newby Wiske in September 1939, never to reopen, and new Up and Down slow lines were built between Thirsk and Pilmoor in 1942 to cope with increased freight traffic of munitions. At the same time, a new link was installed between Skelton Yard and the Down slow line between Skelton Yard and Skelton Bridge. Early in the war, two temporary platforms were built on the Leeds Northern line, on the site of the Melmerby branch platforms which had become redundant after alterations had been made in 1901. These platforms were part of a scheme to provide an alternative main line route through Northallerton if the high-level lines suffered bomb damage. Two tracks were laid from the Leeds Northern line to join the main line north of the station. However, they crossed the Northallerton–Hawes branch at only a slightly lower level so a novel method of working was adopted, the Hawes branch being carried over the emergency line on bogies, which could be moved away should the emergency line need to be used. The Northallerton–Hawes service could still have been worked by using the north side of the Castle Hills triangle, which would have involved reversing all trains to and from the branch. Indeed, during the war, the Leeds Northern route became invaluable for freight traffic from the north-east coast to the Midlands and Lancashire as trains could run to Leeds without using the main line. Also, if trains were routed via Wetherby, they could reach the goods yards at Neville Hill without passing through Holbeck, which was a considerable bottleneck.

When war ended in 1945, the railways had been worked well beyond capacity and there had been little maintenance to the system due to overuse and shortages of staff. Though the majority of the nation's railways had not suffered as much as those in mainland Europe, there were insufficient funds to bring them back to their pre-war state. The railways in Britain, therefore, had to 'make do and mend' as reconstruction of bomb-damaged cities was considered much more important than a more-or-less intact British railway system. At the same time, there were calls for the railways to be nationalised, as had been the case after the previous conflict. This time, however, a new Labour government had been elected by a landslide in 1945 who were in favour of wholesale state ownership of key industries. Thus, despite some resistance from the 'Big Four', the railways were nationalised from 1 January 1948. Under the new 'British Railways', the nation's system was regionalised, the old LNER in the area around York, Harrogate and the Dales becoming BR North-Eastern Region. Despite experiments with diesel traction by the LMS and GWR, electrification by the LNER over its Woodhead route from 1946 and the Southern Railway's three-rail electrification on the old London, Brighton and South Coast Railway in the 1930s, the new British Railways decided to remain with steam traction for the foreseeable future, coal being cheap and plentiful while oil was expensive and required 'hard currency', which Britain was short of after the cost of

the war. By the early 1950s, however, BR had problems recruiting staff to what was a dirty industry when compared to modern factory work and the general public were turning away from the 'dirty' railways in favour of private cars and motor coaches, this road traffic having expanded considerably after the war. Freight traffic, also, was leaving the railways in favour of the roads as many ex-military men had learned to drive lorries during the war and wanted to use these skills in peacetime and the railways were seen as slow, outdated and expensive. In order to attract freight and passengers back, BR came up with the 1955 'Modernisation Plan' which envisaged wholesale electrification of its trunk routes and local services over branch lines operated by diesel multiple units. Apart from the West Coast Main Line, electrified in the 1960s, there were no further developments in this area until the East Coast Main Line was so treated in the 1980s. The Midland Main Line from St Pancras to Sheffield and the ex-GWR line between Paddington and Swansea have only had electrification proposals made in 2012. Meanwhile, diesel-electric traction would replace steam, all of which had disappeared on the main lines by 1968.

Along with replacement of steam traction, some loss-making services were closed. In the Harrogate area, trains to Bradford (Forster Square) were withdrawn in February 1957 and the Melmerby–Thirsk line was closed in 1959. The station at Pickhill was closed in September of the same year, Sinderby closed in January 1962 and Nidd Bridge and Wormald Green followed in June. Passenger services ceased on the Pilmoor–Boroughbridge branch from 25 September 1960, with freight lasting until 1964. Passenger services were also withdrawn on the Wensleydale branch from 26 April 1954, with freight lasting for another ten years. The Pateley Bridge branch lost its passenger trains as early as 2 April 1951, freight operating over the line until 1964. Further closures followed under the infamous Beeching Report of 1963, including the Leeds Northern line north of Harrogate, which closed to passenger traffic as far as Northallerton from 6 March 1967. Goods traffic continued as far as Ripon from the south until 6 October 1969.

The Midland Railway's Settle–Carlisle line was under threat of closure for many years since Beeching, but was useful as a by-pass route while work was being carried out on the WCML. The line also found fame as a main line operating steam excursions using preserved locomotives over the famous 'Long Drag'. BR did try to have the line closed in the 1980s by neglecting to maintain the famous Ribblehead Viaduct, one of the many listed buildings on the line. However, after many objections to closure, the then Minister of State for Transport, Michael Portillo, refused BR permission to close the line and it has thrived ever since. Indeed, Mr Portillo claimed that saving the Settle–Carlisle line was his greatest achievement in politics.

Survival of the Settle–Carlisle line has allowed continued running of steam excursions over the route, recalling the days when the steam locomotive hauled trains throughout the North of England, operating such services through Harrogate, the Leeds Northern line to Ripon and Thirsk and the Great North of England Railway through Northallerton and the cradle of the British railway system, at Darlington.

RAILS AROUND HARROGATE

As a popular spa town, the railways were keen to provide services from London and other major cities to Harrogate. To cater for such visitors, the Great Northern and Midland Railways provided direct trains from the capital. In LNER days, some services from King's Cross were made up of Pullman stock. The first of these, the 'Harrogate Pullman', began running from 1923, operating between King's Cross and Newcastle, via Leeds and Harrogate. Two years later, the service was extended to Edinburgh and, from September 1925, the train was re-routed via Church Fenton, omitting Leeds but still calling at Harrogate. From 1 May 1928, the train reverted to Leeds and was renamed the 'Queen of Scots'.

In September 1925, the 'West Riding Pullman' began operating between King's Cross and Leeds. The Up working, however, started from Harrogate. In May 1928, the service was extended to Harrogate and Newcastle. From September 1935, the train was renamed the 'Yorkshire Pullman' and terminated at Harrogate to avoid clashing with the streamlined 'Silver Jubilee' which was introduced at the same time, running between London and Newcastle, via York. In September 1937, the LNER introduced the 'West Riding Limited', another streamlined service, leading to the re-routing of the Up 'Yorkshire Pullman' via York, these services continuing until withdrawal at the outbreak of the Second World War.

After the war, the 'Queen of Scots' and the 'Yorkshire Pullman' were reinstated, the former ceasing in 1964 due to a lack of passengers north of Harrogate. Between King's Cross and Harrogate it was replaced by the 'White Rose', which ran at about the same time as its predecessor.

In the years before the Second World War, these Pullman trains generally carried visitors to Harrogate but, in the post-war period, most passengers were businesspeople. The two wars had changed much at Harrogate. With its large number of hotels, the town became a major evacuation centre for various ministries and government departments that were moved from London. Since the war, many of those hotels which were able to reopen have mainly catered

for conferences and conventions, delegates having been brought to the town by special trains from major cities, although virtually all of this traffic has now ceased as delegates prefer to travel by car.

With the decline of spa visitors, Harrogate has become a dormitory town for people working in Leeds, Bradford and York, and is considered to be one of the top ten places to live in Great Britain. Local trains operated to these cities from Harrogate, but such services declined as use of the motor car became more popular and many of these services have been withdrawn over the years. Today, most of the lines opened in 1862 still remain, but the Leeds–Thirsk line from Pannal Junction to Starbeck has been closed and lifted.

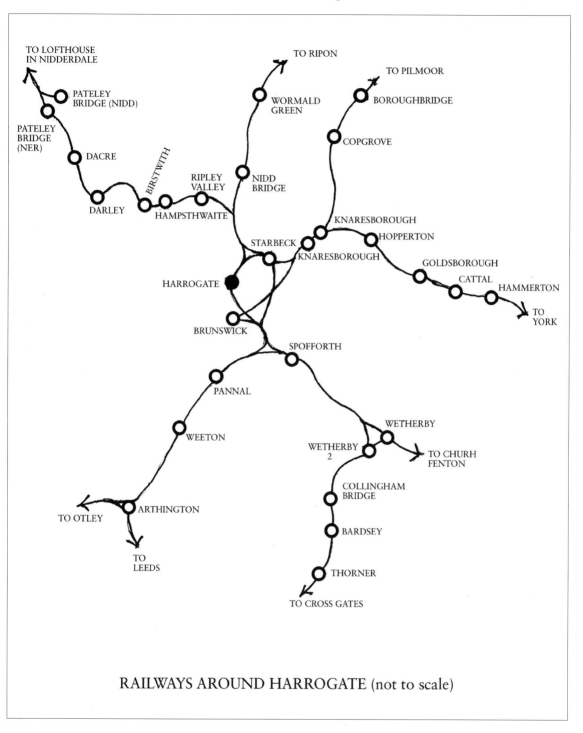

RAILWAYS AROUND HARROGATE (not to scale)

A map showing the railways around Harrogate, including the Leeds & Thirsk line from Leeds, via Arthington and Pannal, to Harrogate and then to Ripon, via Nidd Bridge and Wormald Green, the Y&NMR line from Church Fenton and Wetherby, and lines from Harrogate from Knaresborough to Pilmoor and York. (Author)

LONDON, CHURCH FENTON, WETHERBY, [

Down.		Week Days.											
		mrn	mrn	mrn	mrn	mrn	mrn	aft	aft	mrn	mrn	aft	aft
King's Cross Station, 340 London 342dep.					5 c 5			c 1010	1035			1540	1
724 HULL (Paragon) .. "			6 3		8 55	1015		1230	2 5				
724 SELBY "			7 14		9 55	1125		1 55	2 54				m
609 YORK 723 "		6 50	7 30		9 57	1115		1 36	3 10				5
Church Fentondep.		7 21	8 5		1030	1152		2 17	3 47			a	5
4¾ Tadcaster		7 30	8 14		1039	12 3		2 26	3 56				5
6¼ Newton Kyme		7 36	8 19		1043	1210		2 30	4 0				5
8¼ Thorp Arch, for Boston Spa		7 40	8 23		1047	1216		2 34	4 4				5
10¼ Wetherbyarr.		7 47	8 29		1053	1223		2 40	4 10				5
Wetherbydep.		7 50	8 50		1057			2 43					6
14 Spofforth[710		7 57	8 57		11 5			2 49					6
19 Harrogate 705, 708, arr.		8 8	9 9	m	1116		m	3 0				6 4	6
Wetherbydep.	7 2	7 48	8 34	10 4		1226	1 23	2 20	m	4 12	5 8		
12¼ Collingham Bridge	7 7	7 53	8 39	10 9		1231	1 27	2 25		4 17	5 13		
15 Bardsey	7 13	7 59	8 45	1015		1237	1 32	2 31		4 23	5 19		
17 Thorner	7 20	8 6	8 52	1022		1245	1 37	2 38		4 30	5 26		
19¼ Scholes	7 26	8 12	8 58	1028		1251	1 43	2 44		4 36	5 32		
21¼ Cross Gates 726, 728	7 31	8 17	9 3	1033		1256		2 49		4 41	5 37		
25 Leeds { Marsh Lane	7 40	8 26	9 12	1042		1 5		2 58		4 51	5 46		
25¾ 523 { New Station..arr.	7 43	8 29	9 14	1045		1 8	1 54	3 1		4 54	5 49		

Up.		Week Days.											
		mrn	mrn	m	mrn	mrn	mrn	m	aft	aft	aft	aft	aft
Leeds { New Station..dep.	6 30	8 0	9 13		9 50		1218	1 28			4 35	5 30	
{ Marsh Lane	6 33	8 3	9 16		9 53			1 31			4 38	5 33	
4¼ Cross Gates	6 42	8 11	9 25		10 2			1 40			4 46	5 42	
6¼ Scholes	6 49	8 18	9 32		10 8		1231	1 47			4 52	5 49	
8¼ Thorner	6 55	8 24	9 38		1014		1237	1 53			4 58	5 55	
10¼ Bardsey	7 1	8 30	9 44		1020		1243	1 59			5 4	6 1	
13 Collingham Bridge	7 7	8 36	9 50		1026		1249	2 5			5 9	6 7	
14¼ Wetherby (above)arr.	7 11	8 40	9 54		1030	m	1253	2 9		m	5 14	6 11	
Mls Harrogatedep.	6 45	8 28		b 1010		1149		1 50	2635	3 7	4 53		6
5 Spofforth	6 54	8 37				1159		1 59		3 16	5 2		6
7¾ Wetherby (above). arr.	7 0	8 43				12 6		2 4		3 21	5 7		6
Wetherbydep.	7 13	8 46			1031	1212		2 10		3 26	5 16	6 18	
17¼ Thorp Arch, for Boston Spa	7 20	8 53			1038	1220		2 17		3 33	5 24	6 24	
19 Newton Kyme	7 24	8 57			1042	1224		2 21		3 37	5 28	6 28	
21 Tadcaster[723, 726	7 29	9 2			1047	1230		2 26		3 43	5 33	6 33	
25¼ Church Fenton 340, 609, a	7 37	9 9			1055	1238		2 34	b	3 51	5 41	6 41	
36¼ 608 YORK 722arr.	8 6	9 46				1127	1 8		3 54		4 11	6 29	7 27
56¼ 726 SELBY "	8 16	9 35				1122	1 2		2 55			6 12	
66¼ 726 HULL (Paragon) .. "	9 25	1055				1232	2 4		4 11			6 55	
208¼ 340 LONDON (K.C.) 349 "	1 c 5	1c55			2 15	4c10	6 2		7 0	7 0		c 1045	

a Stops about 5 29 aft. if required to set down from London. **b** Stops at 2 55 aft. if req[London.

A 1910 timetable for services from King's Cross to Harrogate and Leeds. It was the Y&NMR line which reached Harrogate first, terminating at Harrogate Brunswick station. Brunswick station was at the end of the branch of the Y&NMR and the first train arrived on 20 July 1848. Brunswick station was situated on the site where Trinity church now stands. When the NER entered Harrogate via a cutting through The Stray, Brunswick station was closed and the first train into the new station entered on 1 August 1862. (Author's collection)

Y, HARROGATE, and LEEDS.—North Eastern.

ft	aft	aft	aft	aft	aft	aft	aft
40	1 40	1 40	5b25
..	5 12	5 55	
..	m	6 20	8 15	m
.. 5 7	6 15	7 15	8 5	9 40
a 5 36	6 44	7 34	7 44	8 40	10 5
.. 5 44	6 53	7 53	8 49	1014
.. 5 48	6 57	7 57	8 53	1018
.. 5 52	7 1	8 1	8 57	1022
.. 5 58	7 7	8 7	9 3	1028
.. 6 4	7 18	8 11	9 16	
.. 6 10	7 25	8 18	9 23	
4 6 21	m	7 37	8 0	8 30	9 35	
....	7 5	7 9	8 9	9 7	1030	
....	7 14	8 14	9 12	1035	
....	7 20	8 20	9 19	1041	
....	7 27	8 27	9 26	1048	
....	7 33	8 34	9 33	1054	
....	7 38	8 39	9 38	1059	
....	7 47	8 48	9 47	11 8	
....	7 30	7 50	8 51	9 50	1111	

Luncheon Car

ft	aft	m	aft	aft	aft	aft
30	6 30	7 15	8 17	1058	
33	7 18	8 20	11 1	
42	7 27	8 29	1110	
49	6 41	7 34	8 36	1117	
55	6 46	7 40	8 42	1123	
1	6 52	7 46	8 48	1129	
7	6 57	7 52	8 54	1135	
11	7 1	7 56	8 58	1139	
..	6 32	7 38	8 40	
..	6 41	7 47	8 49	
..	6 47	7 53	8 54	
18	7 58	9 0	1141
24	8 5	9 7	1148
28	8 9	9 11	Sig.
33	8 14	9 16	1157
41	8 22	9 24	
27	8 58	10 5	
.	9 1	1023	
.	1012	1133	
.	3c10	5c50	

Tues., Fri., and Sats.

required to take up for | b Thro' Express between King's Cross and Harrogate.
c Via Selby. m Auto-car.

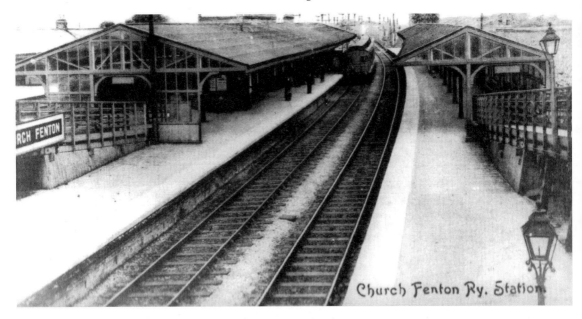

After leaving Leeds, the Y&NMR line to Harrogate passed through Church Fenton, seen here after extensions had been made between 1900 and 1904 with a local train in view. (LOSA)

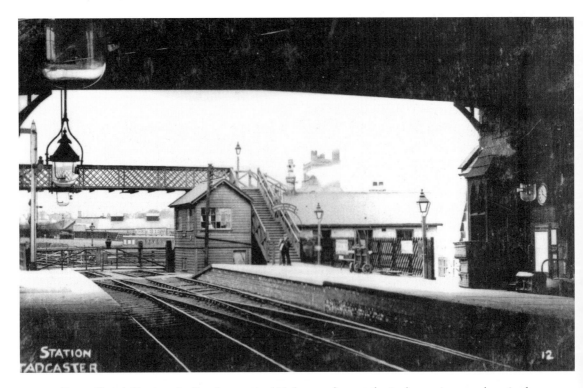

From Church Fenton, the line then entered Tadcaster, famous for its breweries, seen here in the 1900s. From here, the line then passed Newton Kyme and Thorp Arch (for Boston Spa) before arriving at Wetherby. (LOSA)

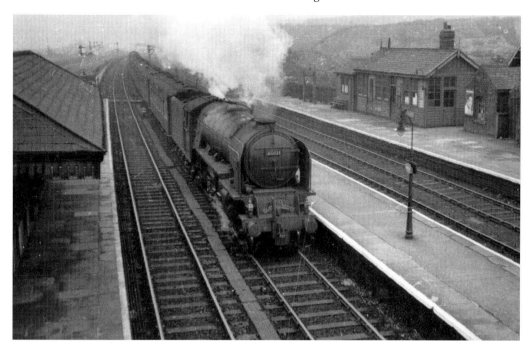

The famous 'Queen of Scots' Pullman train, headed by A1 pacific No. 60131 *Osprey*, in 1956, which called at Harrogate until 1964, being replaced by the 'White Rose' running between King's Cross and Harrogate. (R. Carpenter)

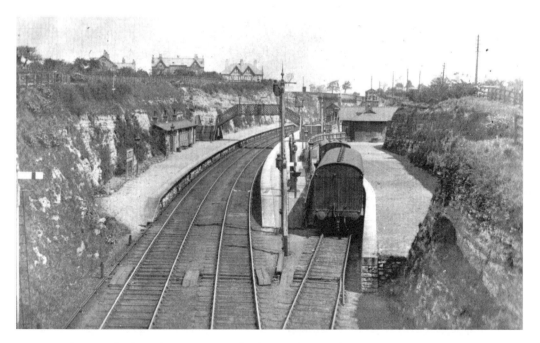

From Thorp Arch, the railway enters Wetherby, seen here early in the twentieth century, with a goods van in the siding. The station here opened with the Y&NMR line to Harrogate in 1848 and was closed in January 1964. (LOSA)

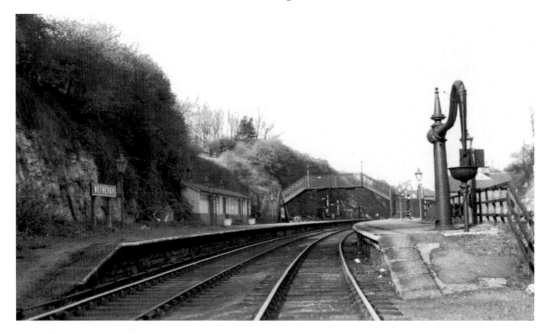

Wetherby station looking north, the same direction as the previous view, on 21 April 1954, with a closer view of the simple buildings on the platforms and the typical NER footbridge. (H. Casserley)

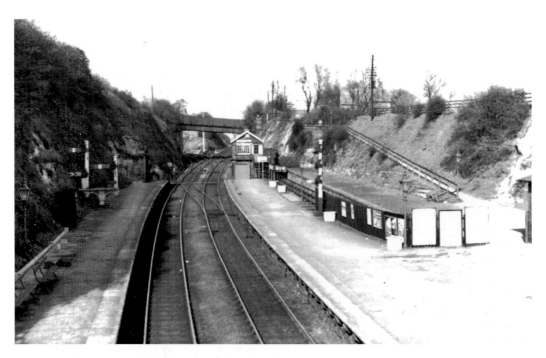

Wetherby station looking south on the same day. The line to Harrogate runs away on the left and the line to Church Fenton is on the right. This view is from the footbridge with the signal box in view and the path up to the road is on the right. The road crosses the railway via the bridge in the distance. (H. Casserley)

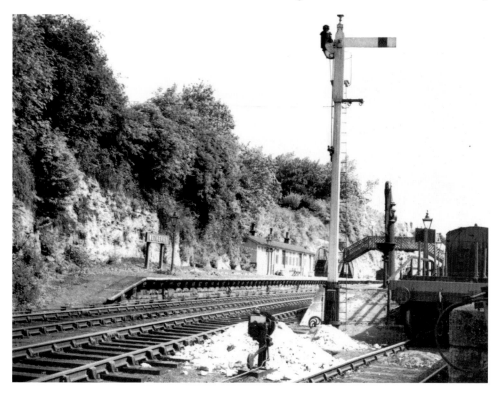

Another view of Wetherby station in 1953 and looking south. A typical NER slotted post signal is clearly seen in the foreground. (LOSA)

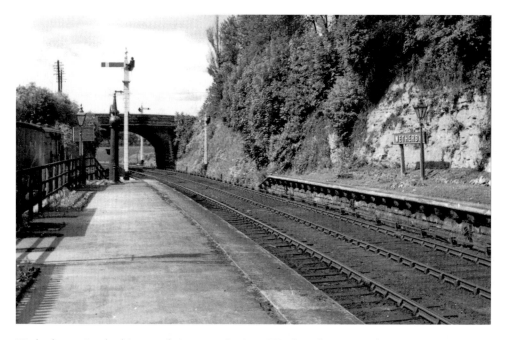

Wetherby station looking north in 1953. Again, NER slotted post signals are in view. (LOSA)

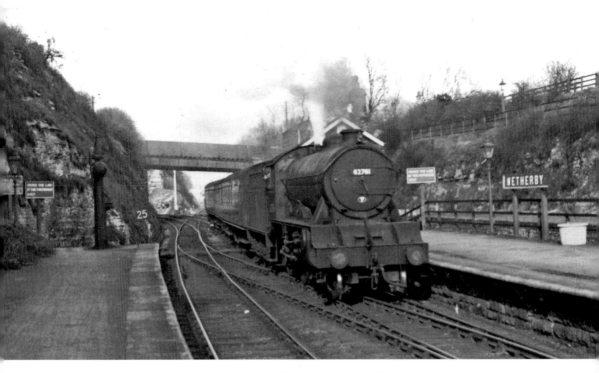

Ex-LNER Class D49 4-4-0 No. 62761 *The Derwent,* one of the Hunt Class engines, is seen at Wetherby with the 4.40 p.m. Harrogate–Leeds service on 21 April 1954. (H. Casserley)

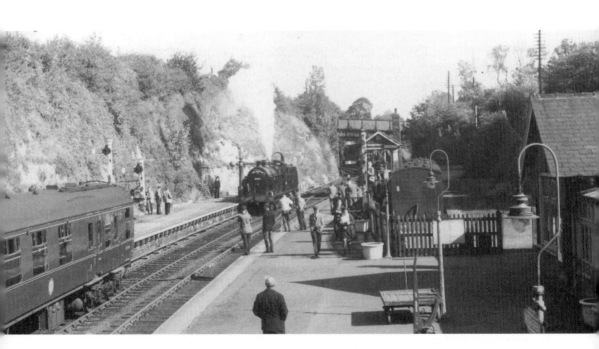

Wetherby station on 27 September 1963 and looking north with ex-LMS 4F 0-6-0 No. 44467 shunting around its coaches as it prepares to continue with a rail tour of the locality. (H. Casserley)

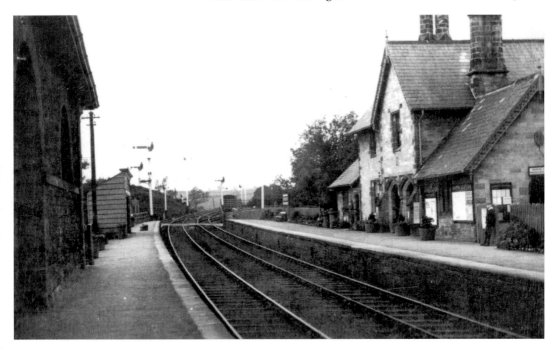

After leaving Wetherby and before reaching Harrogate, the line entered Spofforth station, seen here in NER days. (LOSA)

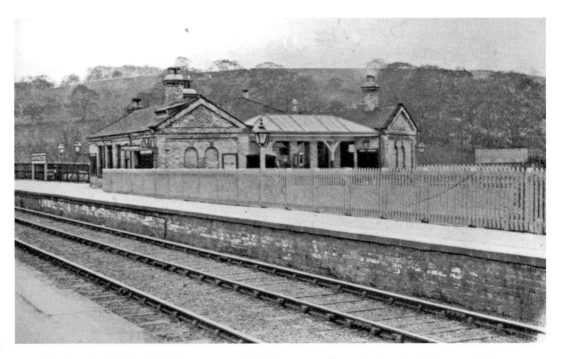

The Leeds & Thirsk Railway approached Harrogate from Leeds via Arthington, Weeton, Pannal and Starbeck. Arthington station is seen here in NER days and was also the junction of the branch for Otley, which could also be reached from Harrogate. (LOSA)

LEEDS, HARROGATE, OTLEY, an[...]

Down. Week [...]

Miles	New Station,	mrn	mrn	mrn	mrn	aft		aft	aft	aft
—	Leedsdep.	7 43	7 55	9 24	1148	1 23	3 05	0 5	3 0[...]
¼	Holbeck (Low Level)...	7 47	7g59	9 28	1152	1 27	3 5	5. 5	5 3[...]
3	Headingley	7 53	9 34	1158	5 11
5¾	Horsforth	8 0	9 41	12 5	5 18
9¼	Arthingtonarr.	8 6	8 13	9 47	1211	3 21	5 24
—	710 Harrogatedep.	7 30	7h40	9h27	1138	1240 h		2h49	5 h5
—	Arthington "	8 7	8 22	9 48	1213	3 22	5 26
10	Pool..............	8 9	8 25	9 51	1216	3 25	5 29
12¼	Otley	8 31	9 57	1222	1 49	3 32	5 36	5 54
15¼	Burley	8 37	10 3	1228	1 55	3 38	5 42	6 [...]
17¾	Ben Rhydding...........	8 42	10 8	1233	2 0	3 43	5 47	6 [...]
18¾	Ilkley 616arr.	8 45	1011	1236	2 3	3 46	5 50	6 [...]

Mls	Up.	mrn	mrn	mrn	mrn	mrn	aft	aft	aft	aft
—	Ilkleydep.	7 25	8 17	9 0	1045	1250	2 16	4 0	6 15
1	Ben Rhydding.........	7 28	8 20	...	9 3	1048	1253	2 19	4 3	6 19
3½	Burley	7 33	8 25	9 8	1053	1259	2 24	4 8	6 23
6	Otley 721	7 39	8 31	m	9 14	1059	1 6	2 30	4 14	6 29
8¼	Pool.............	7 45	8 40	9 20	11 5	1 12	4 21	6 35
9¼	Arthington 708arr.	7 48	8 43	9 22	11 7	1 15	2 35	4 23	6 37
18½	708 Harrogate "	8h14	9h51	1144	1 53	3 7	5 6	7 h1
—	Arthingtondep.	7 51	8 44	9 23	1 8	1 16	2 36	4 24	6 38
13	Horsforth	8 0	8 52	1116	1 25	2 44	4 32	6 46
15¾	Headingley	8 5	8 56	1122	1 31	4 38	6 52
18	Holbeck (Low Level)...	8 11	8 52	9 1	9 39	1130	1 38	2 54	4 44	7 0
18¼	Leeds (New) 722, 726 ar	8 15	8 55	9 4	9 43	1134	1 42	2 58	4 48	7 4

g Wednesdays and Thursdays. h O[...]

☞ For **OTHER TRAINS** between Leeds [...]
 Leeds and Ilkley, see pa[...]

HARROGATE, OTLEY, SHIPL[...]

Week Days only.

Miles		mrn	mrn	mrn	mrn	aft	aft	aft	aft	
—	Harrogatedep	7 35	8 30	9 28	1136	1240	2 55	4 50	7 14
3¼	Pannal	k	k	
6¼	Weeton.............	u		u					u	
12¼	Otley 750	7 57	8 50	9 49	1156	1 0	3 15	5 10	7 36
15¼	Menston	8 10						b	
16¼	Guiseley	8 14	9 59	12 5	1 10	3 27	5 22	7 47
20	Baildon.............	8 24					v		
21¼	Shipley ¶ 672............	8 28	10 9	1214	1 20	3 36	5 35	7 56
23¼	Manningham.........		b	b	b	b	b
24¾	Bradford (Market St.)arr.	8 35	9 12	1016	1223	1 29	3 43	5 43	8 5

b Set down if required from Harrogate and beyond.		**u** Stop if required to take up.	
h Stop if required to set down.		**v** Sets down on Fridays if requi[...] from Newcastle.	
k Stop at Pannal if required on 17th and 31st instant.		**x** Stops if required to take up Harrogate or beyond.	

KLEY.—North Eastern.

ft	aft										
10	1010
15	1015
22	1022
30	1030
36	1036
43	1025
42	1048
45	1051
51	1057
57	11 3
2	11 8
5	1111

ft										
5
8
13
19
25
28
58
44
54
59
5
9

Otley. **m** Auto-car.
rthington, see pages 708 to 711;
5 and 617.

Left: A 1910 NER timetable for services between Leeds, Harrogate, Otley and Ilkley. (Author's collection)

Below: An NER timetable for services from Harrogate to Bradford, via the Leeds & Thirsk and Midland Railways. (Author's collection)

BRADFORD.—North Eastern.

Week Days only.

| | mrn | mrn | aft | Saturdays only. | aft | aft | aft | aft | aft | |
|---|---|---|---|---|---|---|---|---|---|---|---|
| Bradford (Market Street)....dep. | 7 12 | 9 54 | 1218 | | 1 13 | 3 27 | 5 20 | 6 15 | 8 24 | ... |
| Manningham | œ | œ | | | œ | | | œ | œ | ... |
| Shipley ¶ | 7 19 | 10 3 | 1224 | | 1 21 | 3 34 | | 6 24 | 8 32 | ... |
| Baildon | | | | | | | | | | |
| Guiseley | 7 30 | 1013 | 1241 | | 1 32 | 3 43 | | 6 34 | 8 42 | ... |
| Menston ... | | X | | | | | | | | |
| Otley 750 | 7 42 | 1026 | 1251 | | 1 40 | 3 52 | 5 42 | 6 43 | 8 50 | ... |
| Weeton | 7 53 | | | | h | | | h | | |
| Pannal[771 | 7 59 | k | | | h | | | h | | |
| Harrogate 751 to 753, 770 arr. | 8 7 | 1050 | 1 11 | | 2 3 | 4 12 | 6 27 | 4 9 13 | | ... |

Take up if required for Otley and beyond.
tation Road: under ¼ mile from the
.N. (Bridge Street) Station.

☞ **For other Trains**

BETWEEN	PAGE
Harrogate and Otley	750
Otley and Bradford	683

For other Trains BETWEEN Harrogate and Otley 750; Otley and Bradford 683

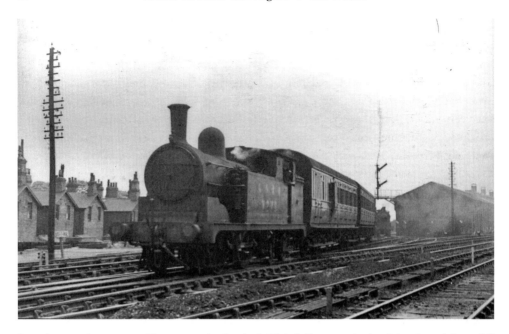

In order to gain access to Harrogate, the Leeds & Thirsk line ran via the Crimple and Stonefall Valleys to Starbeck, thence to Harrogate. Here, leaving Starbeck station with a local service is ex-NER G5 0-4-4T, as LNER No. 7278 with the locoshed in the background. Starbeck was provided with a locoshed in 1857 and in 1864 it was recommended that the shed should be lengthened to accommodate two further engines. As a consequence of the closure of Harrogate Brunswick station, a further extension to the shed was required in June 1877 'in connection with running of trains through from Harrogate to Bradford'. The extension was estimated to cost £625. At the same time, it was decided to build eight cottages as well, which brought the cost up to £1,432. On 1 March 1888, the shed was lengthened again, at a cost of £1,840 and this extension could only have just been completed when the Midland Railway requested that accommodation be provided for two of their engines. Thus, the shed was extended by another 140 feet and, with rearrangement of the tracks, the cost was £2,254. As the MR only paid £25 per year per loco, the extension was not profitable. Further extensions took place in 1900/1, with final modifications taking place when a new roof was installed after the Second World War. In 1930, a new shed was proposed between Starbeck North Junction and Dragon Junction but this was not proceeded with. (H. Casserley)

Starbeck turned out thirteen engines daily for passenger work in 1922/3 with services radiating from Harrogate to York, Leeds, Bradford, Pilmoor, Selby, Pontefract and West Hartlepool. The majority of this work was in the hands of G5 0-4-4Ts, with longer services being operated by 4-4-0s. Along with goods work on branches, Starbeck was responsible for working goods trains north and south between Starbeck and Leeds, A7 4-6-2Ts being used for these trains.

Starbeck became home for many D20 4-4-0s and in 1939 had thirteen, Nos 712, 1026, 1042, 1206, 1217, 1236, 1258, 1672, 2020, 2101, 2104, 2105, and 2107. There were also eleven G5 0-4-4Ts and four D21 4-4-0s. In addition, two Sentinel steam railcars operated between Harrogate and Knaresborough. In 1922/3, the only Sunday working from Starbeck during the winter was the 8.20 a.m. empty to Pateley Bridge , returning on the 9.10 a.m. milk train. Coded 50D in BR days, the shed's allocation in 1950 was as follows:

Ex-NER D20 4-4-0	62341, 62342, 62343, 62370, 62373, 62384, 62389, 62392, 62397
Ex-LNER D49 4-4-0	62738 *The Zetland*, 62749 *The Cottesmore*, 62752 *The Atherstone*, 62753 *The Belvoir*, 62755 *The Bilsdale*, 62758 *The Cattistock*, 62762 *The Fernie*, 62763 *The Fitzwilliam*, 62765 *The Goathland*, 62768 *The Morpeth*, 62772 *The Sinnington*, 62773 *The South Durham*
Ex-LNER J39 0-6-0	64818, 64845, 64855, 64857, 64859, 64860, 64861, 64866, 64922, 64938, 64942, 64944
Ex-NER G5 0-4-4T	67253
Ex-NER J77 0-6-0T	68392, 68393
Ex-NER A6 4-6-2T	69791, 69793, 69794
	Total: 39

The shed closed on 13 September 1959; its final allocation was:

D49 4-4-0	62727 *The Quorn*, 62738 *The Zetland*, 62753 *The Belvoir*, 62759 *The Craven*, 62763 *The Fitzwilliam*
J25 0-6-0	65726
J39 0-6-0	64706, 64821, 64845, 64855, 64857, 64859, 64861, 64866, 64942, 64944
WD 2-8-0	90044, 90054, 90457, 90518
3MT 0-6-0T	47438, 47462, 47581
	Total: 23

KNARESBOROUGH, STARBEC[K]

Miles	Down.	mrn	mrn	mrn		mrn	mrn	mrn		mrn	mrn	a
	Knaresboroughdep.	5 38	6 15	7 25	8 1	8 22	8 39	9 2	9 52	1015
1¾	Starbeck...[752, 770, 771	5 43	6 20	7 30	8 6	8 27	8 44	9 7	9 57	1020
4	Harrogate 750, 751, arr.	5 51	6 28	7 41	8 15	8 34	8 54	9 14	10 4	1028

Down.					Week Days—*Continued.*						
	aft	aft	aft	aft	aft	aft	aft		aft	aft	
Knaresborough......dep.	6 15	6 33	6 24	6 46	7 0	7 30	8 7	8 36	8 47	*Except Sats.*
Starbeck..[752,770,771,	6 20	6 38	6 29	7 5	7 35	8 12	8 41	8 52	
Harrogate 750, 751, arr.	6 29	6 50	6 36	6 59	7 13	7 42	8 19	8 50	9 0	

Miles	Up.	mrn	mrn	mrn		mrn	mrn	mrn		a	mrn	mrn
	Harrogate..........dep.	5 55	6 50	7 26	8 5	8 36	8 42	9 25	9 32	1025
2¼	Starbeck..............	6 0	6 55	7 31	8 10	8 41	8 47	9 30	9 37	1030
4	Knaresborougharr.	6 5	7 0	7 36	8 15	8 46	8 52	9 35	9 42	1035

Up						Week Days—*Continue[d]*						
	aft	aft	aft	aft	aft	aft		aft	aft	aft	aft	
Harrogatedep.	6 20	6 44	7 0	7 10	7 45	7 50	8 5	8 35	9 18	9 50
Starbeck	6 25	6 49	7 5	7 15	7 50	7 55	8 10	8 40	9 23	9 55
Knaresborough......arr.	6 30	6 54	7 10	7 20	7 55	8 0	8 15	8 45	9 28	10 0

A 1910 NER timetable for trains operating between Knaresborough, Starbeck and Harrogate. (Author's collection)

A derelict and almost demolished Starbeck locoshed as it appeared on 25 June 1961. (R. Carpenter)

ıd **HARROGATE.**—North Eastern.

Week Days.

ırn	mrn	mrn	aft	aft		aft	aft	aft	aft		aft	aft	aft		aft	aft	aft	aft
041	11 6	1140	1228	1 28	2 0	2 18	2 55	3 15	3 55	4 4	4 33	4 57	5 45	6 3
046	1111	1145	1233	1 33	1 45	2 5	2 23	3 0	3 20	4 0	4 9	4 38	5 2	5 50	6 8
053	1120	1152	1240	1 42	1 50	2 13	2 30	3 8	3 27	4 7	4 18	4 45	5 10	5 57	6 18

Sundays.

	aft	⎫ Sats.	aft	aft	aft		aft		aft	
	9 17		9 52	10 5	3 25	6 *3	8 40
	9 23		9 57	1010	3 32	6 10	8 47
	9 32	⎭	10 5	3 38	6 16	...	8 53

NOTES.

ᴀ Runs on 17th and 31st instant.

s Saturdays only.

Week Days.

ırn	mrn		aft	aft	aft	aft	aft		aft	aft	aft	aft		aft	aft	aft	aft	aft
120	1146	12 7	1246	2 0	2 30	2 45	3 25	3 35	4 3	4 15	4 40	4 54	5 15	5 47	6 0
125	1151	1212	1251	2 5	2 35	2 50	3 30	3 40	4 8	4 20	4 45	4 59	5 20	5 52	6 5
130	1156	1217	1256	2 10	2 40	2 55	3 35	3 45	4 13	4 25	4 50	5 4	5 25	5 57	6 10

Sundays.

	aft				aft		aft		aft	
Sats.	1047	3 5	5 43	8 15
	1052	3 10	5 48	8 20
	1057	3 15	5 53	8 25

☞ **For other Trains**

BETWEEN PAGES

Starbeck & Harrogate 751, 753

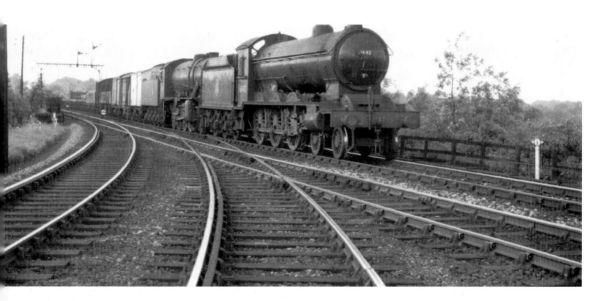

Ex-LNER Class B16 4-6-0 No. 61442 is seen piloting an unidentified ex-WD 2-8-0 on a goods train at Crimple Junction, looking towards Harrogate, in May 1953. (R. Carpenter)

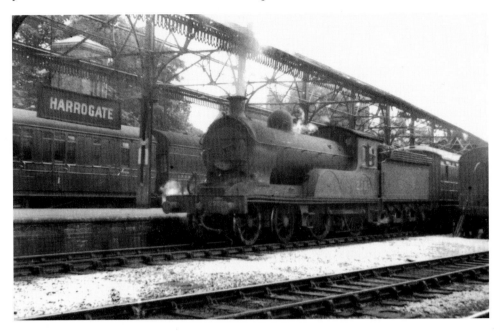

KNARESBOROUGH and ...

Miles	Down.		mrn	mrn	mrn	mrn	mrn	mrn
	Knaresborough,.....dep.		5 38	6 30	7 25	8 5	8 44	9 2
1¼	Starbeck..........[710, 713		5 45	6 37	7 32	8 14	8 51	9 9
4	Harrogate 705, 708, arr.		5 51	6 43	7 38	8 20	8 57	9 15

Down.		Week	aft	aft	aft	aft	aft	aft
Knaresboroughdep.			6 29	6 45	7 15	8 35	9 17	9 45
Starbeck[713			6 38	7 22	8 43	9 24	9 52
Harrogate 705, 708, 710, arr.			6 44	6 55	7 28	8 49	9 30	9 58

Miles	Up.		mrn	mrn	mrn	mrn	mrn	mrn
	Harrogatedep.		6 0	7 5	7 28	8 37	8 50	9 12
2½	Starbeck......................		6 5	7 10	7 33	8 42	8 55	9 17
4	Knaresborougharr.		6 10	7 15	7 58	8 47	9 0	9 22

Up.		Week	aft	aft	aft	aft	aft	aft
Harrogatedep.			6 0	6 55	7 42	8 5	9 5	1015
Starbeck.........................			6 4	7 0	7 47	8 10	9 10	1020
Knaresborougharr.			6 10	7 5	7 52	8 15	9 15	1025

3 Wednesdays o...

Opposite above: Waiting at Harrogate station immediately after the Second World War is ex-NER Class R 4-4-0, LNER Class D20 No. 2383 with an express. The station here opened on 1 August 1862 and its capacity increased in 1883 when it was lengthened by 100 yards. The station in this view was largely demolished between 1964 and 1965 and was replaced with a more modern utilitarian one constructed of that favourite 1960s material, concrete. Today, services from Harrogate are served by Northern Rail. (LOSA)

Below: A 1910 timetable for NER services between Knaresborough and Harrogate. (Author's collection)

OGATE.—North Eastern.

Week Days.

mrn	mrn	mrn	m		aft	aft	aft	aft	aft	aft	aft	aft	aft
5 11 4	1145	1239			1 0	1 25	2 7	2 45	3 40	3 56	5 5	5 58	6 15
2 1111	1152			1 7	1 33	2 14	2 52	3 47	4 3	5 12	6 6	6 23
8 1117	1158	1252			1 13	1 39	2 20	2 58	3 53	4 9	5 18	6 12	6 29

—Continued.

Week Days.

m	mrn	mrn			aft	aft	aft	aft	aft	aft	aft	aft	aft
1030	1055	1143			1240	1250	2 10	2 50	3 15	3 43	4 45	4 58	5 47
1035	11 0	1148			1245	1235	2 15	2 55	3 20	3 48	4 50	5 3	5 52
1040	11 5	1153			1250	1 0	2 20	3 0	3 25	3 53	4 55	5 8	5 57

—Continued.

m Auto-car.

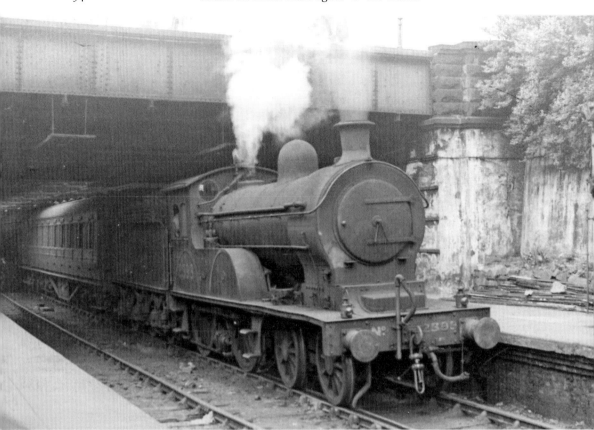

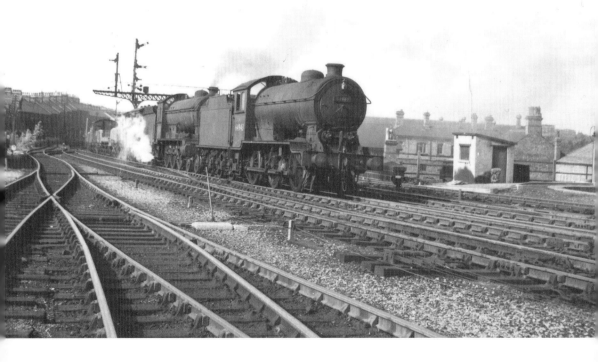

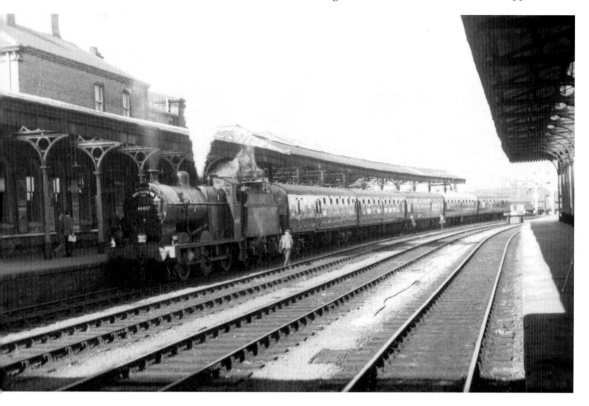

Opposite above: Another LNER Class D20 4-4-0 No. 2393 is seen leaving Harrogate station with the 3.45 p.m. train to Bradford on 11 June 1947. (H. Casserley)

Opposite below: Approaching Harrogate station in May 1953 is ex-LNER J39 0-6-0 No. 64943 piloting an unidentified B16 4-6-0 on a local freight service. (LOSA)

Above: Just arrived at Harrogate station on 27 September 1963 is ex-LMS Class 4F 0-6-0 at the head of an excursion train from the Yorkshire Dales. (H. Casserley)

HARROGATE, BOROUGHBR.

Miles.	Down.		Week Days.						
			mrn	mrn	mrn	aft	aft	aft	
	Harrogatedep.		7 5	9 12	11 43	2 50	4 45	7 42
2¼	Starbeck		7 10	9 17	11 48	2 55	4 50	7 47
3¾	Knaresborough		7 15	9 22	11 53	3 0	4 55	7 52
7¾	Copgrove		7 23	9 30	12 1	3 8	5 3	8 0
11	Boroughbridge {	arr.	7 31	9 38	12 9	3 16	5 11	8 8
		dep.	7 32	9 39	12 10	5 12	8 9
14¼	Brafferton		7 39	9 46	12 17	5 19	8 16
17	Pilmoor 684, 686 arr.		7 46	9 53	12 24	5 26	8 23

***** For LOCAL TRAINS between**
☞ For OTHER TRAINS between

Above: An NER timetable of 1910 for passenger services from Harrogate to Pilmoor, via Boroughbridge. (Author's collection)

Below: After leaving Harrogate, the Leeds Northern line, the old Leeds & Thirsk Railway, headed north towards Ripon and passed Nidd Bridge station, shortly after passing the junction for the Nidderdale branch, seen here with staff and children during the Edwardian period. (LOSA)

Opposite below: The next station on the Leeds Northern line, and before reaching Ripon, was at Wormald Green, seen here in the same period with staff and platelayer posed for the picture. Both Wormald Green and Nidd Bridge appear to have the same station architecture befitting a wayside station. (LOSA)

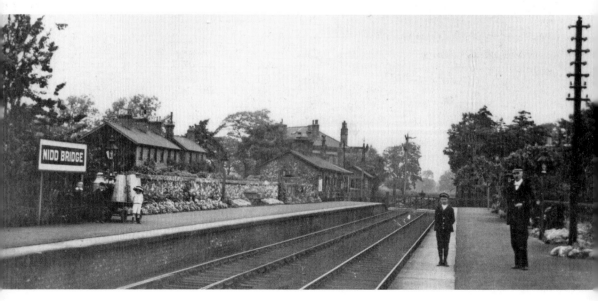

and PILMOOR.—North Eastern.

Up.		mrn	mrn	aft	aft	aft	aft		
Pilmoor............dep.		8 12	10 30	1 35	5 50	8 44
Brafferton		8 18	10 36	1 41	5 57	8 50
Boroughbridge... { arr.		8 26	10 44	1 49	6 6	8 58
{ dep.		8 27	10 46	1 50	3 23	6 11	9 0
Copgrove		8 35	10 54	1 58	3 31	6 20	9 8
Knaresborough 714 ..		8 44	11 4	2 7	3 40	6 29	9 17
Starbeck[713, 718		8 51	11 11	2 14	3 47	6 38	9 24
Harrogate 708, 710 arr.		8 57	11 17	2 20	3 53	6 44	9 30

gate and Knaresborough, see page 714.
eck and Harrogate. see pages 708 to 711.

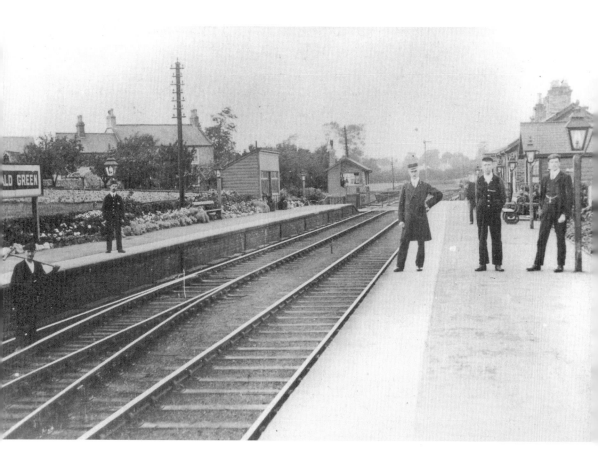

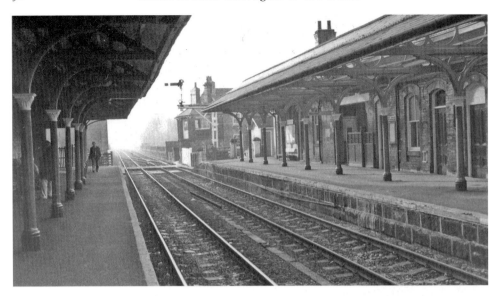

The platforms at Knaresborough station. A line from York's Poppleton Junction to a temporary terminus at Hay Park Lane, Knaresborough was opened by the East & West Junction Railway on 30 October 1848. The E&WJR was taken over by the Y&NMR on 1 July 1851 and, three weeks later when a viaduct across the River Nidd was completed, the temporary station was closed and a new station at *f*borough (the one in this view) was opened on 21 July 1851. (R. Carpenter)

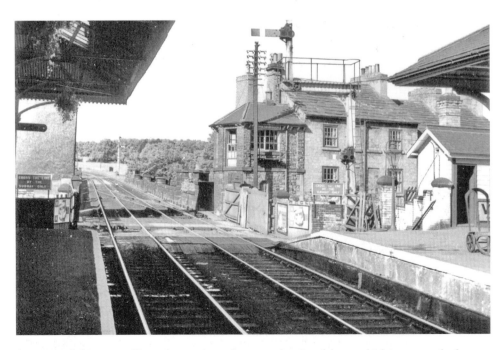

An unusual feature at Knaresborough station was the signal box, which was attached to an adjoining house, as can be seen in this view looking towards Harrogate in 1953. The picture also shows the level crossing here and the top of the viaduct over the River Nidd. This signal box remains in use, controlling a single-line section east to Cattal, the level crossing and a crossover which is used to reverse trains from Leeds which terminate at Knaresborough. (LOSA)

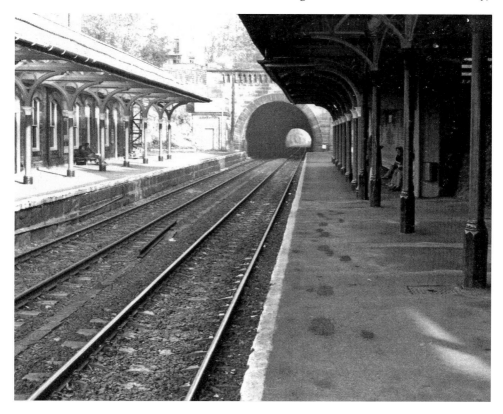

Knaresborough station looking east, with the tunnel beyond the platforms in view. Beyond the tunnel was the goods yard and the junction for the lines to Boroughbridge and to York. (R. Carpenter)

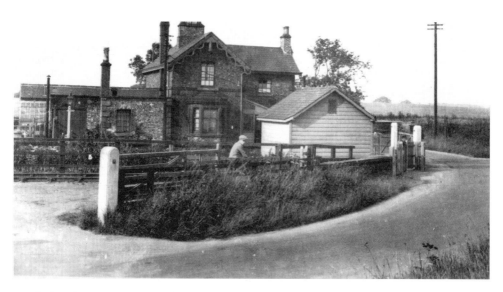

On the line from Harrogate and Knaresborough to York is the station at Goldsborough, the line having passed through Hopperton, seen here prior to the First World War. The station building is clear in this view with the local road crossing the line just right of the station. (LOSA)

YORK, KNARESBOROUGH, and HA

Down.

Miles	Central Station,	mrn	mrn	mrn	mrn	aft	aft	aft	aft
	68⁵Newcastle dep.	1h57	8 0	1028	1220	1230
	68⁵Darlington * ,,	2h48	6 35	8 55	1118	1 9	1 20
—	York dep.	7 20	8 57	1015	1215	1245	2 0	2 30	3 15
3	Poppleton	7 27	9 2	1021	1221	1251	m	3 22
5	Hessay	7 32	m	1026	m	1256	3 27
6	Marston Moor	7 35	1029	1259	3 30
7¼	Wilstrop Siding	k
8¼	Hammerton	7 41	1035	1 5	3 36
10¼	Cattal	7 46	1039	1 9	3 40
12¼	Allerton	7 51	1044	1 14	3 45
13¼	Goldsborough	7 55	1048	1 18	3 49
16¼	Knaresborough 705	8 5	1055	1239	1 25	d	d	3 56
18¼	Starbeck	8 14	11 2	1 33	4 3
20¼	Harrogate 705 708,710 arr.	8 20	11 8	1252	1 39	2 32	3 4	4 9

Up.

Miles		mrn	mrn	mrn	mrn	mrn	mrn	aft	m
	Harrogate dep.	7 28	8 25	8 50	9 20	1055	1250	1 10
2¼	Starbeck	7 33	8 55	11 0	1255
4	Knaresborough	7 38	c	9 0	11 51	1 0	c
6¼	Goldsborough	7 44	9 6	1111	1 6
8¼	Allerton	7 48	9 10	1115	1 10
10¼	Cattal	7 53	9 15	1120	1 15
11¼	Hammerton	7 57	9 19	1124	1 19
12¼	Wilstrop Siding	k
14¼	Marston Moor	8 3	9 25	1130	125
15¼	Hessay	8 6	m	9 28	1133	1 28
17¼	Poppleton [723	8 11	9 7	9 33	1138	1 33
20¼	York 348, 609, 684, arr.	8 20	8 55	9 13	9 43	9 47	1147	1 42	1 46
64¼	684 Darlington * arr.	10 9	1055	1 41	2 54
101	684 Newcastle (Central) ,,	11 7	1155	2 45	3 26

c Stops if required to take up. d Stop if required to set do(wn)

30 mrn. on Mondays. k Stop on Saturdays

* Bank Top Statio(n)

☞ For **OTHER TRAINS** between Starbeck

A 1910 timetable for NER trains between Harrogate, Knaresborough and York. (Author's collection)

nd HARROGATE.—North Eastern.
Week Days.

aft	aft	aft	aft	aft	aft
1230	1 44	3 54	5 4
1 20	2 44	4 56	5 56
2 30	3 15	5 15	5 18	6 22	7 55
m	3 22	5 24	6 1
....	3 27	5 29	8 6
....	3 30	5 32	8 9
....	k
....	3 36	5 38	8 15
....	3 40	5 42	6 36	8 19
....	3 45	5 47	8 24
....	3 49	5 51	8 28
d	3 56	5 58	6 45	8 35
....	4 3	6 6	8 43
3 4	4 9	5 42	6 12	6 55	8 49

Week Days.

aft	m	m	Wednesdays only.	aft	aft	aft	aft
1250	1 10	3 10		3 15	4 58	6 0	8 5
1255		3 20	5 3	6 4	8 10
1 0	c		3 25	5 8	6 10	8 15
1 6		3 31	5 14	8 21
1 10		3 36	5 18	8 25
1 15	3 26		3 41	5 23	8 30
1 19		3 46	5 27	8 34
....
525		3 52	5 33	8 40
1 28		3 55	5 36	8 43
1 33		4 0	5 41	8 48
1 42	1 46	3 43		4 10	5 50	6 32	8 57
....	2 54	5 50		5 50	7 0	9 58
....	3 26	6 42		6 42	7 55	1048

to set down. *h* Leaves Newcastle at 1 36 and Darlington at
turdays for York Passengers. **m** Auto-car.
op Station.
Starbeck and Harrogate, see pages 708 to 711.

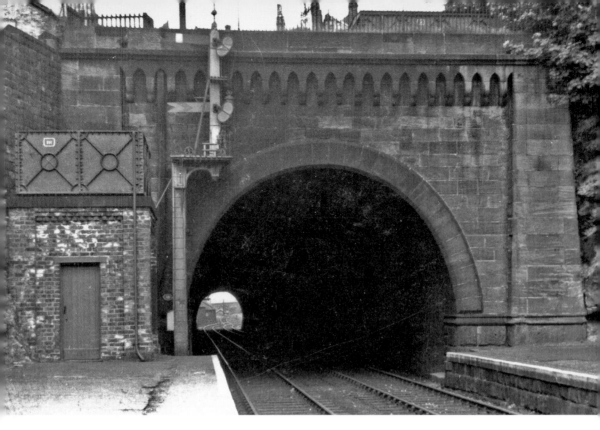

Knaresborough Tunnel as it appeared in 1951. (R. Carpenter)

TWO

THE LEEDS & THIRSK RAILWAY

Although the L&T agreed to use GNER metals between Thirsk and Northallerton in order to obtain its Act of 1846, the company still felt that it would prefer its own line between Melmerby and Northallerton. Such a plan was, therefore, presented in its Bill of 1848, which became successful. Thus, when, as the Leeds Northern Railway, trains from Leeds to Stockton commenced on 2 June 1852, they did not run via Thirsk because there was no connection between the Leeds Northern and the GNER at Northallerton. This situation remained until 1 January 1856 when a connecting curve was installed under the auspices of the North Eastern Railway, allowing a Leeds–Thirsk–Northallerton–Stockton service. The Melmerby–Northallerton line was then reduced to an unimportant branch until 1901 when the line was doubled and it became the more important route of the two. The section between Melmerby and Thirsk was then allowed to decline. To allow trains using the new route to call at Northallerton station, a connecting spur was made from the former Leeds Northern line at Cordio Junction to the GNER line at Northallerton South Junction; they could then use the 1856 curve to rejoin the Leeds Northern at Low Gates. At the same time, a single-line connection was provided for traffic from the Down main line to the Leeds Northern line to the North East, thereby preventing trains crossing the path of those on the Up main line; a similar connection for Up trains was not built for another thirty years.

Early in the twentieth century, the NER brought forward plans to make Northallerton a major centre for freight traffic and a large marshalling yard was to be built in the 'V' section between the main line and the Leeds Northern line south of Northallerton, with access and exit curves to both lines. Although extensive powers were granted under NER Acts of 1901 and 1903, the scheme was abandoned. As a consequence, while Northallerton had its own locoshed to provide engines serving the Wensleydale branch, it never developed as an important railway centre and remains as a North Riding market town, although it is the administrative centre for North Yorkshire.

Although freight traffic remained important over the Leeds Northern line until the 1960s, such traffic has since disappeared between Leeds and Northallerton, but there is still a considerable amount between Eaglescliffe and Northallerton as this provides the main outlet south from industrial Teesside.

NORTHALLERTON an

Miles	Up.	mrn	mrn	mrn	aft	Thursday Only	aft	aft					
	Week Days.												
	High Level Station,	mrn	mrn	mrn	aft		aft	aft					
	Northallertondep.	7 35	1054	1125	2 58		5 53	7 30
3	Newby Wiske.........	7 41	11 0	3 4		7 36
6¾	Pickhill	Th.	d	3 11		Wd
8	Sinderby	7 52	1111	3 15		7 47
10¾	Melmerby 705, 708...	7 57	1116	3 21		7 53
13½	Ripon 708.......arr.	8ɛ11	1122	1146	3 27		6 11	8 ɛ 8

d Stops on Thursdays ; also when required to set down fr
h Stops on Thursdays ; also when required to set down from beyond Harrog
☞ For **OTHER TRAINS** between Northallerton and Rip

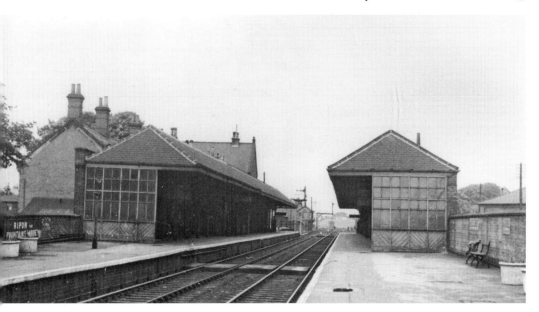

North of Wormald Green on the line to Thirsk lay the station at Ripon, seen here on 26 June 1950, which was opened with the Leeds & Thirsk Railway on 9 July 1848. The line north of Harrogate was closed in 1967, having been allowed to run down, the line remaining open to freight traffic until 6 October 1969. There was much opposition to closure of the station and suggestions have been made to reopen back to Harrogate. Feasibility studies have found that such a line could be economically viable, although it would cost some £40 million to reinstate the line but it could attract some 1,200 passengers a day, which would rise to 2,700. Back in December 1863, a plan was prepared for a locoshed at Ripon and in January 1864 it was reported that such a shed could be built for £600. The plan was put out to tender, but later that month CME Mr Fletcher reported that as a turntable would be required, costing £600, this would raise the cost to £1,000 and the scheme was abandoned. (H. Casserley)

PON.—North Eastern.													
Down.					**Week Days.**								
		mrn	mrn	aft	aft		aft						
Ripondep.	8 46	8*t*54	1227	3 50		8 *t* 0		
Melmerby	9 5	1234	3 57		8 20		
Sinderby	9 11	1240	4 3		8 26		
Pickhill	Wd	h	4 7			
Newby Wiske....[708, 717	9 22	1251	4 14		8 37		
Northallerton(H.L.)684ar	9 4	9 29	1258	4 21		8 44		

yond Northallerton, or to take up for beyond Harrogate.
 to take up for beyond Northallerton. *t* Connection at Melmerby.
 pages 708 to 711; between Ripon and Melmerby, see page 705.

A 1910 timetable for NER services between Ripon and Northallerton, on the Leeds Northern line from Melmerby to Harrogate, opened in 1852. (Author's collection)

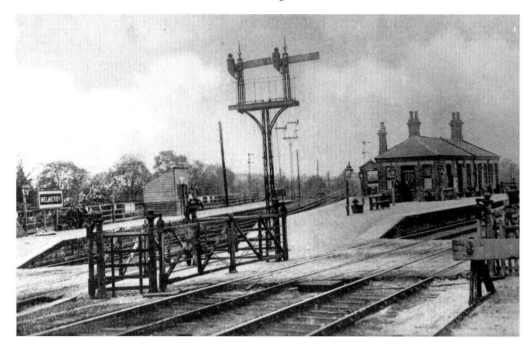

Melmerby station at the end of the nineteenth century. The station was the junction with the original Leeds & Thirsk line to Balderby, Topcliff and Thirsk Town, which was closed in 1959. The station was also the junction for the line to Tanfield and Masham, which opened in 1875. (LOSA)

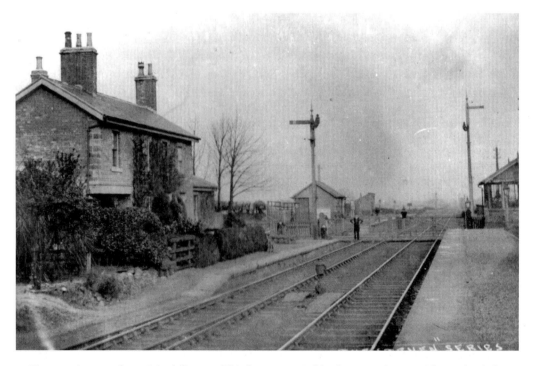

First station on the original line to Thirsk was at Baldersby, seen here at the end of the nineteenth century. The station was closed with the line in 1959. (LOSA)

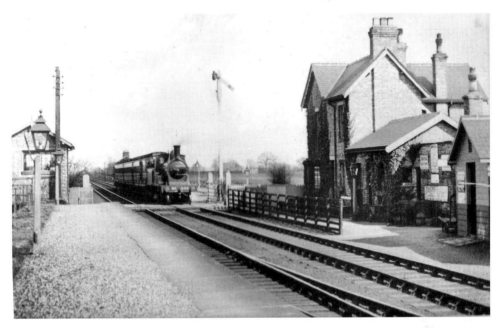

The other station from Melmerby to Thirsk was at Topcliff, seen here at the beginning of the twentieth century with a local train approaching the station with an NER engine at the head. The original Leeds & Thirsk Railway actually built a locoshed at Thirsk Town, but little is known about it. (LOSA)

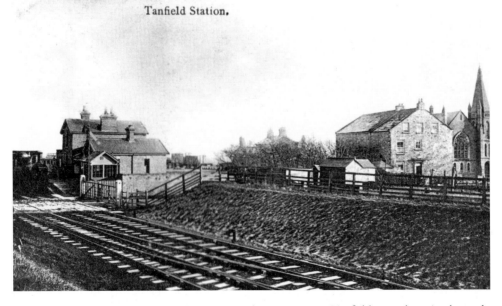

The little branch to Masham had an intermediate station at Tanfield, seen here in the early twentieth century with the church in the background and a local train, on the far left, is waiting to depart. Along with the terminus at Masham, passenger services ceased in 1931 and the line finally closed when goods traffic ceased in 1963. (LOSA)

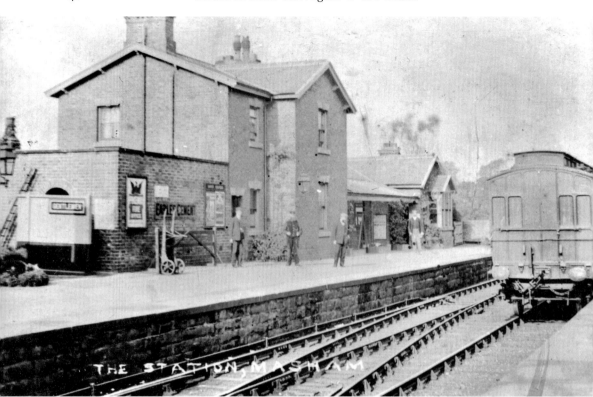

Above: The terminus at Masham at the end of the nineteenth century, with branch coaching stock at the near platform and station staff on the main platform. In July 1874, a report stated that a shed for two locos was necessary at the opening of the little branch, along with coaling and watering facilities and four cottages for railway staff. The cottages were completed in March 1875, the branch opening in June. The loco shedded at Masham was G5 0-4-4T No. 1911 until closure on 1 January 1931. On the same day, the branch closed to passengers but remained open to goods traffic until 11 November 1963. Unusually for the NER, the shed could only be reached via the turntable and was demolished in 1941. (LOSA)

Below: A 1910 timetable for the few local trains along the branch in 1910. (Author's collection)

RIPON and MAS

Mls	Down.		mrn	non	aft	aft		Mls	
—	Ripondep.		9 17	12 3	4 17	8 0	—	Mash
3	Melmerby		9 24	1210	4 24	8 7	3¼	Tanfi
7½	Tanfield		9 32	1218	4 32	8 15	7¼	Melm
10¼	Masham †arr.		9 40	1226	4 40	8 23	10¼	Ripor

☞ For **OTHER TRAINS** between Rip

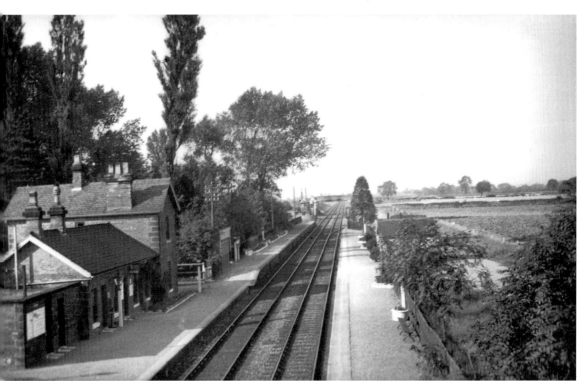

Now titled the Leeds Northern Railway, the line from Melmerby to Northallerton and Stockton was opened in 1852, becoming part of the North Eastern Railway two years later. The Leeds Northern line did not connect with the York–Darlington line when first opened, calling at its own station at Northallerton Town near the point where the line passed under the line to Darlington. By 1854, after both lines had become part of the NER, through trains were running along the Leeds Northern route, via Thirsk. The line was then rejoined at Eaglescliffe by means of of a new link at High Junction, opened in 1856. The original Leeds Northern line south to Melmerby was then used as a branch until 1901 when the NER connected it to the main line via another new junction at the southern end of Northallerton station and began using it as the primary route from the West Riding to Teesside once again. Between Melmerby and Northallerton there were stations at Sinderby, seen here before closure in 1962, Pickhill (closed 1959) and Newby Wiske (closed 1939). (LOSA)

M.—North Eastern.

p.		mrn	mrn	aft	aft		
........dep.	7 25	1010	1 8	6 10	† Station for Hack Fall	
........	7 33	1018	1 16	6 18	(3½ miles), and Swin-	
708.	7 41	1026	1 24	6 26	ton Park (1¼ miles).	
........, arr.	7 48	1033	1 31	6 33		

nd Melmerby, see pages 708 to 711 and 713.

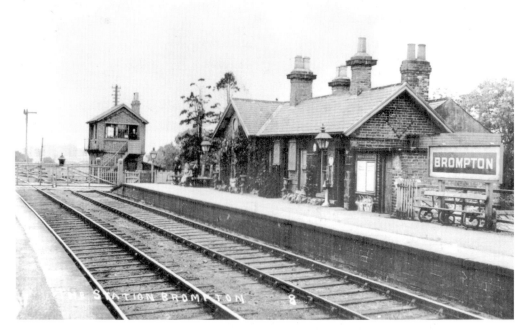

North of Northallerton Town station on the line to Stockton, there was a station at Brompton. The attractive little station is seen here early in the twentieth century. (LOSA)

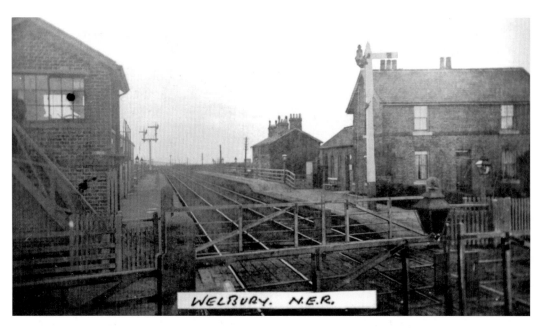

The next station north was at Welbury, seen here early in the twentieth century and having a rather neglected look. The line closed to passengers in 1967, but remains open to serve freight traffic between Northallerton and Teesside. (LOSA)

THREE

THE GREAT NORTH OF ENGLAND RAILWAY

After the first sod was cut for the southern section of the GNER at Croft (enough land having been purchased for up to four tracks' width), tenders were soon let for the most important construction contracts. A tender of £14,481 was accepted for building of a bridge over the River Tees, immediately south of Croft, which is still in use today. Only three major engineering works were required between Croft and York: a bridge over the River Ouse, on the approach to York; an embankment at Northallerton, which necessitated tipping of some 252,641 cubic yards of soil; and a cutting at Dalton, where 388,742 cubic yards of earth had to be excavated. Work on the bridge at Croft was slow and there were often labour troubles, including a strike for higher pay in November 1838 which appeared to have been resolved during the following month, as work was then continuing without interruption.

In 1839, the Croft branch of the Stockton & Darlington Railway was purchased for some £20,000 by the GNER so that it could be incorporated into its main line, but only about half of it, at the northern end, was used. The southern end of the branch was left *in situ* to serve the coal depot at Croft and remained in use until April 1964.

The directors of the GNER were eager to have its line opened as soon as possible, but numerous delays made progress slow. Eventually, the engineer, Thomas Storey, resigned and George Stephenson was asked to take charge. He sent his son, Robert, to report on the situation. The intention was to have the line opened by 25 November 1840, but it was not yet ready. However, shortly afterwards, the directors issued 'a peremptory order to open the line for coal traffic, if not general traffic, on 4 January 1841'. The line did open for mineral traffic on the due date, but passenger traffic only started on 30 March. The new station at York, which was to be shared with the Y&NMR, did actually open on 4 January, but the GNER did not begin to use it for a further three months, when its passenger services began. Despite delays and setbacks, the opening of both York station and the GNER to passengers still provided excuses for celebration.

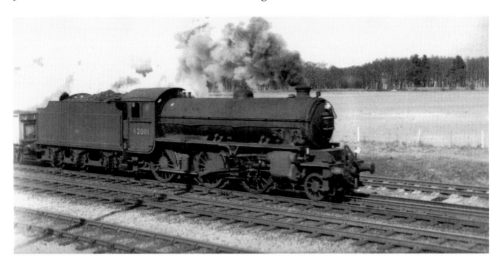

Ex-LNER Gresley Class K1 2-6-0 No. 62001 is seen passing Pilmoor in 1963. Pilmoor became a junction a century earlier with the opening of a branch from the north-east curve at Pilmoor to Scarborough Road Junction, where it joined the Malton & Driffield Railway for access to Malton. At Gilling another line was opened in 1875 to serve Pickering, via Helmsley and Kirkbymoorside. Passenger services on the line between Pilmoor and Gilling had disappeared by 1930, but the line was used for excursions to Scarborough into the 1960s. The line to Malton was finally closed in August 1964. The line between Pickering and Pilmoor, via Gilling Junction, carried passengers until 31 January 1953, and the last train operating from York to Pickering was the 6 p.m. service hauled by D49 Shire Class 4-4-0 No. 62735 *Westmorland*. The line itself was closed on 27 July 1964. (LOSA)

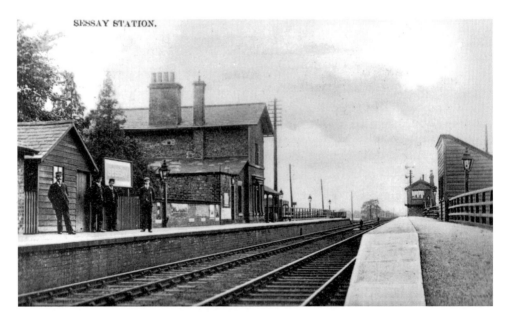

Lying between Pilmoor and Thirsk was the wayside station at Sessay, seen here at the end of the nineteenth century, complete with NER main building on the left and simple wooden waiting room on the right. The signal box is in the distance and station staff are posed on the left. (LOSA)

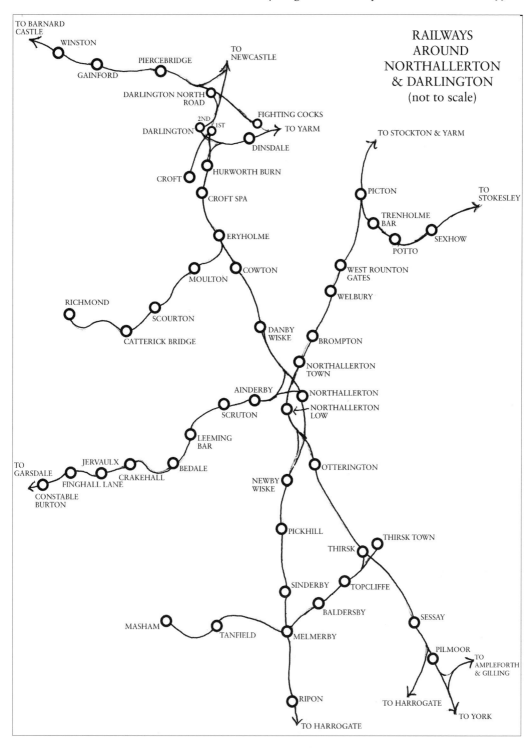

A map showing the main GNER line between Pilmoor and Darlington, along with the Leeds Northern line from Ripon, via Northallerton, to Picton for the onward route to Yarm. Also shown are the branches from Melmerby to Masham and Thirsk, along with branches to Richmond, Garsdale, Gilling, Stokesley and Barnard Castle. (Author)

YORK, PILMOOR, GILLING, MAL'

	Down.	Week Days only.				
Miles		mrn	mrn	mrn	aft	aft
	Yorkdep.	7 48	1015	3 10 5 17
5¼	Beningbrough	1025	3 20 5 27
9¾	Tollerton	1033	3 28 5 35
11¼	Alne 772	8 5	1037	3 32 5 40
13¼	Raskelf	8 10	1042	3 37 5 45
14	Pilmoor 753 arr.	5 51
—	731 Newcastle ‡ ..dep.	?616	7?35	10?15 4 0
—	731 Darlington † !!	6?28	9?13	12?18 4 25
—	731 Thirsk !!	7?22	10?3	1 ?6 5 11
—	Pilmoordep.	5 58
18¾	Husthwaite Gate......	8 20	1052	3 47 6 7
20½	Coxwold	8 30	11 0	3 53 6 12
22¼	Ampleforth	8 36	11 6	3 59 6 18
25¼	Gilling *arr.	8 41	1111	4 4 6 23
—	Gillingdep.	8 20	1116	4 15 6 43
28¾	Hovingham Spa.....	8 26	1122	4 21 6 49
30½	Slingsby	8 31	1127	4 26 6 54
32¼	Barton-le-Street.....	8 35	1131	4 30 6 58
34	Amotherby.........	8 39	1135	4 34 7 2
38¼	Malton 758,759 arr.	8 52	1148	4 47 7 15
—	Gillingdep.	8 48	1115	4 10 6 36
28¼	Nunnington.............	8 54	1121	4 16 6 42
31¾	Helmsley { arr.	9 0	1127	4 22 6 48
	Helmsley { dep.	9 1	1130	4 24 6 49
34½	Nawton.............	9 7	1136	4 30 6 55
37	Kirby Moorside.......	9 14	1144	4 36 7 1
40	Sinnington [below	9 20	1151	4 42 7 7
44	**Pickering**....750, arr.	9 28	12 0	4 50 7 15

a Stops when required to set down from beyond Alne
b Change at Raskelf.
d Change at Alne.
k Passengers for Pilmoor and the North change at Alne.

7 Saturdays onl
***** Station for A
† Bank Top Sta
‡ Central Static
§ 1¼ miles to Yor
Derwent Valle

A 1922 NER timetable for passenger services between York and Pickering, via Pilmoor and Gilling Junction. (Author's collection)

and PICKERING.—North Eastern.

Up.	Week Days only.			
	mrn	k aft		aft
Pickeringdep.	7 15	9 57 3 55		5 51
4 Sinnington.............	7 24	10 7 4 4....		6 0
7 Kirby Moorside.......	7 34	10 14 4 11		6 8
9¼ Nawton.............	7 40	10 20 4 17		6 14
2¼ Helmsley........ { arr.	7 45	10 25 4 22		6 19
{ dep.	7 50	10 26 4 25		6 21
5¼ Nunnington..........	7 57	10 33 4 32		6 28
8¾ Gilling * arr.	8 4	10 39 4 38		6 34
Mls Maltondep.	7 25	9 57 3 20		5 54
4¼ Amotherby	7 39	10 11 3 34 ...		6 8
6 Barton-le-Street ..	7 43	10 15 3 38		6 12
7¾ Slingsby..........	7 48	10 20 3 43		6 17
9¼ Hovingham Spa ..	7 53	10 25 3 48		6 22
13 Gilling * arr.	8 0	10 32 3 55		6 29
Gillingdep.	8 10	10 44 4 44		6 40
1¼ Ampleforth..........	8 16	10 50 4 50		6 46
3¼ Coxwold..............	8 30	11 7 4 56 ...		6 52
5¼ Husthwaite Gate.	8 34	11 12 5 0		6 56
0 Pilmoor **728, 753** arr. 5 16
6¼ 728 THIRSK arr.	9 20	12d47 6 7		7b42
3¼ 728 DARLINGTON†. "	10b8	1d39 7 7		8b40
4¼ 728 NEWCASTLE ⌐.. "	11b37	2d53 8 26		10 5
Pilmoordep. 5 34
0¼ Raskelf	8 43 5 40		7 6
2¼ Alne **772**.............	8 49	11 24 5 46		7 11
4¼ Tollerton	8 53	a 6 0		7 15
3¼ Beningbrough....[766	9 1	a 6 8		7 23
4 York § **338, 763**, arr.	9 14	11 47 6 18		7 35

ging at Raskelf.
rth College.

erthorpe) Sta.,

☞ **For other Trains**

BETWEEN PAGE

York and Pilmoor728
York and Pickering759

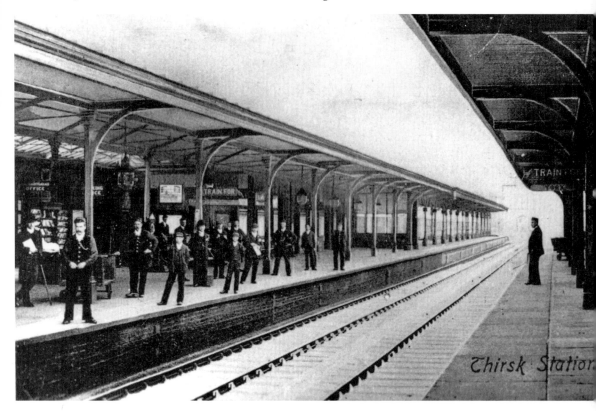

Standing some 22¼ miles north of York is Thirsk station, seen here at the end of the nineteenth century, complete with numerous station staff. The station opened on 31 March 1841 and was originally named Newcastle Junction, the Leeds Northern line from Harrogate meeting the GNER at this point. Along with the station, Thirsk was also given a two-road engine shed which was opened in 1887, having been authorised in November 1886. In April 1896, extensions were authorised to increase accommodation to five locos, at an estimated cost of £800, followed in September 1897 by an office and store at a cost of £60. Locomotives based at Thirsk were mainly used on local goods workings and a single passenger turn which was combined with goods workings. This passenger train was the 7.26 a.m. Thirsk to Melmerby, thence empty to Ripon, followed by the 8.54 a.m. Thirsk, Northallerton and West Hartlepool. The return from West Hartlepool was on a goods train leaving at 12.20, due Thirsk at 2.26 p.m.; the loco then continued on the 2.55 p.m. to Ripon and returned on the 7.30 p.m. Ripon–Thirsk goods.

The allocation at Thirsk shed in 1923 included two A7 4-6-2Ts, one G5 0-4-4T, one J38 0-6-0, one J21 0-6-0, seven J25 0-6-0s and two J77 0-6-0Ts.

In 1927, another A7 arrived at Thirsk, but on 12 December both engines, Nos 1176 and 1179, were sent to Leeds and Starbeck respectively and replaced by Q5 0-8-0 No. 715, followed later by No. 443. The two 0-8-0s left in 1929, leaving two J25 0-6-0s and one J77 0-6-0T. J25 No. 1723 was transferred to Starbeck on 8 October 1930 when the Thirsk–Helmsley goods was withdrawn, leaving J25 No. 2142 to go to Starbeck and J77 No. 604 to go to Northallerton when the shed closed on 10 November 1930. The shed remained *in situ* until 1965, demolition commencing on 14 June and the site being completely cleared. (LOSA)

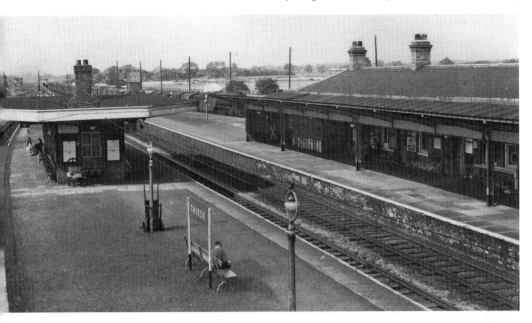

Thirsk station on 27 August 1958 with, in the distance, ex-LNER Gresley V2 Class 2-6-2 No. 60978 at the head of a fitted freight to York. (R. Carpenter)

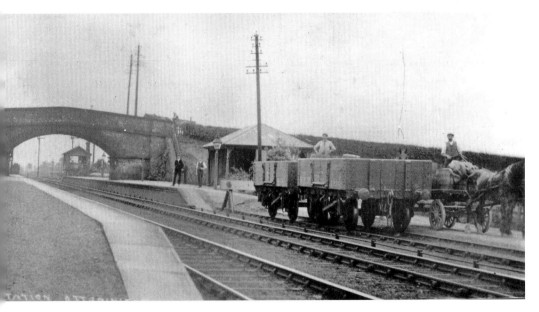

Otterington station at the end of the nineteenth century with wagons in the goods yard. In the background is the signal box featured in the story of the Manor House disaster. It was at this box that the weary signalman had informed another signalman here that his wife's mother was due from York and that he was really too exhausted to work. The stationmaster here should also have recognised that the Manor House signalman was unfit to work and should have ensured that proper cover was arranged for him. (LOSA)

Thirsk was the site of several railway accidents, in 1867, 1870, 1875, 1879, 1882 and 1967. Perhaps, the worst was the Manor House disaster of 2 November 1892 some 3 miles north of the station. The signalman at Manor House box was extremely tired after his daughter had been taken ill and died the day before the accident and he had been awake for some thirty-six hours. He did report to the stationmaster at Otterington station that he would be unfit to work the following night but the stationmaster had only asked for a relief signalman without giving a reason why. Consequently, no relief signalman was sent and the regular man was forced to work his shift. His wife's mother was due to arrive from York and he asked the signalman at Otterington to inform him when she arrived. He also told the signalman there that he was exhausted following the death of his daughter and having to comfort his wife. The night itself was misty, which later thickened to a fog. Around three hours into his shift, two expresses were due from the north, but the second had been delayed so a goods train was sent down the line after the first express. The goods entered the Manor House section and waited at the signal box, but the signalman had fallen asleep (understandable under the circumstances) and woke in a state of confusion some thirteen minutes later as the Otterington signalman warned him to expect the second express. His instruments showed that a train was still in his section, but having fallen asleep, he cleared his instruments believing that they were for the first express and he fallen asleep without clearing them. Thus, he accepted the second express while the goods train was still outside his box. The express hit the goods train at 60 mph, which had just started to move at walking pace. Nine passengers and the guard of the goods train were killed and thirty-nine people were injured. A little under an hour later, coal from the firebox of the loco of the express set the wreckage on fire and the gas lighting used in the coaches acted as an accelerant, adding to the fire which incinerated two bodies which were never recovered. The signalman was found guilty of manslaughter but given an absolute discharge, supported by the jury and the public. The NER was, however, criticised for its poor treatment of the signalman, as was the Otterington signalman who had taken no action when there had been silence from Manor House box for the best part of fifteen minutes. The crew of the goods train were also censured for not going to the signal box although the train had been at a standstill for several minutes. It was felt that track circuiting may well have prevented the accident, but it had only recently been invented and this section of the line was only short, with no junctions, and would only have had a low priority.

The accident of 1967 occurred when the 1A26 express from King's Cross to Edinburgh collided at speed with the derailed wreckage of a freight train on 31 July 1967 at around 3.15 p.m., killing seven people and injuring forty-five, fifteen seriously. The wagons of the freight train were derailed due to excessive wear in the suspension components, caused, it was thought, by cement dust from the wagons, which caused excessive oscillation of these tank wagons.

After the derailment, the driver of the freight train ran back to telephone the signalman, but had no time as the express, headed by a DP2 diesel-electric loco, came into view and hit the wagon fouling the track. Fortunately the driver of the express was not accelerating as hard as normal which probably prevented further deaths. The Thirsk signalman reacted quickly and threw all of his signals to danger and sent the 'obstruction on line' bell-code to the Northallerton and Pilmoor boxes, which stopped a London-bound express at Thirsk station, preventing a further collision which would have occurred a few minutes later.

Other incidents have occurred on the line near Thirsk, including a near miss in the 1930s. On this occasion, an A4 Pacific broke a connecting rod close to its little end. The rod dropped, caught in a track sleeper, and the engine jumped over it as it went round the curve. Unbelievably, the loco dropped back on the rails and just as fortunately the coaches rode over the buckled track and no injuries were sustained, although the ride may well have been rather rough.

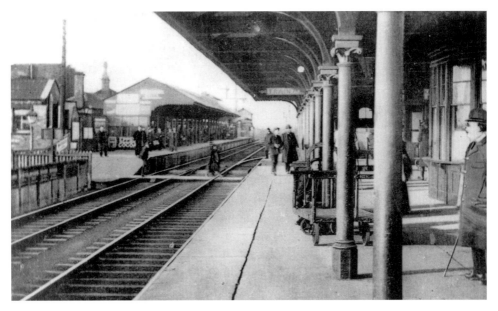

An early twentieth-century view of Northallerton station with staff and passengers in view. The station was opened with the GNER line in 1841 and was to become a junction with the Leeds Northern line from Harrogate and the Wensleydale branch from 1848, its trains using a bay at the northern end of the northbound platform. Passenger trains along the branch ceased operating from April 1954, although the line remained open to serve the MOD and quarries at Redmire. Although the station remains open to serve the county town of North Yorkshire, the old Leeds Northern line to Ripon was closed in 1967. (LOSA)

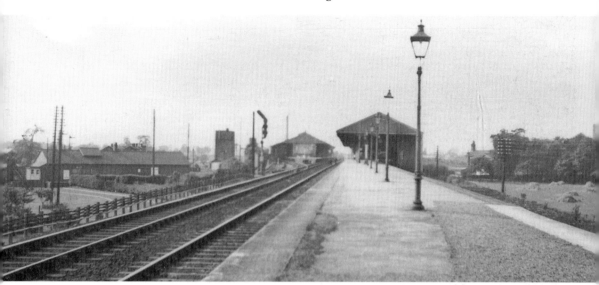

Above: Another view of Northallerton station, looking south in the 1960s, colour light signalling having replaced the old semaphore signals and the old signal box seems to have been removed. Less than two years after the disaster at Thirsk, on 4 October 1894, another rear-end collision occurred a little north of Northallerton, but this time no passengers were killed. Once again, it was the Up night Scottish express, the engine of which, Class M1 No. 1622, took charge of the train at Newcastle. On the way south, the driver was experiencing trouble with his Westinghouse brake and at Darlington he requested a pilot engine, Fletcher Class 901 2-4-0 No. 905, which was coupled to the front. The driver of the pilot engine considered that he was only assisting the main engine and was not responsible for the sighting of signals, but the driver of the main engine assumed that the pilot engine was in charge. Consequently, they were both unaware that they were passing signals set at danger. Eventually, they collided with the rear of a mineral train from Darlington to York. At this time, Pullman cars were being used as part of the East Coast joint stock and car *India* was totally destroyed in the Manor House accident, which cost the NER £1,700, paid to the Pullman Car Company. Another Pullman car, *Iona*, was damaged in Northallerton collision but was not beyond repair.

A few years earlier, in 1870, a boiler explosion occurred at Northallerton. The engine was one built by Stephenson's in 1847 and was recorded as having an elliptical boiler of 3 feet 8 inches by 3 feet 5 inches. In those days, such engines were fitted with Salter safety valves which crews could screw down to increase the locomotive's performance. Also, the boilers themselves were not as well maintained as they were in later years. Spring-loaded safety valves replaced the Salter type in later years to prevent practices of screwing down those valves, and boiler explosions became almost unknown as the nineteenth century progressed. (LOSA)

Opposite above: Northallerton station on 4 September 1955 with ex-NER locos at the head of a special, the Northern Dales Rail Tour, which is about to enter the Wensleydale branch, whose passenger services had ceased the year before. The loco in charge is Class A8 4-6-2T No. 69855 piloting an unidentified Class D20 4-4-0, at this time one of the last still in existence. (R. Casserley)

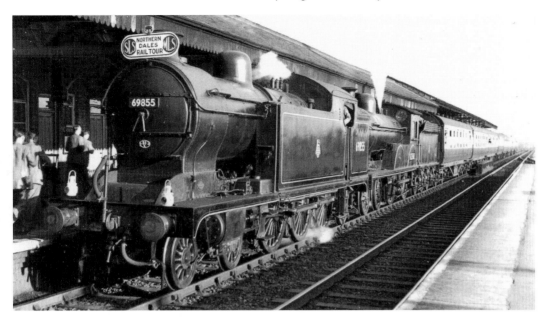

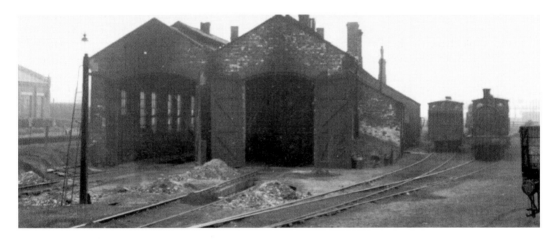

Northallerton was provided with a locoshed after the Wensleydale branch had been opened and is seen here on 17 May 1952. (H. Casserley)

Coded 51J when transferred to British Railways ownership, its allocation in 1950 was as follows:

Ex-NER D20 4-4-0	62359, 62338, 63291
Ex-NER J21 0-6-0	65030
Ex-NER J25 0-6-0	65645, 65693, 65725
Ex-NER G5 0-4-4T	67324, 67344, 67346
Ex-LNER Sentinel Y3 0-4-0T	68159
Ex-NER N10 0-6-2T	69101
	Total: 12

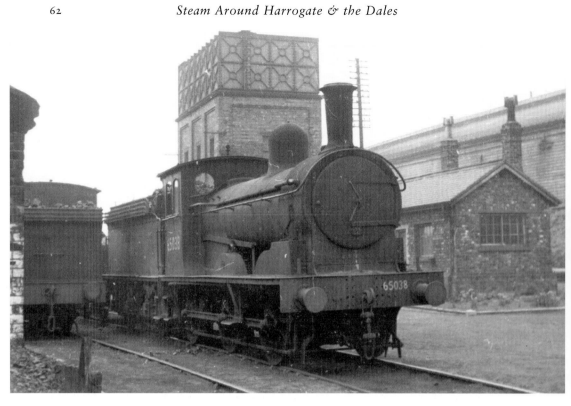

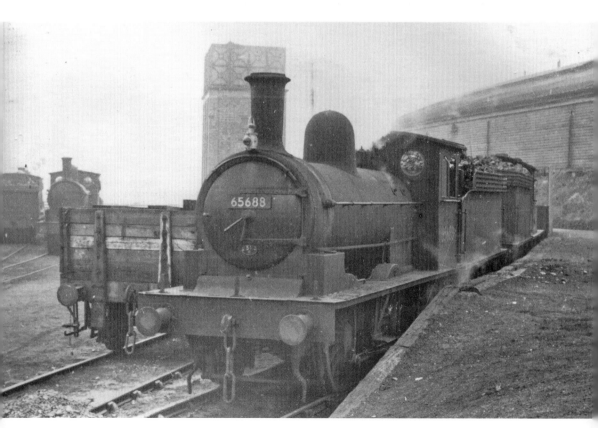

Opposite above: Northallerton shed on 17 May 1952 with ex-NER Class J21 0-6-0 No. 65038 resting near the water tower. These engines would have operated local goods trains over the Wensleydale branch. (H. Casserley)

Opposite below: On the same day at Northallerton shed is ex-NER Worsdell J25 0-6-0 No. 65688 awaiting its turn of duty. The shed here would have closed when the Wensleydale branch closed to steam traction. (H. Casserley)

Below: From Northallerton, heading north, the line passed Danby Wiske and Cowton before entering the junction station at Eryholme. Eryholme was the junction for the branch to Richmond and was opened with the GNER in 1841. Originally Dalton, the station was renamed Eryholme in 1901 and only had a short life, closing to passengers on 1 October 1911. This view shows the station looking south towards Northallerton, early in the twentieth century, with the branch to Richmond curving off to the right. (LOSA)

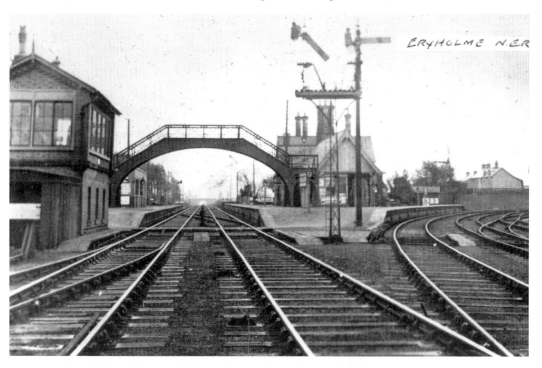

LONDON, BIRMINGHAM, YORK, DARLINGTON, DURH.

Chief Pass. Agent, E. L. Davis, York. Chief En

Down. **Sundays.**

	aft	aft	*(see note)*	aft	aft	mrn	mrn	mrn	aft	non	aft
346 London (King's C.) dp.	8y45	1130		1030y						12A0	
544 " (St. Pancras) "	6y0			8y40					1130	
583 Birmingham (N.St.) "	7y18			1125y		3 55			1 42	
544 Sheffield (Midland) "	9y50		1 58			9 5			4 15	
608 " (Vic.) 652 "	10y5	12y0		12y0						4 0	
347 Doncaster......... "	1217		2 15						3 45	
734 Liverpool (Exch.). "	7y15					9 0			1 15	
522 " (Lime St.). "	7y0			1045y							
734 Manchester (Vic.). "	8y30						1040			2 15	
522 " (Exch.). "	9y0			12m5							
722 Leeds (New)........ "	1055y			2 48			9 0				
722 Normanton......... "	1057y				2 50		1 30			4 29	
721 Hull (Paragon) 724 "	1125y						6 50			3 10	
York..............dep.	1 14	3 19		3 35	3 45	4 5	6 30	2 30		5 45	6 40
Beningbrough...........							6 40			5 55	
Tollerton..............							6 49			6 4	
Alne							6 53			6 8	
Raskelf							6 58			6 13	
Pilmoor...............							7 4			6 19	
Sessay................							7 9			6 24	
Thirsk 709, 711......arr.							7 18			6 32	7
709 Liverpool (Lime St.) dp									mrn {	7 30	
709 Manchester (Exch.) "										10 0	
709 Leeds (New) "										4 35	
Thirskdep.							7 20			6 37	7 1
Otterington...........							7 28			6 46	
Northallerton 709, 711 arr.				4 11	4 25	4 44	7 35			6 53	
709 Middlesbrough .. arr.						5 45	9g15				8y5
709 Stockton "						5 8	9g11				8g5
709 West Hartlepool "						5 33	9y46				9g3
Northallerton.........dep.				4 16	4 27	4 46	7 41			7 9	
Danby Wiske							7 48			7 17	
Cowton...............							7 55			7 24	
Eryholme 701							8 0			7 29	
Croft Spa.............							8 6			7 35	
Darlington (BnkTop) { arr.	2 6			4 36	4 47		8 12			7 41	7 4
699, 703, 706 { dep.	2 11			4 41	4 52		8 20		7 35	8 3	7 5
Aycliffe..............							8 30		7 46	d	
Bradbury							8 40		7 56	d	
Ferryhill 702, 704.. { arr.				5 2	5 13		8 48		8 3	8 29	
{ dep.				5 5	5 15		8 50		8 6	8 31	
Croxdale ...											
Durham 698, 701, 714 arr.				5 18	5 28		9i28			9i4	8 3
692 Sunderland 701.. arr.					6 23	6 6	9i54	4c43			9 5
693 South Shields 699 "					6c55	7 4	10i2	5c40		z1010	9i4
Durham ¶..........dep.				5 24	5 32		8i55				8 3
Newcastle (Central) ¶ { arr.	2 58	4 54		5 45	5 58	6 31	10 34	3 9	21	9 43	9
690 to 698 { dep.	3 8	4 59			6 20	8 0	1035	4 10			
Morpeth 694...........					6 58	8 49	11 7				
Alnmouth 692.........					7 29	9 34	1137				
Berwick ¶ 689, 795.. arr.	4 36				8 32	11 0	1230	5 28			
795 Edinburgh (Wav.) arr.	5 55	7 30					6 53				
795 Glasgow (Qn. St.) "	7 30	1035					9 54				
795 Dundee* (TayBdge) "		9 14									
795 Aberdeen* "		1125									
795 Perth † "		8 55									
795 Inverness "		1 50									

"Sleeping Saloons and Through Carriages, London (King's Cross) to Perth and Inverness, on Saturday nights, see Note at foot of page 1. Sleeping Carriages London (King's Cross) to Edinburgh, Glasgow, and Dundee." — "Via Stockton, West Hartlepool, and Sunderland."

A 1910 NER timetable for train services along the GNER line between York and Darlington, via Thirsk and Northallerton. (Author's collection)

NDERLAND, NEWCASTLE, BERWICK, and SCOTLAND.—N.E.
Bengough, York, and C. A. Harrison, Newcastle-on-Tyne.

Up.		Sundays.					
	mrn	mrn	mrn	aft	aft	aft	aft
INVERNESSdep.	1010k
PERTH † "	4 10
ABERDEEN * "	3 30
DUNDEE*(TayBdge) "	7 15	5 30
GLASGOW (Qn. St.) "	8 35	5 0	9 35
EDINBURGH (Wav.) "	12 0	7 45	1050
wick ¶dep.	6 25	1 29	4 35	9 17
nouth 692 "	7 36	5 29	10 6
peth 694 "	8 20	6 8	1036
castle(Central)¶ { arr.	9 10	2 50	6 38	11 0	1 30
690 to 698 { dep.	6 25	10 0	3 0	5 20	7 8	1119	1 36
ham¶698,701,714 arr	7i27	1023	6i23	7 31	1141
SOUTH SHIELDS699 dep.	6z10	9 c 8	1c45	5 z 5	6c20	1020 c
SUNDERLAND701 "	6i37	9 10	2c17	5i20	6c10	1029 c
hamdep.	6i50	1028	5i55	7 35	1147
:dale
yhill 702, 704 { arr.	7 41	6 31
{ dep.	7 46	6 35
lbury	7 55	6 45
iffe	8 5	6 55
ington(BnkTop) { arr.	8 16	1055	3 48	7 6	8 5	1216	2 25
99, 703, 706 { dep.	8 23	11 3	3 54	7 11	8 9	1223	2 30
tSpa	8 30	7 17
holme	7 23
ton	8 39	7 28
by Wiske	8 46	7 35
thallerton709, 711 arr.	8 54	7 41	8 29
WEST HARTLEPOOL dep.	6b45	8/10	5/48
STOCKTON "	8/46	6/23
MIDDLESBROUGH "	7g21	9/52	6g23
thallertondep.	8 59	7 48	8 34
rington	9 6	7 55
sk 711 arr.	9 14	8 2
LEEDS (New) "	11 6
MANCHESTER (Exch.) "	2 28
LIVERPOOL(Lime St) "	3 15
rskdep.	9 20	8 5
ay	9 28	8 13
noor	Sig.	8 18
kelf	9 40	8 25
e	9 46	8 31
erton	9 51	8 36
ingbrough	10 0	8 45
k 352, 715, 723 ..arr.	1016	1158	4 45	9 0	9 16	1 15	3 21
HULL(Paragon)726 arr.	2 0	9 13	1123	4 42	8 11
NORMANTON "	1110	1 5	8 7	1010	2 25	7 47
LEEDS (New) "	1h40	6h23	10 0	1020	3b9	4 35
MANCHESTER(Exch.) "	9 0	12 7	8 10
" (Vic.) "	1p25	4 28	1111	5 22	1016
LIVERPOOL(LimeSt.) "	1115	2 15	9 18
" (Exch.) "	2p55	6 10	8 11	11 4
DONCASTER "	1 37	6 5	1055	4 37
SHEFFIELD(Vic.)659 "	1 40	8 38	6 40
" (Midland) "	1257	2 5	1112	4 5	7N12
BIRMINGHAM (N. St) "	3 45	3 45	2 7	7 25	1012 N
London(St.Pancras) "	5 0	9 50	4 20	9 20	1040 N
" (King's C.) "	5 45	9 40	3 10	5 50	7 10

(Vertical column notes: "Luncheon Car Express. Newcastle to King's Crs." / "Sleeping Cars from Edinburgh and Newcastle to London (King's Cross)." / "Sleeping Carriages, Glasgow and Edinburgh to London (King's Cross).")

NOTES.

A Luncheon Car Express to Doncaster.
b Wellington Station, via Normanton.
b Via Ferryhill.
c Via Newcastle.
d Stops when required to set down from beyond Darlington.
g Via Darlington.
h Via Selby.
i Via Leamside.
j Stops at 11 20 mrn. when required to take up for South of York.
k Morning time.
n London Road Sta.
N Via Leeds (Wellington Station).
p Passengers from Thirsk and beyond can arrive at Manchester (Victoria) at 1 6, and Liverpool (Exch.) at 2 35 aft.
t Via Gateshead.
y Saturday night.
z Via Pelaw.
* Via the Forth and Tay Bridges.
† General Station; via Forth Bridge.

¶ **For Local Trains** and **intermediate Stations**

BETWEEN PAGE
Durham and Newcastle 698
Newcastle and Berwick 690

** **For other Trains***

BETWEEN PAGE
Eryholme and Darlington 701

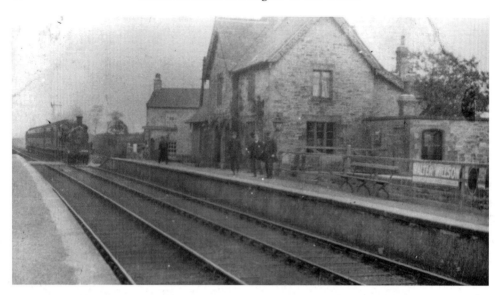

In 1845, the GNER obtained powers to build a branch from Coopers House, near Dalton, to Richmond but became part of the York & Newcastle Railway while construction was underway and this company opened the branch in 1846. The present station at Richmond was, however, not opened until 9 April 1847; a temporary wooden platform was provided until the station was completed. The line was double track throughout and had stations at Moulton, Scorton and Catterick Bridge, all of which were designed by Y&NMR architect G. T. Andrews in a Tudor style. The main building at Scorton is seen in this early twentieth-century view with an NER tank loco at the head of a branch passenger train. (LOSA)

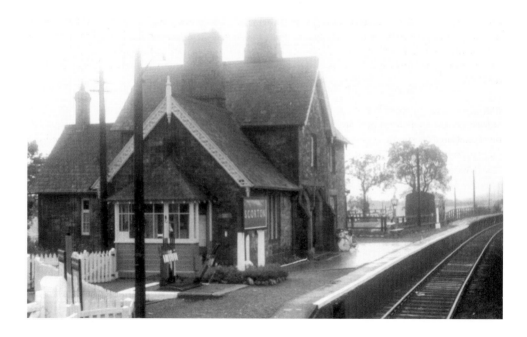

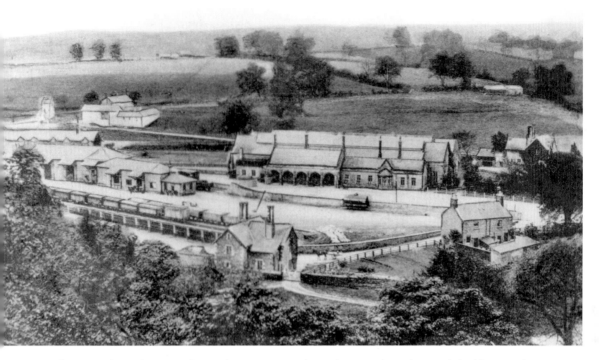

Above: Richmond station from above in NER days, showing the substantial buildings and generous layout of the station area. The branch crossed the River Swale at Easby and terminated in the Parish of St Martin's, on the south bank of the river and opposite the town of Richmond. As well as the main station building, Richmond station was provided with other facilities which included a large goods shed, an engine shed, gasworks, signal box, stationmaster's house, goods agent's house, six staff cottages, two goods staff cottages, a water pumping station at Sand Beck, turntable, and fifty coal drops. The main station building was designed by G. T. Andrews and was specifically designed to blend in with the town. The two-ridge train shed covered the platform line and two sidings. The original platform was low and short and was subsequently extended in 1860. (LOSA)

Opposite below: Another view of Scorton station on 3 September 1956, only a few years before closure in 1967. The branch had been listed for closure as part of the Beeching proposals but resistance to such plans meant that they were withdrawn. However, BR policy allowed the line to be progressively run down until final closure, all track being lifted soon afterwards. (R. Casserley)

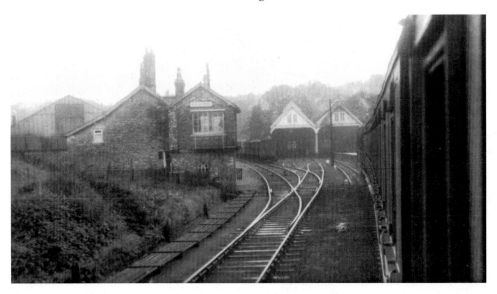

Approaching Richmond station on 3 September 1956. The train shed is clearly visible with the signal box on the left along with a siding. Along with the station, the railway company also constructed a road bridge over the River Swale and a road into the town, providing access to the station. The bridge had four Gothic arches of 52 feet span and 10 feet rise. Robert Stephenson, as engineer-in-chief of the York & Newcastle Railway, designed the bridge, which was unique in that it was a road bridge owned by a railway company. The bridge was eventually taken over by the town council, but still retains its NER bridge plates, No. 8, and is now known as Mercury Bridge. (R. Casserley)

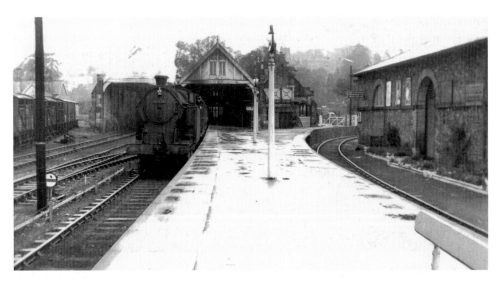

Richmond station on the same day with ex-LNER Gresley Class A5/2 4-6-2T No. 69834 about to depart with the 8.42 a.m. to Darlington. Following closure of the line, the station was closed on 3 March 1969 and was by then a Grade II listed building; only the goods shed was demolished, the rest of the buildings finding other uses, becoming 'The Station' on 9 November 2007 and including a cinema, restaurant, art gallery, a heritage centre, and rooms for public use. The old station houses were sold off and still exist as private homes. (R. Casserley)

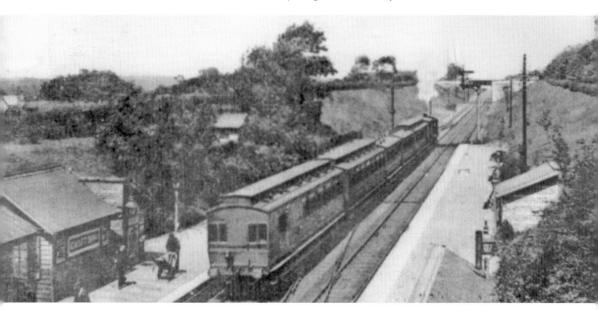

Back on the main line and the next station from Eryholme was at Croft Spa, seen here from the signal box with a local train departing. Croft Spa was opened with the line in 1841, but the 'Spa' was only added in 1896. The station remained open until March 1969, but was only served by Richmond branch trains in the later years. (LOSA)

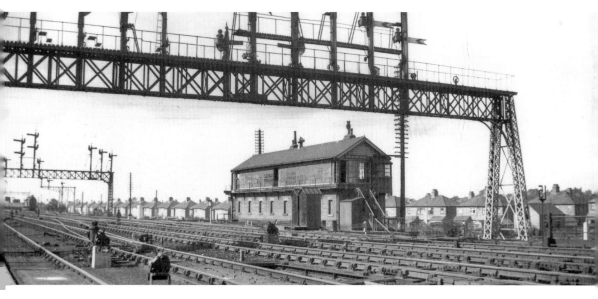

From Croft Spa the line passed through Hurworth Burn before entering the important junction station at Darlington. Darlington was at the cradle of the railway system in Great Britain; the first line reaching the town was the world-famous Stockton & Darlington Railway, whose mineral branch from Albert Hill Junction was opened on 27 October 1829 and is now the site of the present Darlington railway station. This view shows Darlington South signal box and signal gantry in the late 1930s as the line approaches the town from Croft Spa. (R. Carpenter)

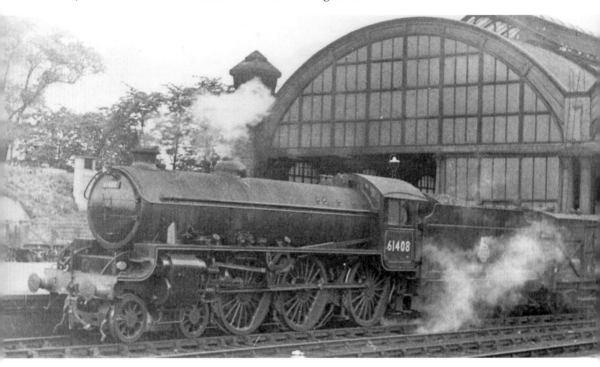

Darlington station on 24 June 1950 with ex-LNER B16 Class 4-6-0 No. 61408 at the head of a fitted freight train. These B16 engines were originally built by the NER between 1919 and 1924, some being rebuilt by Gresley in the 1930s and by Thompson from 1944 onwards. These engines had three cylinders and were classified as mixed traffic locos. This engine appears to be one of the Gresley rebuilds with the high running plate and had the conjugated valve gear for which he was famous. (H. Casserley)

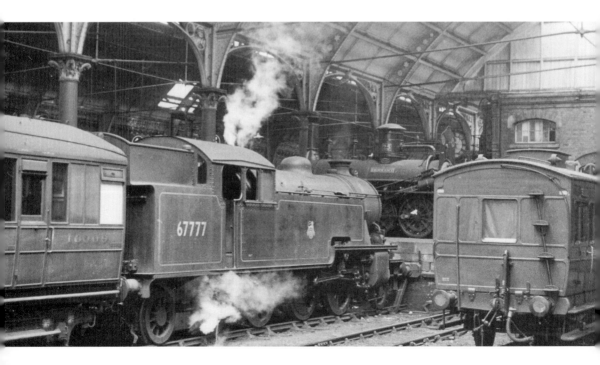

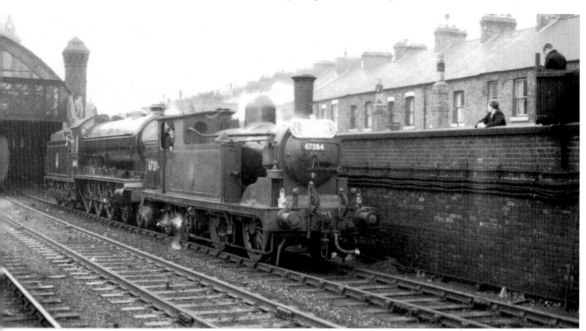

Above: Standing outside Bank Top station are ex-LNER locos No. 67284, a G5 0-4-4T, and B16 Class 4-6-0 No. 61443 after bringing in a special train. At the south end of the station, a major accident occurred on 27 June 1928 which killed twenty-five passengers and seriously injured some forty-five more. A Class B16 4-6-0 No. 2369 was shunting a parcels train that it was due to work south when the driver overran a signal and stopped foul of the main line over which a return excursion from Scarborough to Newcastle was due to pass and was to run non-stop through Darlington station and, headed by Class C7 4-4-2 No. 2164, was travelling at around 45 mph when it struck the engine of the parcels train, which was pushed back around 60 yards. Some of the passenger coaches were badly telescoped but, luckily, the wreckage did not catch fire as had happened in previous collisions and this probably reduced the potential casualty levels, although there were still a lot of people killed and injured in this incident. (H. Casserley)

Opposite below: Darlington station, known also as Darlington Bank Top, was the original station serving the GNER main line at the point where it met the Newcastle and Darlington Junction Railway, whose line opened in 1844. Bank Top station was a modest structure and was rebuilt in 1860 to accommodate increasing traffic levels on the main line. However, by the mid-1880s even this station was becoming too small so the NER decided to invest in a major upgrade of the station. Included in the project was an ornate station with a three-span roof, with new sidings and a goods line placed alongside it. A new connecting line from the south end of the station at Polam Junction met the original S&D line from Middlesbrough at Oak Tree Junction near Dinsdale. The new station was completed on 1 July 1887 and the old route west of Oak Tree was closed to passengers, although it remained in use for freight until 1967. The 1887 station is seen in this view of 24 June 1950 with ex-LNER L1 Class 2-6-4T No. 67777 at the buffer stops after bringing in a local train. Visible in the background, at the bay, is ex-S&D engine *Locomotion No. 1* which had been preserved in 1857 and was set on a pedestal near Darlington North Road station until moved here to Bank Top in 1892. In view, on the right, is Saloon No. 900272. (H. Casserley)

DARLINGTON (Bank Top) and DAR... W

Miles	Down.			mrn	mrn	m	mrn	mrn	mrn	mrn	mrn	mrn	aft
	Darling-	Bank Top,......dep.	6 55	7 0	8 15	8 27	9 22	9c26	10 0	1032	1112	1240	1
1¼	ton	North Roadarr.	6 59	7 4	8 19	8 31	9 26	9c30	10 4	1036	1116	1244	1

Mls	Up.			mrn	mrn	mrn	mrn	mrn	mrn	mrn	mrn	mrn	aft
—	Darling-	North Road.....dep.	7 20	8 15	8 27	8 52	9 48	9 52	10c30	1048	1149	1 6	
1¼	ton	Bank Top........arr.	7 24	8 19	8 31	8 56	9 52	9 56	10c34	1052	1153	1 10	

c Runs on the 13th and

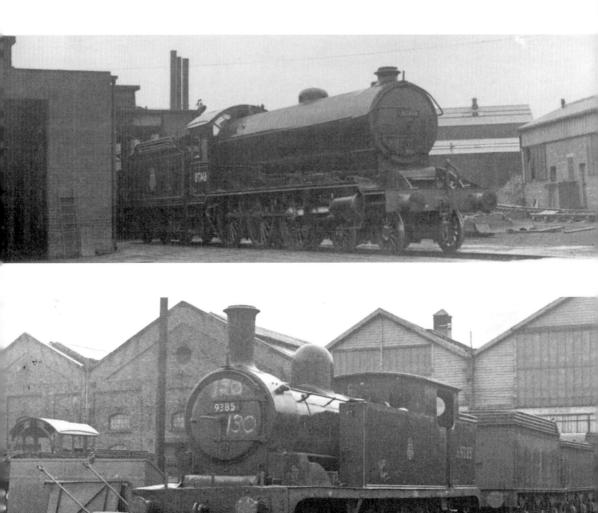

¬TON (North Road).—North Eastern.																		
Days.													**Sundays.**					
aft	aft	aft	aft	m	aft	aft	aft						mrn	mrn	aft	aft		
2 3	7 4	10 5	3 5	8 6	12 7	27 7	32 1015		8 35	8 40	8 15	8 25
6 3	11 4	14 5	7 5	12 6	16 7	31 7	36 1019		8 39	8 44	8 19	8 29
aft	aft	aft	m	aft	aft	m	aft	aft					mrn	mrn	aft	aft		
9 4	15 4	40 5	41 6	25 6	46 7	55 9	17 9	26 1120		7 53	8 4	6 42	6 53
3 4	19 4	44 5	45 6	29 6	50 7	59 9	21 9	30 1124		7 57	8 8	6 46	6 57
...stant.		**m** Auto-car.																

Above: A 1910 timetable for shuttle services between Bank Top and North Road. Along with the main line, the station also served trains to Richmond, Barnard Castle and Penrith as well as services along the Tees Valley line to Bishop Auckland and Saltburn. (Author's collection)

Opposite middle: Standing outside Darlington works on 24 June 1950 is ex-LNER B16 4-6-0 No. 61478, one of the first ten of the class which were renumbered between 61469 and 61478 in order to free up numbers for the new Thompson B1 4-6-0s which were just coming into service. A railway works was established in 1863 by the Stockton & Darlington Railway and the first locomotives built here were for the S&D, although the line had been amalgamated with the North Eastern Railway in the same year. It was not until 1877 that the first NER-designed engines appeared from the works. Additional works were constructed, a boiler and paint shop, west of the S&D in the Stooperdale area of Darlington, along with NER offices, built in 1911, to a design by William Bell. These offices were used by CME Vincent Raven until 1917. Raven was responsible for NER T2 Class 0-8-0 freight engines and by 1921 the works had produced 120 of them, later designated Q6 by the LNER. A further fifteen of the more powerful Class T3 (LNER Q7) were completed by 1924. Under LNER auspices, Darlington works produced Gresley K3 2-6-0s in 1924 and both Class V2 and A1 express engines were also built. After nationalisation, the works built LNER Class E1 0-6-0Ts and all of the BR Ivatt Standard Class 2 2-6-0s, a total of sixty-five. Latterly, Darlington has been involved in the construction of the first brand-new steam loco since modernisation, this being Peppercorn A1 Pacific No. 60163 *Tornado*. The project began in 1997 and the engine was completed ten years later and is now a celebrity when on main line excursion duty. (H. Casserley)

Opposite below: Standing outside Darlington works and awaiting repair is ex-NER N8 0-6-2T No. 69385. Behind the engine are tenders from the various locos under repair. (H. Casserley)

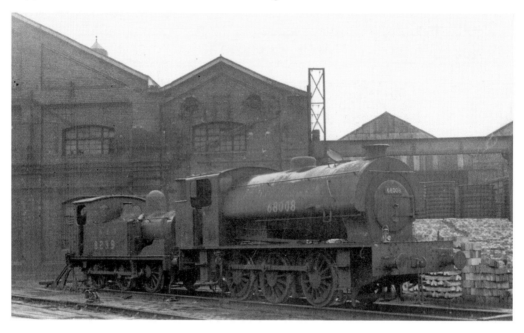

Standing outside the works is ex-War Department Hunslet 0-6-0 Saddle Tank No. 68008, the LNER having bought some seventy-five of these engines from the military in 1945 and classified them J94. Behind the J94 is ex-LNER J71 0-6-0, still retaining its pre-nationalisation number of 8239. (H. Casserley)

With boiler, firebox, coupling rods, two pairs of driving wheels and cylinders removed, Thompson B1 4-6-0 No. E1303 stands outside the works on 24 June 1950. The engine was originally built by the North British Locomotive Company (works No. 26204) and entered traffic on 26 March 1948. The engine was first allocated to Darlington before moving to Stockton on 14 November 1948, where she was to remain until 14 June 1959 when she was transferred to Thornaby. From there she went to Hull Dairycoates from 4 March 1962, thence to York from 6 September 1964. Renumbered 61303 from August 1950, she was condemned on 21 November 1966 and was sold for scrap to Arnott Young of Parkgate in February 1967. (H. Casserley)

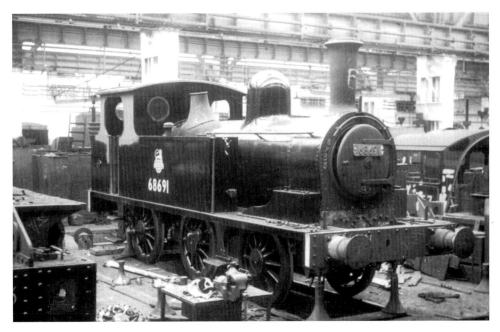

Standing inside the works having undergone heavy repair and a full repaint is ex-NER/LNER J72 0-6-0T No. 68691 awaiting refitting of its coupling rods, seen here on 4 September 1955. (H. Casserley)

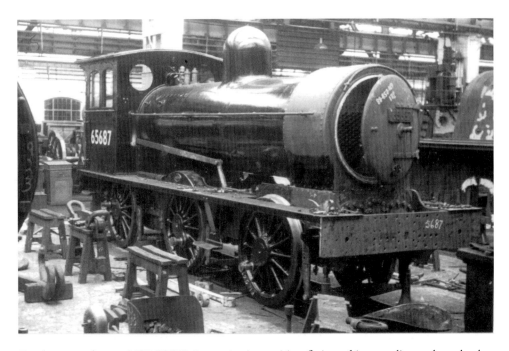

On the same day, ex-NER/LNER J25 0-6-0 is awaiting fitting of its coupling rods and other fitments after heavy overhaul. (H. Casserley)

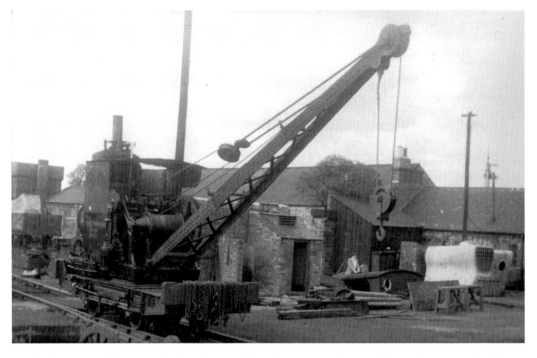

Darlington works crane is standing outside the scrapyard on 4 September 1955. In the background are fireboxes from locos under repair. (R. Casserley)

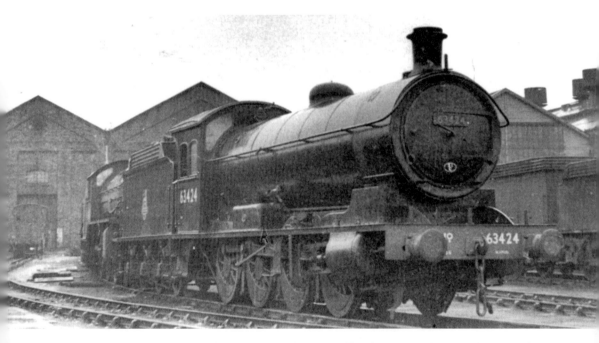

Along with the works, Darlington also had its own locoshed dating back to the days of the Stockton & Darlington Railway. Here, in 1950, ex-LNER 0-8-0 Class Q6 No. 63424, one of those built locally, is seen outside the shed. (H. Casserley)

Situated on the East Coast Main Line and serving various branches in the area, the shed had a variety of motive power allocated here as this 1950 allocation shows:

BR code: 51A

Ex-LNER A3 Pacific	60070 *Gladiateur*
Ex-LNER B1 4-6-0	61021 *Reitbok*, 61023 *Hirola*, 61022 *Sassaby*, 61039 *Steinbok*, 61173, 61176, 61198, 61224, 61255, 61273, 61274, 61275, 61289, 61291
Ex-LNER K1 2-6-0	62004, 62006, 62008, 62009, 62044, 62045, 62046, 62047, 62048, 62049, 62050, 62056, 62057, 62058, 62059, 62061, 62062
Ex-NER J21 0-6-0	65038, 65068, 65090, 65098, 65110, 65119
Ex-NER J25 0-6-0	65647, 65648, 65650, 65672, 65677, 65688, 65692, 65720
Ex-NER G5 0-4-4T	67333, 67342
Ex-WD J94 0-6-0ST	68008, 68015, 68025, 68027, 68039, 68043, 68045, 68047, 68050, 68051, 68052
Ex-LNER Y1 0-4-0T	68136s, 68153s (works shunters)
Ex-NER J77 0-6-0T	68408, 68410, 68423, 68432
Ex-NER J72 0-6-0T	68679, 68707, 69004
Ex-NER N9 0-6-2T	69426
Ex-NER A5 4-6-2T	69832, 69833, 69835, 69836, 69837, 69838, 69839, 69840, 69841
Ex-WD 2-8-0	90061, 90078, 90467
	Total: 81

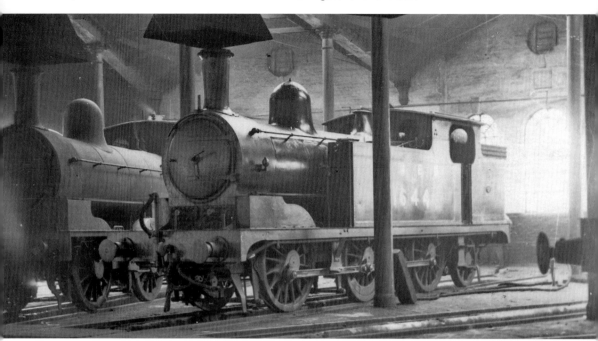

Standing inside Darlington shed is ex-NER Class N9 0-6-2T No. 1644 on 5 June 1935. (H. Casserley)

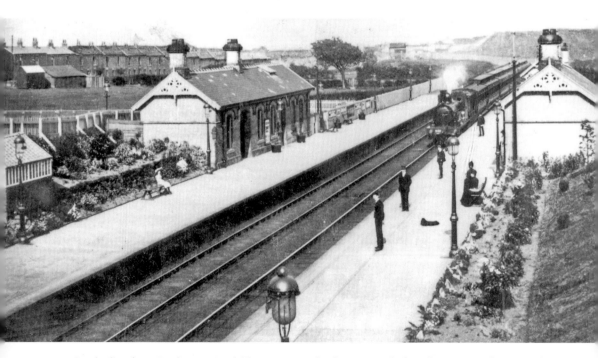

On the line from Darlington Bank Top to Yarm, the first station before the junction from North Road meets the main line is the station at Dinsdale, seen here in the early twentieth century with a local train drawing into the station. (LOSA)

FOUR

DALES BRANCHES

Although the branches through the Yorkshire Dales ran through very attractive country, services were often infrequent and slow, powered by small tank locos and old rolling stock. As an example, the Wensleydale branch ran through lush Wensleydale and up to bleak moorland at Hawes, and its freight traffic usually consisted of milk traffic from local farms and stone from quarries at Redmire. Passenger services were operated by Class O 0-4-4 tank locos in NER days and by G5 0-4-4Ts in LNER and BR days, while freight traffic along the branch was in the hands of 0-6-0 tender engines, usually Class J21s or Class J25s shedded at Northallerton. Often, in NER days, the contrasts were obvious while awaiting departure along the branch at Northallerton. The little tank engine at the head of the branch train would be sizzling away while a procession of expresses and freight trains would pass on the main line.

The little train would then depart from Northallerton and up through the dale, passing soft, lush countryside, which would gradually give way to a harsher moorland scene, with its rushing streams and stone walls, until arriving at the joint NER and Midland station at Hawes, where an onward connection could be made, via the MR Settle–Carlisle line, to Cumberland and Scottish towns.

The wayside stations on the Wensleydale branch had some fascinating names, including Leeming Bar (where the Great Northern Road was crossed), Jervaulx, Finghall Lane, and Burton Constable. The famous waterfalls at Aysgarth lie just west of Leyburn. Passenger services lasted until 26 April 1954, almost a decade before Beeching introduced his closure plans, and ten years later, goods services were withdrawn from the western end of the line, traffic from Redmire quarry lasting until 1992.

Despite loss of traffic, the Wensleydale branch still survives in part, thanks to the efforts of preservationists who formed the Wensleydale Railway Association

in 1990. Passenger services were restored to the line in July 2003 with stations at Leeming Bar and Leyburn. Further stations were reopened at Bedale, Finghall and Redmire in 2004. Passenger trains over this picturesque line are usually operated by preserved DMUs, although steam is sometimes operated using ex-BR 2-6-4T locos.

Unfortunately, virtually all of the other dales branches have not been so lucky and have ceased to exist since the 1960s.

Opposite: A map of the branches at Nidderdale. The line from Harrogate to Pateley Bridge was operated by the NER, while the Nidd Valley Railway operated from its own station at Pateley Bridge through to Lofthouse-in-Nidderdale's, the NER making a connection with the NVR just north of its own Pateley Bridge station. (Author)

THE NIDDERDALE BRANCH
(not to scale)

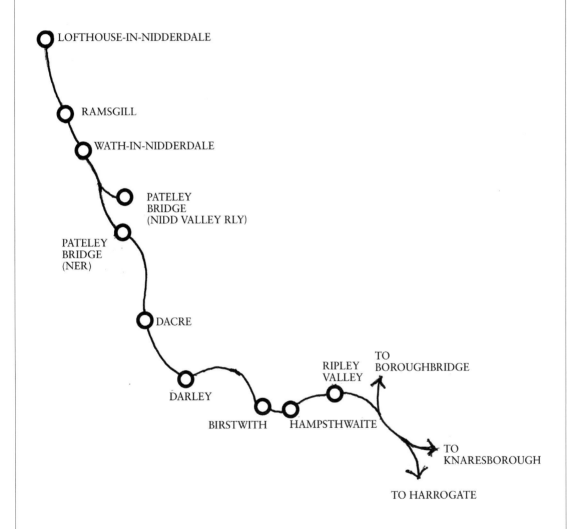

Mls	PATELEY BRIDGE and LOFTHOU. Sec. and Man., Wm. Tho	mrn	mrn	aft	aft		
—	Pateley Bridge...........dep.	8 40	10 20	1 45	4 10
1½	Wath-in-Nidderdale............	8 45	10 25	1 50	4 15
4	Ramsgill....................	8 55	10 35	2 0	4 25
6	Lofthouse-in-Nidderdale.. arr.	9 0	10 40	2 5	4 30

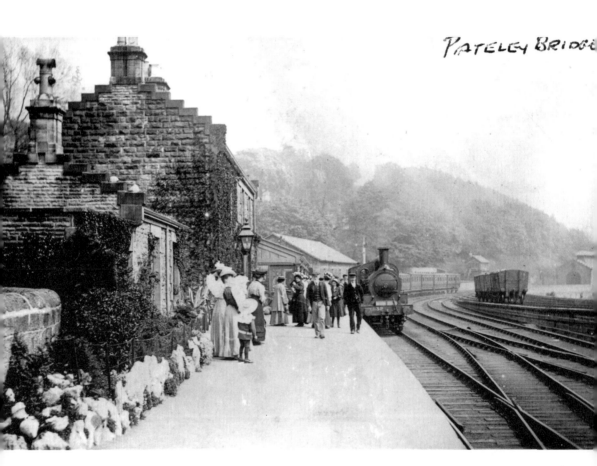

PATELEY BRIDGE

N-NIDDERDALE.—Nidd Valley Light.
ft, Town H ll, Bradford.

		mrn	mrn	aft	aft		
ls	Lofthouse-in-Nidderdale..dep.	9 20	11 5	2 55	4 50
2	Ramsgill	9 25	1110	3 0	4 55
1½	Wath-in-Nidderdale...........	9 35	1120	3 10	5 5
3	Pateley Bridge *(above)*.....arr.	9 40	1125	3 15	5 10

Above: A 1910 timetable for services run by the NVR from its station at Pateley Bridge to Lofthouse-in-Nidderdale. This section of the valley was served by a line built by Bradford Corporation which was needed for construction of a reservoir. The line ran along the valley to the site of the reservoirs at Angram and Scar House and a passenger service was provided from 11 September 1907 until 1 January 1930. The service was operated in later years by a steam railcar which had been purchased from the Great Western Railway. This line was closed in 1936 when construction of the reservoirs had been completed and the line was dismantled. Although there was an end-on connection between the NER and NVR no through trains were operated, special arrangements being made to transfer coaches between the lines when special trains ran. (Author's collection)

Opposite below: The NER station at Pateley Bridge during the Edwardian period with a train from Harrogate arriving. A line to Pateley Bridge had been authorised by Parliament in 1848 but was allowed to lapse. The NER revived the idea and received powers for the branch on 21 July 1859. The line opened on 1 May 1862, with intermediate stations at Ripley Valley, Hampsthwaite, Burstwith, Darley and Dacre, and served an important part in the life of the fertile dale until the roads took over. The line was closed to passengers from 2 April 1951 but freight along the branch continued until 1964. In the right background of this view is the small locoshed which was opened at the same time as the station in 1862. The stone shed seen here was replaced by a wooden structure, probably due to subsidence caused by the weight of the building on the riverbank. Engines allocated to the shed (coded P. BRIDGE in LNER days and 50D, a subshed of Starbeck, in BR days) were usually 2-4-0s when opened and were replaced by a BTP 0-4-4T, itself being replaced by G5 0-4-4T No. 1839, which worked all day between Pateley Bridge and Harrogate, with a morning trip to Wetherby and back. By 1939, two trips to Knaresborough and one to Pilmoor were introduced to cover engine stopover time at Harrogate. Push-pull working was introduced on the branch in 1939 and No. 1839 went to Starbeck in exchange for push-pull-fitted G5 No. 830 on 20 March 1939. Loco No. 1839 returned to Pateley Bridge in June 1939 with No. 830 going to Kirkby Stephen. This loco, becoming 67253 in BR ownership, continued working from the shed until it closed with withdrawal of passenger services in April 1951. (LOSA)

HARROGATE and PATE

Mls	Down.	mrn	aft	aft	aft		aft	aft	
—	Harrogatedep.	9 15	1210	3 5	4 53		7 10	7e40	
4¾	Ripley Valley.........	9 24	1219	3 14	5 2		7 19	7e49	
6¼	Hampsthwaite	9 28	1223	3 18	5 6		7 23	7e53	
8¼	Birstwith............	9 31	1226	3 21	5 9		7 26	7e56	
9¾	Darley	9 37	1232	3 27	5 15		7 32	8 e 2	
11	Dacre ‡	9 41	1236	3 31	5 19		7 36	8 e 6	
14¾	Pateley Bridge.. arr.	9 50	1245	3 40	5 28		7 45	8e15	

e Except Saturdays. ‡ Sta

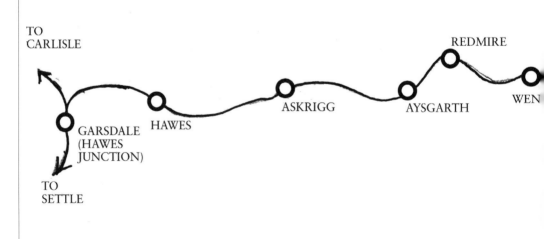

THE WENSLEYDALE BRANCH
(not to scale)

TO CARLISLE

REDMIRE

TO SETTLE

GARSDALE (HAWES JUNCTION) HAWES ASKRIGG AYSGARTH WEN

Top: A 1910 NER timetable for passenger services between Harrogate and Pateley Bridge, the last Saturday train leaving Harrogate at 9.10 p.m., an earlier service whistling to announce that the next train would be the last for Pateley Bridge, giving time for residents of Pateley Bridge to drink up in the hostelries of Harrogate before returning home. (Author's collection)

BRIDGE.—North Eastern.

Mls	Up.	mrn	mrn	aft	aft	aft		aft
—	Pateley Bridge....dep.	7 38	1012	1 15	3 53	5 40		8 0
3½	Dacre ‡	7 46	1020	1 23	4 1	5 48	Sats. only.	8 8
5	Darley	7 50	1024	1 27	4 5	5 52		8 12
7¾	Birstwith................	7 58	1030	1 33	4 11	6 0		8 18
9	Hampsthwaite	8 1	1033	1 36	4 14	6 3		8 21
10¼	Ripley Valley.[713,718	8 4	1036	1 39	4 17	6 6		8 24
14½	Harrogate 708, 710 arr.	8 15	1047	1 50	4 28	6 17		8 35

for Brimham Rocks, 2 miles.

Above: A map of the Wensleydale branch which ran from Northallerton to Hawes, where it connected with the Midland Railway's Settle–Carlisle Railway at Hawes Junction (Garsdale). (Author)

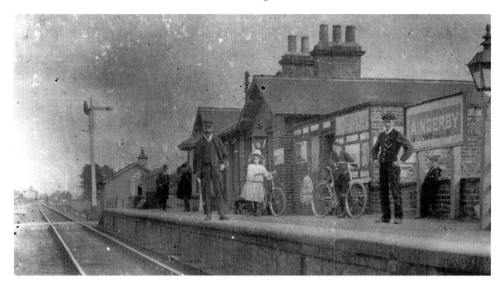

The first station on the Wensleydale branch was at Ainderby, seen here in Edwardian days with staff and local children posed on the station platform. In these days of overprotection of children, such pictures would not be allowed without active involvement of parents. The first section of the branch, which would eventually run for 34 miles from Northallerton to Bedale, was authorised under the GNER Act of 26 June 1846 but was completed by the York, Newcastle & Berwick Railway in 1848. The next section, from Bedale to Leyburn, a distance of 11¾ miles, was built under the Bedale & Leyburn Act of 4 August 1853, capital being provided by local landowners. This section was opened to freight on 24 November 1855 and to passengers on 19 May 1856. Threats from other railways, notably the Northern Counties Union Railway, who planned to build a line from Thirsk to Clifton (south of Penrith) and Bishop Auckland to Tebay, and possible invasion in the Wensley area, forced the NER to take control of the Bedale & Leyburn Railway, under an Act of 8 August 1859. (LOSA)

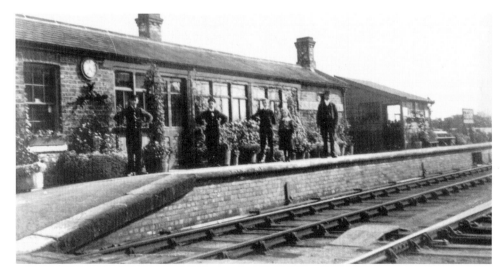

The second station on the Northallerton–Bedale section was at Scruton, seen here in the early years of the twentieth century. (LOSA)

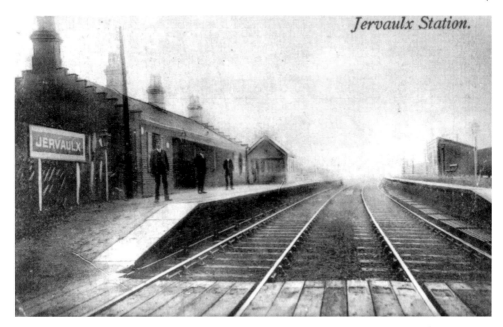

The second station on the section from Bedale to Leyburn was the exotically named Jervaulx station, its simple buildings seen here in this view. (LOSA)

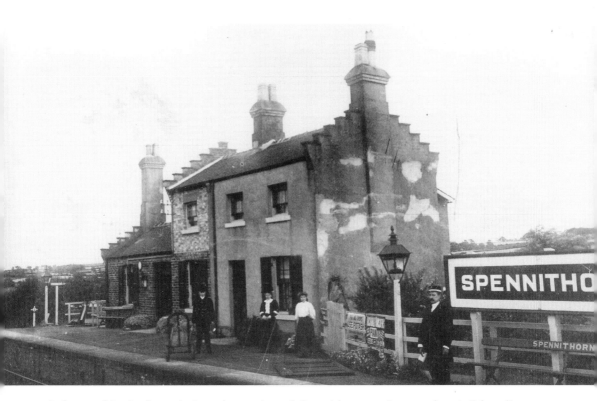

Before reaching Leyburn, the branch runs through Spennithorne station, seen here in Edwardian days, with the small number of staff in view. The main building appears to have suffered some damage (or is that a fault on the negative?). (LOSA)

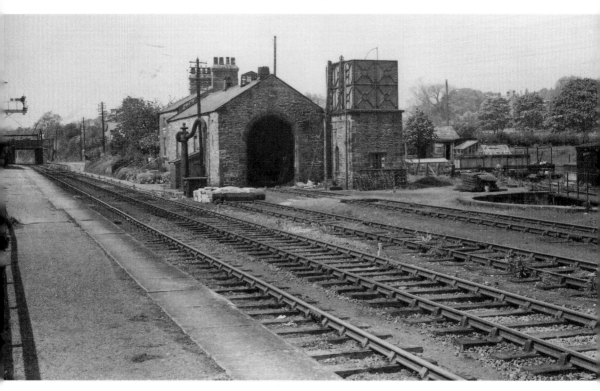

The station at Leyburn as it appeared on 1 June 1963 with the goods yard and small locoshed, complete with water tower in view. (R. Carpenter)

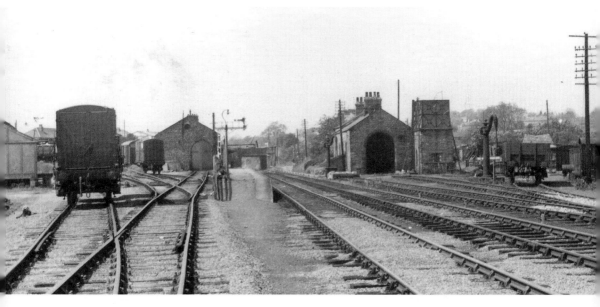

Another view of Leyburn showing the locoshed, goods shed and expanse of sidings as they appeared in 1963. (R. Carpenter)

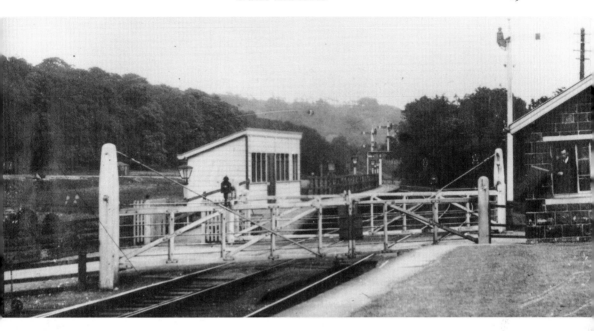

The station at Wensley, the dale taking its name from the town, which was opened to passengers in October 1878. In 1865, powers were obtained, under the Hawes & Melmerby Act, to build a line from Hawes to Wensley, with a connection from Finghall to the Leeds Northern line at Melmerby; but this scheme was postponed for economic reasons and replaced by a cheaper plan to connect Hawes and Leyburn, a distance of 16 miles. This plan was authorised on 4 July 1870 and opened to goods traffic on 1 June 1878 and to passengers in October. (LOSA)

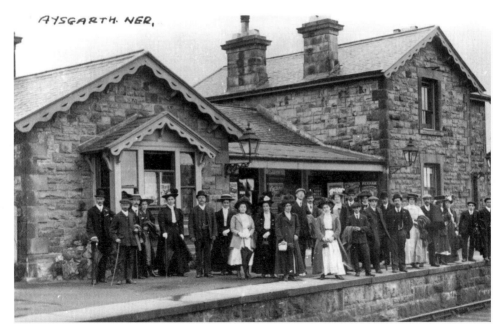

Aysgarth station crowded with Edwardian passengers waiting outside the fine stone main building for a local train, possibly after visiting the famous waterfalls close by. (LOSA)

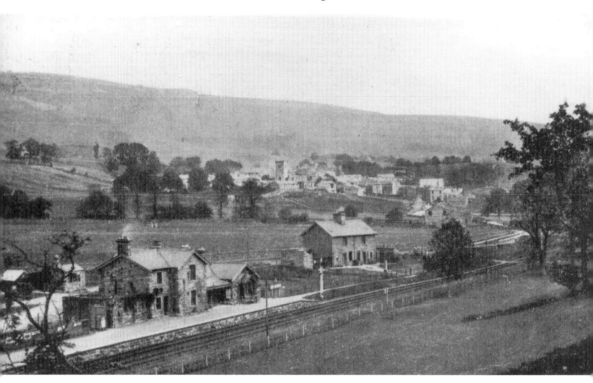

NORTHALLERTON, BEDALE, LEYBURN, an[d]

Miles	Down.	mrn	mrn	mrn	mrn	aft	aft	aft	aft	aft
	684 YORK......dep.	5 55	8 45	9 57	1250	2 40	5 47	8 5
	Northallerton dep.	7 20	9 48	1052	1 38	3 55	6 33	9 40
3	Ainderby	7 27	9 55	1059	1 45	4 2	6 40	9 47
4½	Scruton	7 31	9 59	11 3	1 49	4 6	6 44	9 51
5½	Leeming Bar........	7 35	10 3	11 7	1 53	4 10	6 48	9 55
7½	Bedale.	7 41	10 7	1113	1 59	4 16	6 54	10 1
9½	Crakehall	7 47	1119	2 5	4 22	7 0	10 7
11½	Jervaulx	7 54	1123	2 13	4 30	7 5	10 12
13½	Finghall Lane......	7 59	1128	2 18	4 35	7 10	Sig.
14½	Constable Burton ..	8 3	1132	2 22	4 39	7 14	10 21
16½	Spennithorne	8 7	1136	2 26	4 43	7 18	**k**
17½	Leyburn..........	8 17	1146	2 37	4 54	7 30	10 27
20	Wensley..........	8 23	1151	2 43	5 0	7 36
22	Redmire..........	8 28	1156	2 49	5 5	7 41
25	Aysgarth	8 35	12 3	2 55	5 12	7 49
29½	Askrigg...........	8 45	1213	3 5	5 22	7 59
34	Hawes........[621	3 54	1010	1222	3 14	4 5	5 31	8 8
39½	Hawes Junc.†620ar	1025	1238	4 17	5 47	8 25

k Stops on Saturdays when required to set do[wn]

Opposite above: A bird's eye view of the handsome stone station at Askrigg with the village in the background. The sheep in the foreground and soft dales country in the background, the pasture-land of which provided agricultural traffic for the railway, along with stone traffic from the nearby quarries at Redmire. (Author's collection)

Below: A 1910 timetable for NER services along the Wensleydale branch, connecting with the Midland at Hawes and Garsdale. (Author's collection)

RN, and HAWES JUNCTION.—North Eastern.

t	aft	Mls	Hawes Junc. and	mrn	mrn	mrn	mrn	aft	aft	aft	Sn aft
17	8 5	—	Garsdaledep		6 42	1054	1 5	3 15	6 25	aft
33	9 40	5¾	Hawes		6 55	9 7	11 6	1 17	3 35	6 38	5 25
10	9 47	10½	Askrigg		7 4	9 15	1114	1 25	3 44	6 49	5 37
4	9 51	14¾	Aysgarth		7 14	9 24	1123	1 34	3 53	7 0	5 50
8	9 55	17¾	Redmire		7 21	9 30	1129	1 41	4 0	7 7	5 57
54	10 1	19¾	Wensley		7 26	9 35	1134	1 46	4 5	7 12	6 3
0	10 7	22½	Leyburn	6 10	7 38	9 44	1144	1 56	4 14	7 25	6 11
5	10 12	23½	Spennithorne		7 42	1149	Sig.	4 18	7 29
0	Sig.	25½	Constable Burton	Sig.	7 46	9 50	1153	2 5	4 22	7 33	6 17
4	10 21	26¾	Finghall Lane		7 49	1156	2 8	4 25	7 36	6 20
8	k	28¼	Jervaulx	Sig.	7 53	9 56	12 0	2 12	4 29	7 40	6 24
0	10 27	30	Crakehall	Sig.	7 57	12 5	2 17	4 34	7 45	6 29
6	32¼	Bedale	6 29	8 2	10 1	1210	2 22	4 39	7 50	6 34
1	34	Leeming Bar	6 37	8 10	10 7	1217	2 29	4 46	7 58	6 40
9	35¼	Scruton	Sig.	8 15	1011	1221	2 33	4 50	8 2	6 44
9	36¾	Ainderby......[686	6 44	8 20	1015	1225	2 37	4 54	8 6	6 48
8	39¼	Northallerton..arr.	6 52	8 28	1022	1233	2 45	5 2	8 13	6 54
5	69¾	686 Yorkarr.	8 32	9 19	1128	2 4	3 48	6 10	9 18	9 0

o set down. † Hawes Junction and Garsdale.

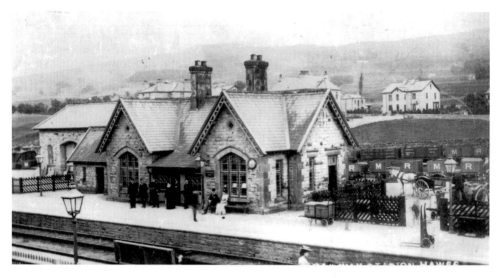

Above: Hawes station at the end of the Wensleydale branch. The station here was jointly owned by the NER and MR, the architecture suggesting that it was built by the Derby company. From here, the line continued to Hawes Junction, some NER trains running through to the Midland Main Line for access to Carlisle. Passenger services along the whole of the Wensleydale branch ceased on 26 April 1954, goods services west of Redmire finished ten years later. Quarry traffic from Redmire to Northallerton continued until 1992, but the Ministry of Defence also wanted the line to carry armoured vehicles for Catterick Camp and they restored the line. In 1990, the Wensleydale Railway Association was formed with the intention of restoring passenger services. When BR decided to sell the line, the association aimed to operate its own passenger services. In 2000, the WRA formed the operating company Wensleydale Railway plc and issued shares, raising £1.2 million. Railtrack then agreed to lease the line to the operating company and a ninety-nine-year lease was signed in 2003. Passenger services started on 4 July 2003 with stations at Leeming Bar and Leyburn. In 2004, stations at Bedale, Finghall and Redmire were reopened; three or four trains operate over the line using ex-BR DMU trains, with an occasional visit by steam locos. In 2012, the railway announced that it wished to raise £250,000 to bring the line from Leeming Bar to Northallerton where a connection would be made to the ECML which could attract around 6,000 extra passengers to the line and would bring extra income to the local economy. Let's hope that the railway is successful. (LOSA)

Opposite above: Trains at Hawes Junction in 1905 with the local train to Northallerton on the right and a rake of MR coaches on the left. (R. Carpenter)

Opposite middle: The branch from Pilmoor to Malton was opened on 19 May 1853, after three Acts had been approved. The first was the GNER Act which allowed construction of a line from Malton to Dalton, approved on 18 June 1846, and allowed north and south connections to the main line. The York & Newcastle Act of 9 July 1847 allowed a line south-west from the above line at Husthwaite to join the main line at Raskelf. Finally, the line as built was authorised by the York, Newcastle & Berwick Act of 22 July 1848. The final Act involved complete modification of the line west of Gilling with connections to the main line between Raskelf and Pilmoor. In the event, only the northern curve was built and the southern curve had to be reauthorised in 1865 and finally opened between Bishophouse Junction and Sunbeck Junction on 9 October 1871. Situated on the branch between Pilmoor and Gilling is the station at Husthwaite Gate, seen here at the beginning of the twentieth century at the junction with the goods line and the main single line, with the stationmaster's house in the foreground and the little station on the single line in the background. (LOSA)

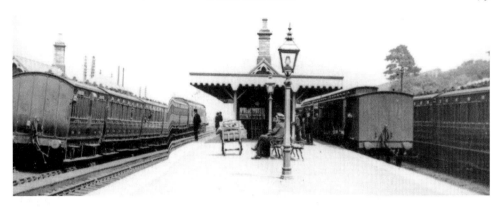

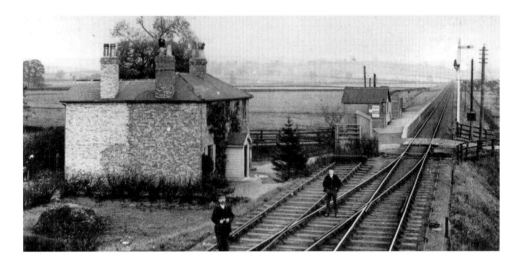

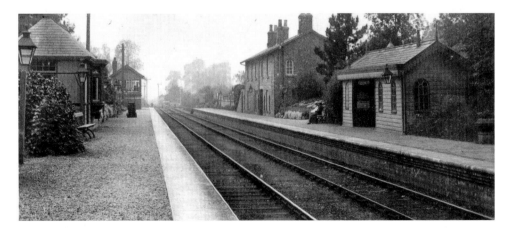

The next station along the branch was at Coxwold, seen here in the early years of the twentieth century. Passenger services to York were discontinued on 2 February 1953 and the south curve was later removed. The north curve remained in use for summer Saturday services to Scarborough from Scotland until September 1962. Before the summer of 1963, the junction at Pilmoor was destroyed by a derailment and was closed. Trains to Scarborough then ran via York. (LOSA)

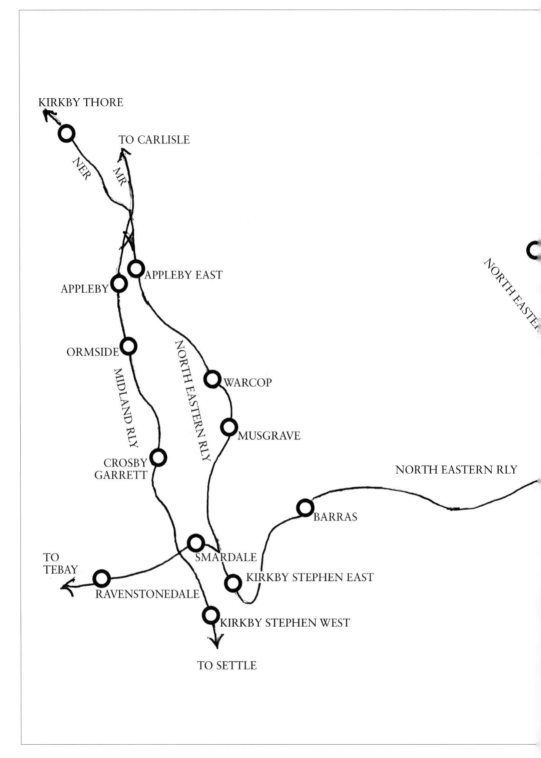

A map of the Teesdale branches from Darlington to Middleton-in-Teesdale, Tebay and Appleby East and connecting with the MR Settle–Carlisle line. (Author)

TEESDALE LINES
(not to scale)

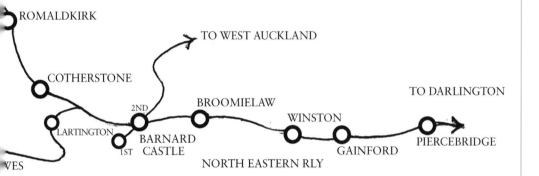

ON-IN-TEESDALE

ETON

ROMALDKIRK

TO WEST AUCKLAND

COTHERSTONE

TO DARLINGTON

2ND

BROOMIELAW

WINSTON

LARTINGTON

BARNARD
1ST CASTLE

PIERCEBRIDGE

GAINFORD

VES

NORTH EASTERN RLY

MIDDLETON-IN-TEESDALE and

Miles	Up.	Week Days.						
		mrn	mrn	non	aft	aft		
	Middleton-in-Teesdale dep.	6 45	8 16	12 0	2 27	5 38	5
1¼	Mickleton	6 49	8 20	12 4	2 31	5 42	5
3¼	Romaldkirk	6 54	8 25	12 9	2 36	5 47	
6	Cotherston	7 0	8 31	1215	2 42	5 53	
8¼	Barnard Castle (above) arr.	7 7	8 38	1223	2 49	6 1	

A timetable of 1910 for services from Midleton-in-Teesdale to Barnard Castle.
(Author's collection)

BISHOP AUCKLAND and BA

Miles	Up.	Week Days.				Auto-car.		
		mrn	mrn	aft	aft		aft	af
	Bishop Aucklanddep.	6 52	10 8	1222	4 8		5 20	7
2¼	West Auckland	6 59	1015	1229	4 15		5 27	7
5¼	Evenwood...............	7 6	1022	1236	4 22		5 33	7 2
7½	Cockfield...............	7 14	1030	1244	4 30		5 41	7 2
15	Barnard Castle (above) arr	7 30	1045	1 0	4 45		5 55	7

Timetable for services in 1910 between Bishop Auckland and Barnard Castle.
(Author's collection)

NARD CASTLE.—North Eastern.

Down.	Week Days.					Sn
	mrn	mrn	aft	aft	aft	mrn
Barnard Castledep.	7 43	1122	1 33	4 49	9 8	9 20
Cotherston	7 50	1129	1 40	4 56	9 15	9 27
Romaldkirk...............	7 56	1135	1 46	5 2	9 21	9 33
Mickleton[dale	8 1	1140	1 51	5 7	9 26 ...	9 38
Middleton-in-Tees- arr.	8 6	1145	1 56	5 12	9 31	9 43

RD CASTLE.—North Eastern.

Miles	Down.	Week Days.					
		mrn	mrn	aft	aft	aft	aft
	Barnard Castle.........dep.	7 10	8 40	1240	2 55	4 30	6 15
7¼	Cockfield	7 26	8 56	1256	3 11	4 47	6 31
9¾	Evenwood...................	7 31	9 1	1 1	3 16	4 52	6 36
12¼	West Auckland.....[to 704	7 37	9 7	1 7	3 22	4 58	6 41
15	Bishop Auckland 701 arr.	7 44	9 13	1 14	3 29	5 5	6 47

DARLINGTON, KIRKBY STEPHEN, PENRITH, and TEBAY.—North Eastern.

Down. Week Days. Suns.

Miles	Station	mrn	mrn	mrn	mrn	mrn	aft	aft	aft					mrn	aft
	702 Newcastledep.		5 10	8 0	9 30	10 42	1 44	3 54	5 12					6 25	7 8
—	Darlington (Bank Top) dep.		6 55	9 26	1032	1240	3 2	5 3	7 27					8 35	8 15
1¼	" (North Road)...		7 0	9 31	1037	1245	3 7	5 8	7 32					8 40	8 20
6¼	Piercebridge		7 9	9 40	1046	1254	3 16	5 17	7 41					8 49	8 29
9	Gainford		7 17	9 47	1054	1 2	3 24	5 25	7 49					8 57	8 37
11	Winston		7 22	9 52	1059	1 7	3 29	5 30	7 54					9 2	8 42
16¼	Barnard Castle *(see below)*.		7 40	10 5	1115	1 24	3 43	5 47	8 7					9 15	8 55
19	Lartington		7 46			1 30	3 49	5 53							
22¼	Bowes		7 56		1128	1 39	3 58	6 2							
33	Barras[621]		8 15		1147	1 57		6 21							
39¼	Kirkby Stephen *620, arr.		8 25		1157	2 7	4 25	6 31							
—	Kirkby Stephen........dep.		8 30		12 7	2 51	4 28	6 42							
43¾	Musgrave		8 38		1215	2 59	4 35	6 50							
45¾	Warcop		8 43		1220	3 4	4 39	6 55							
50½	Appleby † 620 ...		8 53		1230	3 13	4 48	7 5							
54¼	Kirkby Thore		9 2		1240	3 24	4 58	7 15							
56¾	Temple Sowerby		9 7		1245	3 29	5 3	7 20							
58¾	Cliburn		9 12		1250	3 34	5 8	7 25							
61	Clifton		9 20		1258	3 42	5 17	7 33							
64¾	Penrith ‡ 420,512...arr.		9 27		1 5	3 49	5 24	7 40							
—	Kirkby Stephendep.	7 0	8 38		12 0	2 11	4 40	6 33							
41¼	Smardale	7 6	8 44		12 6		4 46								
45½	Ravenstonedale	7 14	8 52		1214	2 22	4 54	6 45							
49	Gaisgill	7 20	8 58		1220		5 1	6 51							
51¾	Tebay 420, 425 ...arr.	7 27	9 5		1227	2 34	5 8	6 58							

Up. Week Days. Suns.

Mls	Station	mrn	mrn	mrn	mrn	mrn	aft	aft	aft	aft				mrn	aft
	Tebaydep.		8 0		1115	2 15		5 0	5 40	7 37					
2¼	Gaisgill		8 6		1121	2 23			5 46	7 43					
6	Ravenstonedale......		8 14		1129	2 31		5 11	5 54	7 51					
9½	Smardale		8 22		1137	2 39			6 2	7 59					
11½	Kirkby Stephen *620, arr.		8 27		1142	2 44		5 21	6 7	8 4					
Mls	Penrithdep.		7 18		1042	1 40		4 15		6 48					4 0
3¾	Clifton		7 26		1050	1 48		4 23		6 56					4 8
6¾	Cliburn		7 32		1056	1 54		4 30		7 2					4 14
8¾	Temple Sowerby		7 37		11 0	1 58		4 35		7 6					4 18
10	Kirkby Thore		7 42		11 4	2 2		4 41		7 10					4 24
14	Appleby † 620, 621 ...		7 53		1114	2 12		4 52		7 25					4 36
19½	Warcop		8 4		1122	2 22		5 1		7 35					4 48
21	Musgrave....[620, 621]		8 8		1126	2 26		5 5		7 39					4 52
25¾	Kirkby Stephen * arr.		8 17		1134	2 34		5 13		7 48					5 2
—	Kirkby Stephendep.	6 40	8 31		1145	2 47		5 23		8 7					5 4
18¼	Barras..........	6 55	8 46		12 0	3 2		5 38		8 22					5 19
29¾	Bowes	7 12	9 8		1217	3 19		5 55		8 39					5 36
32¼	Lartington	7 20	9 11		1225	3 27	m	6 3		8 47					5 45
34¼	Barnard Castle *(see below)*.	7a40	9 19	1016	1233	3 36	5 57	6 12		8 54				7 20	6 5
40¼	Winston..........	7 51	9 30	1027	1244	3 47		6 23		9 4				7 31	6 16
42¼	Gainford..........	7 56	9 35	1032	1249	3 52		6 28		9 9				7 36	6 21
45	Piercebridge......	8 2	9 43	1039	1257	4 0		6 34		9 17				7 44	6 28
50	Darlington (N.Rd)...[686	8 15	9 50	1048	1 6	4 9		6 46		9 26				7 53	6 42
51¼	" (B.T.) 684, arr.	8 19	9 56	1052	1 10	4 13		6 50		9 30				7 57	6 46
87¼	684 Newcastle (Cen.)..arr.	9 30	1134	1155	2 45	5 25		7 52	7 55		1048			10 3	9 7

NOTES.

a Arrives at 7 25 mrn.

b Arrives at 5 50 aft.

d Via Bishop Auckland.

m Auto-car.

* About 1 mile to Midland Station.

† About ¼ mile to Midland Station.

‡ Station for Ullswater.

☞ **For Local Trains**
BETWEEN PAGE
Darlington (Bank Top) and Darlington (North Road)...........704

* * **For other Trains**
BETWEEN PAGE
Kirkby Stephen and Appleby 620 and 621

A 1910 NER timetable for passenger services between Darlington and Tebay.
(Author's collection)

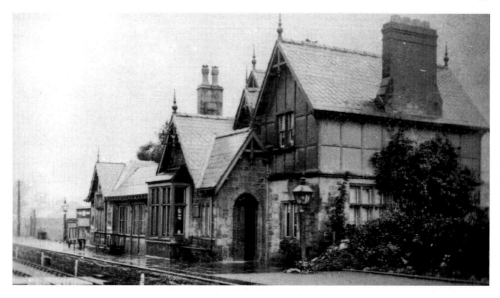

From Darlington, the branch through Teesdale ran through Gainford, Winston, Bromielaw, and Barnard Castle where there was a junction for West Auckland and Middleton-in-Teesdale. From the junction, the line passes Lartington before entering Bowes. The imposing main station building at Bowes is seen in this early twentieth-century view. (LOSA)

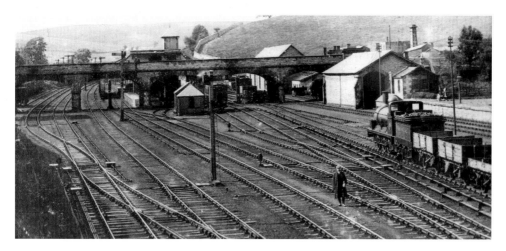

From Bowes the line then passes Barras before turning right and running parallel with the MR Settle–Carlisle line as it enters Kirkby Stephen East station (Kirkby Stephen West station is on the Settle–Carlisle line). Looking more important than that on the MR line, the NER station looks busy with an unidentified 0-6-0 goods engine shunting in the goods yard. The goods shed is visible on the right and the station lies beyond the road bridge. (LOSA)

The NER also provided a locoshed here, coded 51H in BR days. Its allocation was made up of goods engines as this 1950 allocation shows:

Ex-NER Class J21 0-6-0	65028, 65040, 65047, 65089, 65100, 65103
Ex-NER Class J25 0-6-0	65653, 65655, 65673, 65717
	Total: 10

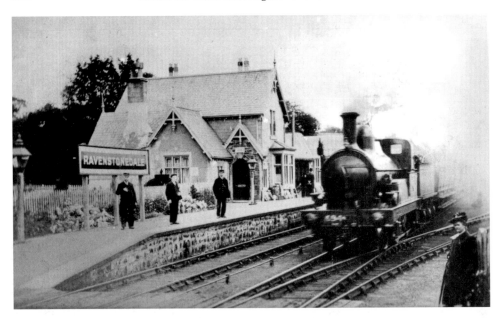

After leaving Kirkby Stephen, a branch to Tebay leaves the line, passes Smardale, crosses the Settle–Carlisle line and then enters Ravenstonedale, seen here at the end of the nineteenth century with an NER 2-4-0 leaving with a passenger train for Tebay while station staff look on. (LOSA)

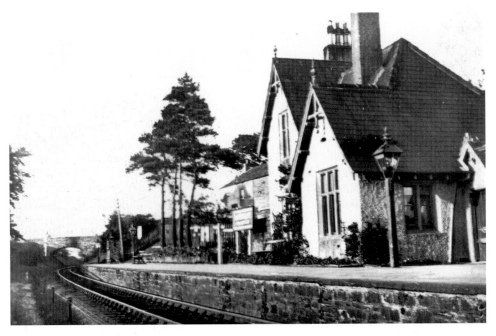

Heading towards Appleby, the line enters Musgrave station. The line is seen here with the main station building at Musgrave in view on the right. (LOSA)

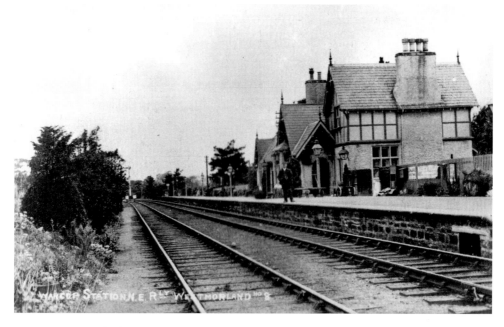

Next station on the line was at Warcop, seen here in the early years of the twentieth century. (LOSA)

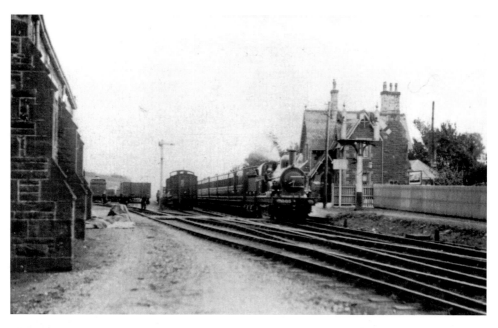

The NER station at Appleby, known as Appleby East to avoid confusion with the MR station at Appleby on the Settle–Carlisle line. The station is seen here with a passenger train headed by an unidentified NER loco waiting at the station. To the left is the goods shed and goods yard with another NER engine on shunting duties. From here, the line will cross the MR line and head towards Kirkby Thorne on its way to Clifton Moor where it will connect with the LNWR line to Carlisle, north of Shap. (LOSA)

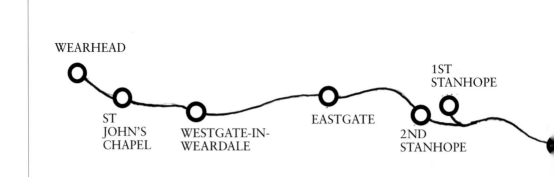

THE WEAR VALLEY BRANCH
(not to scale)

A map of the Wear Valley branch which left the main line north of Darlington, between West Auckland and Durham. (Author)

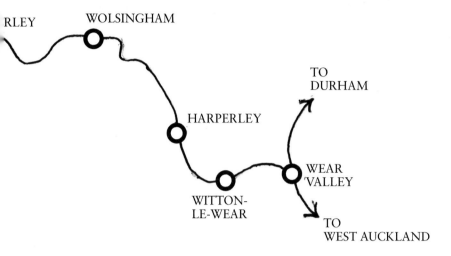

RLEY WOLSINGHAM

HARPERLEY

WITTON-
LE-WEAR

WEAR
VALLEY

TO
DURHAM

TO
WEST AUCKLAND

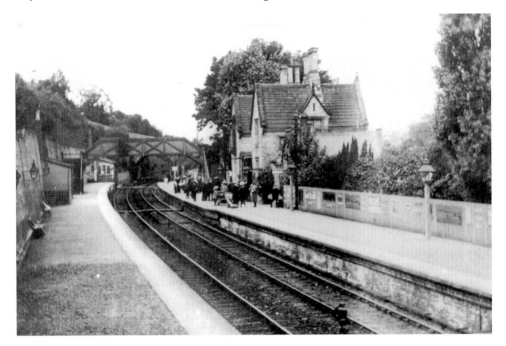

Above: On leaving the main line at Wear Valley, the branch then passed through Witton-le-Wear, thence to Harperley before entering Wolsingham station, seen here on a busy day at the beginning of the twentieth century. (LOSA)

Opposite top: Next station on the branch was at Frosterley, seen here in the middle of the twentieth century. The goods yard appears to have been taken out of use and the track lifted. The town and its church spire can be seen in the background. (LOSA)

Opposite bottom: After Frosterley, the line reached Stanhope, which once had two stations. This view appears to show both stations; the new one is in the lower ground, while the original seems to be in use as a goods yard. The village is seen in the background. (LOSA)

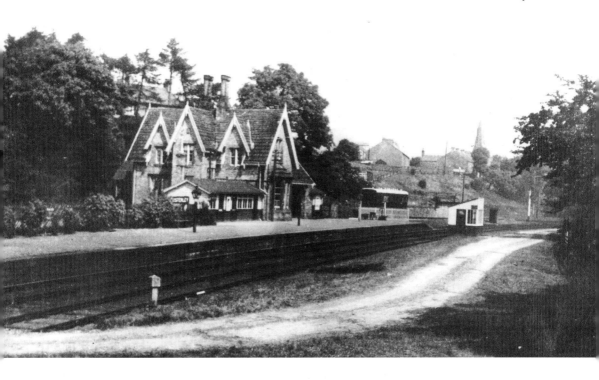

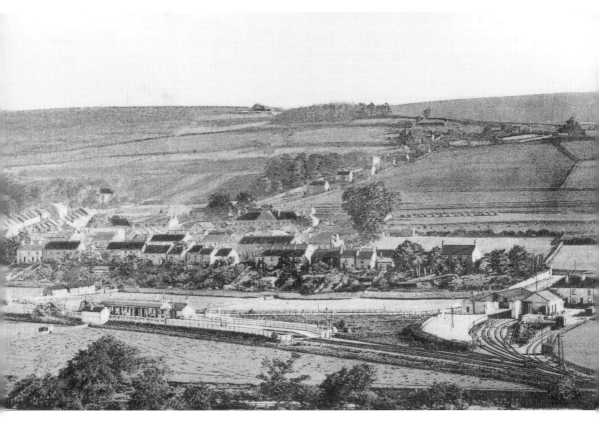

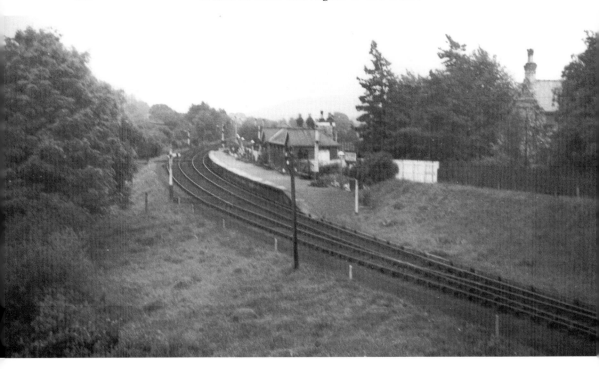

WEAR VALLEY JUNCTION, STANH

Miles frm W. Valley	Down.		Week Days.							Sunday	
	Central Station,	mrn	mrn	mrn	mrn	aft	aft	aft		mrn	aft
	686 NEWCASTLEdep.	1k57	5 10	8 0	10 4	1 44	3 54	7 20	6 25	7 8
	699 DARLINGTON (Bank Top). "	5 40	7 0	9 22	1112	3 7	5 8	7 32	8 40	8 25
	Wear Valley Junctiondep.	6 33	7 52	10 9	1155	3 55	5 55	8 44	9 20	9 8
1¼	Witton-le-Wear................	6 38	7 57	1014	12 0	4 0	6 0	8 49	9 25	9 13
4¼	Harperley	8 4	1021	12 7	4 7	6 7	8 56	9 32	9 20
7¾	Wolsingham	6 52	8 11	1028	1214	4 14	6 14	9 3	9 39	9 27
10¾	Frosterley....................	7 0	8 19	1036	1222	4 22	6 22	9 11	9 47	9 35
12¼	Stanhope...........{ arr.	7 6	8 25	1042	1228	4 28	6 28	9 17	9 53	9 41
	{ dep.	7 15	8 33	1235	4 34	6 43
15¼	Eastgate......................	7 23	8 40	1243	4 42	6 51
18¼	Westgate-in-Weardale..........	7 31	8 48	1251	4 50	6 59
20	St. John's Chapel	7 36	8 53	1256	4 55	7 4
22	Wearhead.................arr.	7 42	8 59	1 2	5 1	7 10

k Leaves at 1

Opposite: From Stanhope, the line passed Eastgate before reaching Westgate-in-Weardale, seen on the approach. (LOSA)

Below: A 1910 NER timetable for local services along the Wear Valley branch. (Author's collection)

and WEARHEAD.—North Eastern.

Up.	Week Days.						Sundays.	
	mrn	mrn	aft	aft	aft	aft	mrn	aft
Wearheaddep.	6 35	8 0	12 2	4 0	6 10
St. John's Chapel	6 40	8 5	12 7	4 5	6 15
Westgate-in-Weardale...........	6 45	8 10	1212	4 10	6 20
Eastgate	6 53	8 18	1220	4 18	6 28
Stanhope { arr.	7 0	8 25	1227	4 25	6 35
Stanhope { dep.	7 8	8 30	1236	3 3	4 30	6 45	6 54	5 45
Frosterley....................	7 13	8 35	1241	3 8	4 35	6 50	6 59	5 50
Wolsingham	7 22	8 44	1250	3 17	4 44	6 59	7 8	5 59
Harperley	7 28	8 50	1256	3 23	4 50	7 5	7 14	6 5
Witton-le-Wear	7 35	8 57	1 3	3 30	4 57	7 12	7 21	6 12
Wear Valley Junction 699.. arr.	7 39	9 1	1 7	3 34	5 1	7 16	7 25	6 16
699 Darlington (Bank Top). arr.	8 31	9 52	1 52	4 19	5 45	7 59	8 8	6 57
684 Newcastle (Central).... "	9 16	1012	2 45	5 3	6 42	8 48	9 58	9 7

. on Mondays.

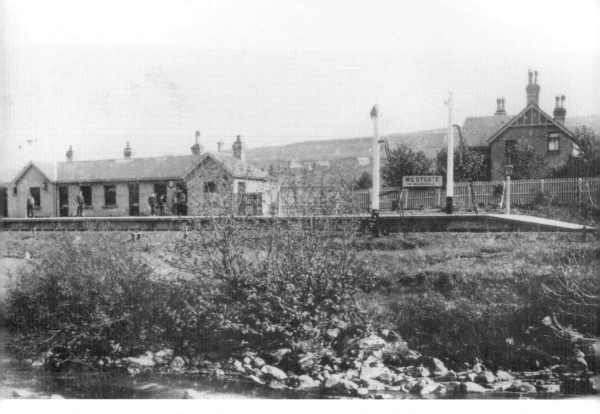

The main station building at Westgate-in-Weardale. From here, the line passed St John's Chapel station before terminating at Wearhead. (LOSA)

FIVE

THE SETTLE & CARLISLE RAILWAY

Perhaps the most famous railway which passes through the Yorkshire Dales, on its way through Westmorland to Carlisle, the Midland Railway's Settle–Carlisle line was built due to difficulties in relations with the London & North Western Railway, who were not happy to share their main line over Shap to the Cumbrian city.

Midland traffic for Carlisle came off the 'Little North Western' Clapham–Ingleton branch of the Settle–Lancaster and Morecambe line and used the LNWR main line over Shap to complete the journey to Carlisle. The MR had been reluctant to build its own line to the Cumbrian city due to potential difficulties in construction, but the LNWR thwarted the Derby company's efforts to come to an agreement for use of their main line. Thus, in 1866, the MR embarked on construction of the Settle–Carlisle line (which would offer a third alternative route to Scotland), which was to become the most imposing of all British trunk routes, with its long severe gradients, nineteen viaducts, 34 miles of tunnels, and its wild settings high among the moors and mountains of Yorkshire and Westmorland. After completion, in the spring of 1876, the MR could open its own through service from London to Scotland in conjunction with the Glasgow & South Western Railway and the North British Railway, the latter creating the now-defunct Waverley route which gave access to Edinburgh, along with Glasgow, to the Anglo-Scottish newcomer.

The Settle–Carlisle line climbs from around 450 feet above sea level to over 1,000 feet and its construction was extremely difficult. Indeed, such were the problems with the building of the line that the MR actually requested parliamentary permission to abandon the project, but that request was refused. Construction of the line was also dangerous and cost the lives of many 'navvies' who built it, and a plaque (one of two) commemorating those who sacrificed their lives is situated in Settle church which, itself, was less than thirty years old when building of the Settle–Carlisle line was commenced, and was paid for jointly by the contractors and the Midland Railway.

With opening of the new line, the route being longer than those of the Derby company's rivals, the MR set up new standards of passenger comfort to compensate for longer journey times. When MR Anglo-Scottish expresses began operating from 1 May 1876, Pullman drawing room cars were available for day travel and Pullman sleeping cars were run on night services. By this time, the MR had abolished second-class travel, reclassifying second-class coaches as thirds and, from then on, all third-class coaches were built to second-class standards. On MR Anglo-Scottish expresses, ordinary first- and third-class passengers travelled in comfortable compartment coaches, carried on four- or six-wheeled bogies while other companies were still using rigid six-wheeled stock. In the longer term, passengers preferred the comfort of MR coaches rather than the Pullman cars. Other railway companies were forced to follow MR's coach-building policy or lose customers to the Derby company, especially on the lucrative Scottish traffic.

By the late 1960s, British Railways abandoned the Settle–Carlisle line as a major through route, which ended the career of the famous 'Thames–Clyde Expresses', although the line remained as a useful by-pass route for several years. Had BR had their way, however, the line would have been closed in the 1980s after the Ribblehead Viaduct, with its magnificent views of Whernside, was allowed to fall into disrepair, but the line survives and today plays host to popular steam excursions.

Opposite: A map of the southern section of the Settle–Carlisle line with its junctions at Settle itself, the line from Leeds, via Hellifield, lies south, while the 'Little North Western' is seen branching off to the left as it heads towards Clapham and Ingleton before joining the LNWR for access to Carlisle via Kirkby Lonsdale and Shap. At Garsdale, originally known as Hawes Junction, the NER line joins from Northallerton, over joint tracks from Hawes. Further north is the NER line from Barnard Castle which crosses the Settle–Carlisle line north of Kirkby Stephen as it heads towards Tebay, and again between Appleby and Long Marton, for Penrith. (Author)

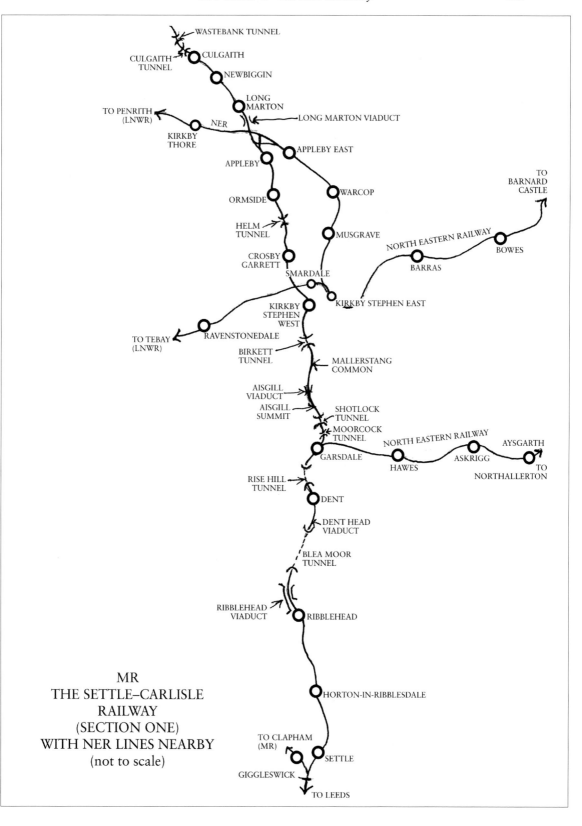

WASTEBANK TUNNEL

CULGAITH TUNNEL CULGAITH

NEWBIGGIN

LONG MARTON

TO PENRITH (LNWR)

NER

LONG MARTON VIADUCT

KIRKBY THORE

APPLEBY EAST

APPLEBY

WARCOP

ORMSIDE

TO BARNARD CASTLE

HELM TUNNEL

MUSGRAVE

NORTH EASTERN RAILWAY

BOWES

CROSBY GARRETT

SMARDALE

BARRAS

KIRKBY STEPHEN EAST

KIRKBY STEPHEN WEST

TO TEBAY (LNWR)

RAVENSTONEDALE

BIRKETT TUNNEL

MALLERSTANG COMMON

AISGILL VIADUCT

AISGILL SUMMIT

SHOTLOCK TUNNEL

MOORCOCK TUNNEL

GARSDALE

NORTH EASTERN RAILWAY

AYSGARTH

HAWES ASKRIGG

TO NORTHALLERTON

RISE HILL TUNNEL

DENT

DENT HEAD VIADUCT

BLEA MOOR TUNNEL

RIBBLEHEAD VIADUCT

RIBBLEHEAD

MR
THE SETTLE–CARLISLE RAILWAY
(SECTION ONE)
WITH NER LINES NEARBY
(not to scale)

HORTON-IN-RIBBLESDALE

TO CLAPHAM (MR)

SETTLE

GIGGLESWICK

TO LEEDS

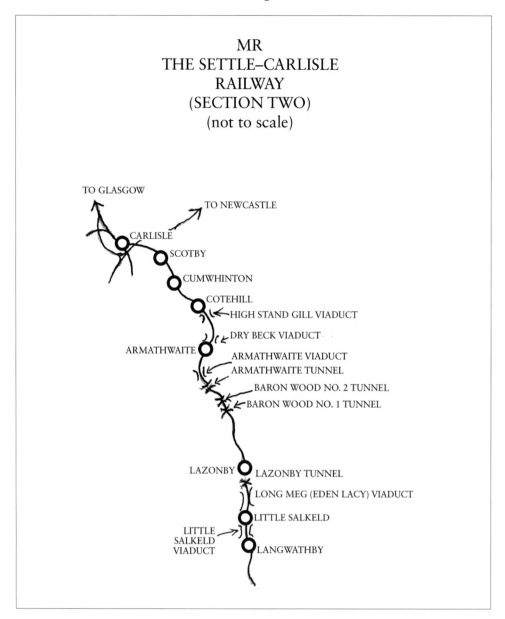

MR
THE SETTLE–CARLISLE RAILWAY
(SECTION TWO)
(not to scale)

TO GLASGOW

TO NEWCASTLE

CARLISLE

SCOTBY

CUMWHINTON

COTEHILL

HIGH STAND GILL VIADUCT

DRY BECK VIADUCT

ARMATHWAITE

ARMATHWAITE VIADUCT

ARMATHWAITE TUNNEL

BARON WOOD NO. 2 TUNNEL

BARON WOOD NO. 1 TUNNEL

LAZONBY

LAZONBY TUNNEL

LONG MEG (EDEN LACY) VIADUCT

LITTLE SALKELD

LITTLE SALKELD VIADUCT

LANGWATHBY

The northern section of the Settle–Carlisle line to Carlisle itself, where it will meet the LNWR's West Coast Main Line from Euston to gain access to the Cumbrian city and will connect with Scottish services to Glasgow and Edinburgh. (Author)

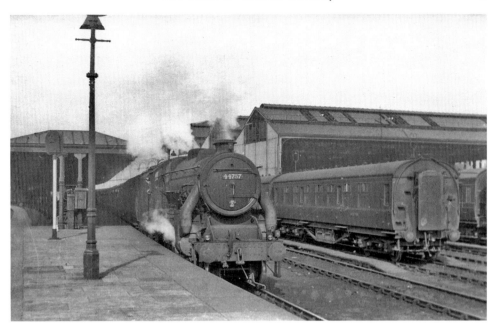

Departing from Leeds City station with its train for Carlisle is ex-LMS Caprotti valve-geared 'Blacks' 4-6-0 No. 44757 on 26 June 1954. (H. Casserley)

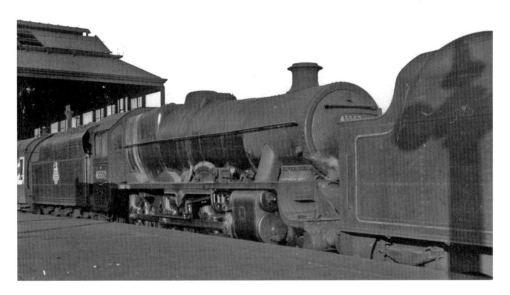

On 1 June 1957, ex-LMS 'Jubilee' 4-6-0 No. 45552 *Silver Jubilee*, doyen of the class, double-heading with an unknown 4-6-0, waits to leave Leeds with a Carlisle train. (H. Casserley)

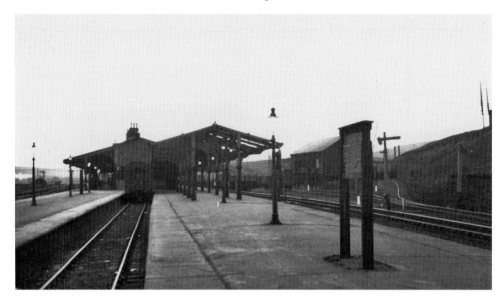

Before approaching the Settle–Carlisle line, trains from Leeds entered the junction station at Hellifield where trains from Lancashire met those from Leeds. The station is seen here in April 1953 with the locoshed in the background. This four-road shed had an allocation of twenty-three engines in 1950, reducing to fifteen in 1959 and was coded 20G at nationalisation, recoded 23B in 1950, reverted to 20G in 1951. After closure in 1963, the shed was used to store historic engines and an unusual feature of the shed was the wooden coaling stage, seen in this view, which was still in use in 1961. (H. Casserley)

In January 1954, the shed was allocated some eighteen locos for local passenger and freight use, some of which operated local services over the Settle–Carlisle line. The allocation was as follows:

Ex-LMS Stanier 2-6-2T	40162, 40163, 40183, 40184
Ex-LMS Fowler 2P 4-4-0	40632
Ex-LMS Ivatt 2-6-2T	41205, 41206
Ex-LMS Hughes-Fowler Crab 2-6-0	42770, 42784
Ex-MR Johnson 3F 0-6-0	43585, 43586
Ex-LMS 4F 0-6-0	44149, 44245, 44276, 44282, 44579
Ex-LMS Stanier 8F 2-8-0	48105, 48616

The locoshed at Hellifield as it appeared on 1 June 1963. (R. Carpenter)

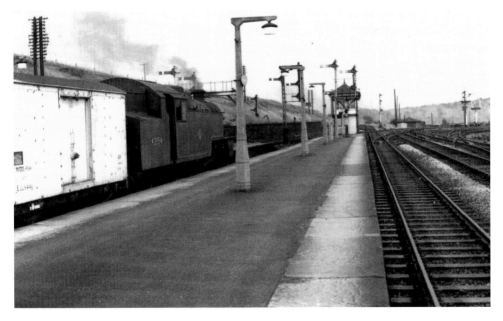

Ex-LMS Fairburn 2-6-4T is at the head of a train for Blackburn at Hellifield station in June 1962. (R. Carpenter)

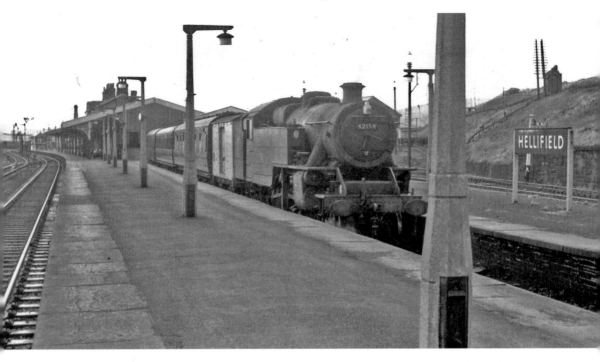

Another view of the same train at Hellifield station in 1962; the engine was allocated to Lower Darwen shed, Lancashire, at this time. (R. Carpenter)

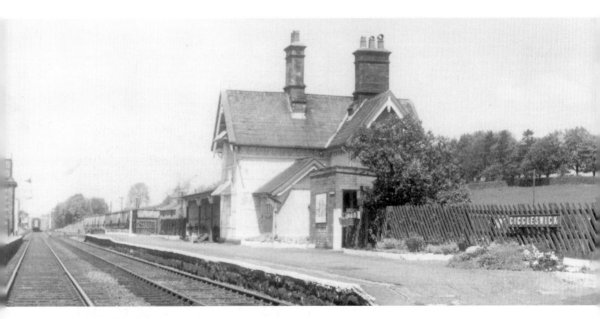

Just beyond the start of the 'Little North Western' line to Clapham and Ingleton stands the station at Giggleswick, the town being the home of a famous Yorkshire public school. The station is seen here on 1 June 1963 looking towards Lancaster; its main building is on the right and the water tower is just visible on the left. In the distance a train for Lancaster has just departed. (H. Casserley)

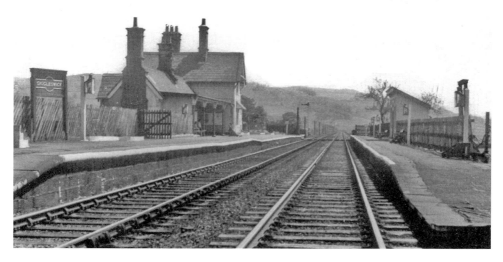

Giggleswick station facing Hellifield as it appeared on 1 June 1963. (H. Casserley)

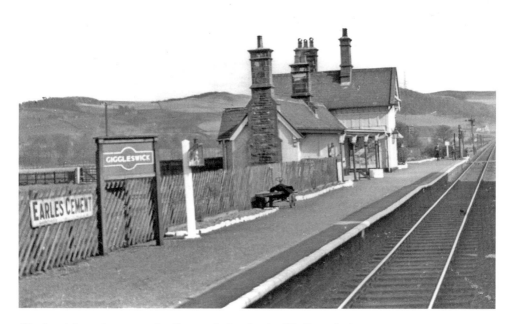

Giggleswick station on 22 April 1954 facing Leeds. (H. Casserley)

ELLIFIELD, SETTLE, KIRKBY STEPHEN, APPLEBY, LAZONBY, and CARLISLE.—Midland.

Week Days.

Down. St. Pancras,	mrn	mrn	ngt.	mrn		mrn		mrn	mrn	aft		mrn	aft	aft		aft	aft	aft		
610 Londondep.	1255	8 h5		5 0	9 30		1130		1 30	3 30			
610 Leeds (Wellington). "	6 38	8 35			10 0	10 0	1 33		3 32	3 38		5 37	7 55			
610 Bradford(MrktSt.) "	6 15	8 35			9 35	9 35	c1253	1228 y		3 12	3 42		5r15	8 20			
610 Skipton "	7 20	9 32			1038	1115	1 19		3 50	4 40		5 33	9 30			
742 Liverpool (Exch.). "	2 30	6 0			9 25	9 25	1235		2 20g		4 35	5 50			
766 Manchester (Vic.). "	5 35	6 10			9 32	9 32	1230		2 25g		4 35	6 55			
766 Blackburn "	6 32	8 13			1024	1024	1 29		3 20	3 28		5 32	7 43			
	mrn	mrn	mrn	mrn		mrn		mrn	aft	aft		aft	aft	aft		aft	aft	aft		
Hellifielddep.	7 30	8 0	10 0			11 4		1141	2 24	2 29		4 24	4 32			5 5		6 27	6 38	9 52
Long Preston	7 34	8 3	10 3					1144		2 32					5 8		6 41	9 55		
Settle	7 42	8 12	1010					1154		2 40					5 16		6-49	10 3		
Horton	8 24	1020					12 8		2 52					5 28		7 0	1016		
Ribblehead	8 35	1029					1219		a					5 39					
Dent [717	8 47	1040					1231		a					5 51					
Hawes Junc. and Garsdale §	8 54	1046					d1250		3 11					5 58					
Kirkby Stephen ** 703	9 9	11 0					1 6							6 14					
Crosby Garrett	9 15	11 6					1 12							6 20					
Ormside	9 23	1115					1 20							6 28					
Appleby †† 703	7 45	9 30	1120			12 6		1 27							6 35					
Long Marton	7 51	9 36	1125					1 34				5 33	5 40	6 35						
New Biggin	7 57	9 42	1131					1 40				5 46	6 41							
Culgaith :	8 1	9 46	1134					1 44				5 52	6 47							
Langwathby	8 8	9 53	1140					1 52				5 56	6 51							
Little Salkeld	8 12	9 57	1144					1 56				6 3	6 58							
Lazonby and Kirkoswald .	8 19	10 3	1150				d	2 3				6 7	7 2							
Armathwaite	8 30	1013	12 0				d	2 14				6 13	7 8							
Cotehill...............	8 36	1019	12 6					2 20				6 23	7 18							
Cumwhinton	8 43	1026	1214					2 27				6 36	7 31							
Scotby...[818, 830, 848,	8 47	1030	1219					2 31				6 39	7 34							
Carlisle * 513, 697, 798, arr	8 53	1035	1225			1240		2 37		3 50		5 50	6 6	6 45	7 40		7 53			
830 Glasgow (St. E.) .. arr.	1 25					3 20				6 35		8 25						1020		
798 Edinbro' (Wav.) .. "					3 55				6 10				8 48				1025		
798 Perth † "					6 26				7 51				1036						
798 Inverness "													5g10						
798 Aberdeen ‡ "					8 50				10 5										

Week Days—Continued.

Down. St. Pancras,	aft		aft	aft	ngt			aft		aft	aft	ngt		NOTES.
0 Londondep.	8 15		9 30	9 30	12 0			8 15		9 30	9 30	12 0		
0 Leeds (Wellington). "	1238		1 50	2 0	4 8			1238		1 50	2 0	4 8		
0 Bradford(MrktSt.) "	1045c		1 15	1 15	2 c 5			10½c		1 15	1 15	2 c 5		
0 Skipton "		1 51	1 51					2 20	2x20			
2 Liverpool (Exch.).. "		1245	1245					1245	1245			
6 Manchester (Vic.) "		1250	1250					1 44	1 44			
6 Blackburn "		1 44	1 44									
	mrn		mrn	mrn				mrn		mrn	mrn	mrn		
Hellifielddep.		2 42	2 52					2 42	2 52			
Long Preston														
Settle														
Horton														
Ribblehead														
Dent [717														
Hawes Junc. and Garsdale §														
Kirkby Stephen ** 703														
Crosby Garrett														
Ormside														
Appleby †† 703														
Long Marton														
New Biggin														
Culgaith														
Langwathby														
Little Salkeld														
Lazonby and Kirkoswald ..														
Armathwaite														
Cotehill...............														
Cumwhinton														
Scotby...[818, 830, 848,	2 50		4 15	4 30	6 25			2 50		4 15	4 30	6 25		
Carlisle * 513, 697, 798, arr	6 10		7q5	9 0			6 10		7 5	9 0		
0 Glasgow (St. E.) .. arr.		6 50		12q6			12 6			
8 Edinbro' (Wav.) .. "		9x10		3q32 p				9 10	3 32			
8 Perth † "		1 50		8g 0				1 50	8 0			
8 Inverness "		1132		6g 10				1132	6 10			
8 Aberdeen ‡ "														

Sundays.

(Sunday nights and Monday mornings.)

NOTES.

a Stops when required to set down.
b Leaves at 12 night on Sundays.
c Via Leeds.
d Stops to set down from Clitheroe and beyond; also from Skipton and South thereof when required.
e Arrives at 12 37 aft.
g Thro' Carriages to Edinburgh and Glasgow.
g Except Sundays.
h Leaves at 9 mrn. on Mondays.
k Calls at Salford on Tuesdays to take up for North of Hellifield.
n Stops when required to set down from Hellifield and beyond, including the L. & Y. Line.

* Citadel Station.
† General Station, via Forth Bridge.
‡ Via Forth and Tay Bridges.
§ Station for Hawes.
** Kirkby Stephen & Ravenstonedale; about 1 mile to North Eastern Sta.
†† About ½ mile to North Eastern Sta.

: Arrives at 8 55 mrn. on Sundays. Fridays only, if required, for Passengers from Hellifield and beyond.
: Arrives at 3 17 aft. on Saturdays.
: Arrives at 7 43 mrn. on Sundays.

r Leaves at 4 55 aft. on Saturdays.
s Leaves at 1 5 aft. on Saturdays.
x Departs at 2 30 mrn. for G. & S. W. Line only.
y Leaves at 12 25 aft. on Saturdays.

A timetable of 1910 showing trains which operated between Hellifield and Carlisle, via the Settle–Carlisle line. (Author's collection)

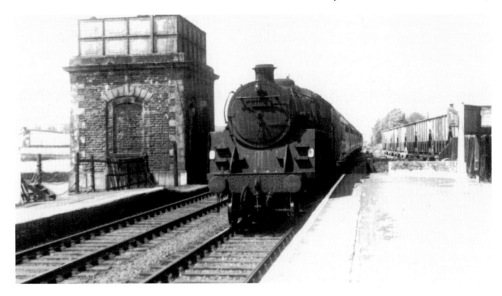

Entering Giggleswick station on 1 June 1963 is BR Standard Class 5 4-6-0 at the head of the 12.30 p.m. train from Morecambe to Leeds. The station's water tower is clearly visible on the left and a rake of wagons used for the transporting of stone are in the sidings. (H. Casserley)

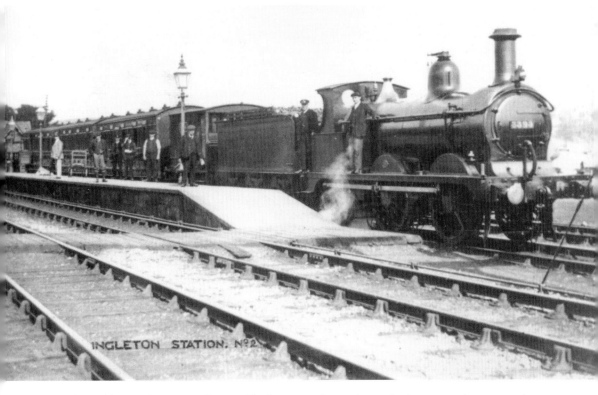

On the 'Little North Western' line to Clapham was the station at Ingleton, seen here around 1910 with a typical MR local train with what appears to be a Johnson 0-6-0 No. 3393 at the head. (R. Carpenter)

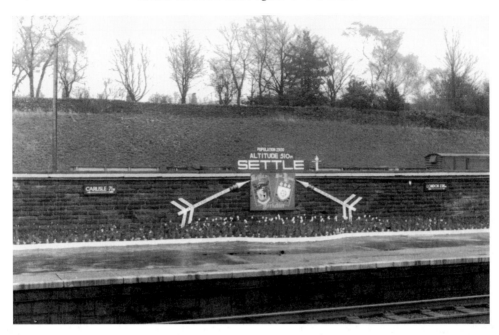

Considered to be the start of the Settle–Carlisle line, Settle station, seen here on 7 May 1965, has not altered much over the years, although its sidings have been removed. Below the station sign are the coats of arms for the town of Settle and of the County of Yorkshire. The sign above the station name shows that it lies 510 metres above sea level and the town had a population of 2,300. From here, Carlisle is 71 miles north and London is 235 miles south. (H. Casserley)

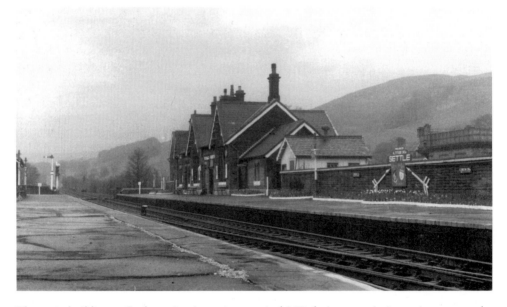

The main building at Settle station in 1965, a typical MR design, seen in its setting among the hills around the Ribble Valley, the line running through it for around 13 miles and passing through soft pasture and woodland at the start of the line from Settle Junction to treeless land at Batty Moss. The view here is looking towards Carlisle. (H. Casserley)

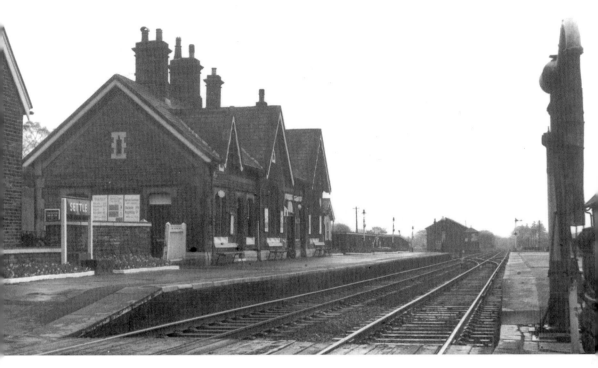

Settle station looking in the opposite direction, showing the goods shed and sidings. (H. Casserley)

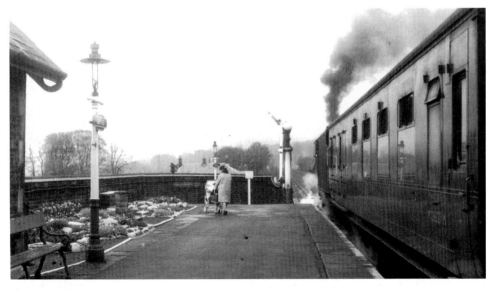

Ex-LMS Black Five No. 45236 is departing from Settle station with a train for Carlisle on 7 May 1965. From here, the line will cross Settle Viaduct as the line begins its climb from around 450 feet at Settle Junction to 1,000 feet at its peak and the nature of the country changes as Great Scar Limestone mixes with local grassland, creating an environment suitable for sheep farming rather than for arable use. (H. Casserley)

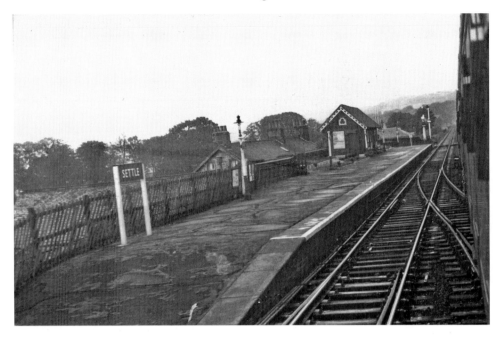

The Down platform at Settle station as it appeared on 13 June 1964. (H. Casserley)

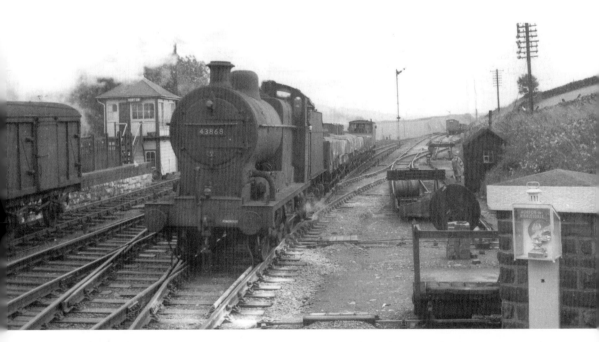

A freight train, headed by ex-MR 3F 0-6-0, passes through Horton-in-Ribblesdale in the 1950s. From Settle, the line will have crossed Kirkgate Viaduct, Marshfield Viaduct and Taitlands Tunnel as the line crosses the River Ribble with Fountain's Fell (668 feet) in the background. The line crosses the Ribble again on the approach to Horton-in-Ribblesdale, crossing Sheriff Brow Bridge and Helwith Bridge. The famous Pen-y-Ghent Fell, at 694 feet, is visible on the right. The station itself was closed in the 1960s. (LOSA)

RIBBLEHEAD. M.R.

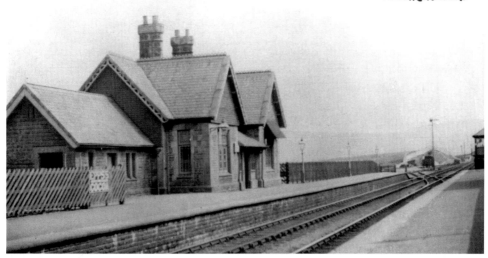

After leaving Horton-in-Ribblesdale, the line follows the Ribble all the way to Ribblehead station, passing Ingleborough Fell (723 feet), Simon Fell (636 feet) and Park Fell (563 feet), these mountains being visible on the left. The station at Ribblehead is seen here in Midland Railway days with the sidings in view under the brooding fells in the distance. (LOSA)

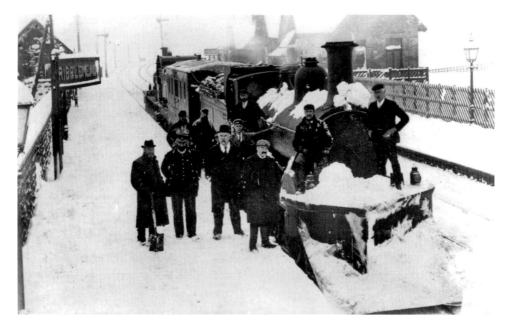

Situated in the high mountains, the railway was often affected by bad winter weather, drifting snow often being a problem, and snowploughs were needed to clear snow from the railway. Such a situation is visible here at Ribblehead station early in the twentieth century, where a Midland engine is at the head of a snow-clearing train with its large snowplough at the front; a coach for support staff is situated before another loco at the back. The section beyond the station appears to have been cleared of snow and the crew are taking a break before carrying on. (LOSA)

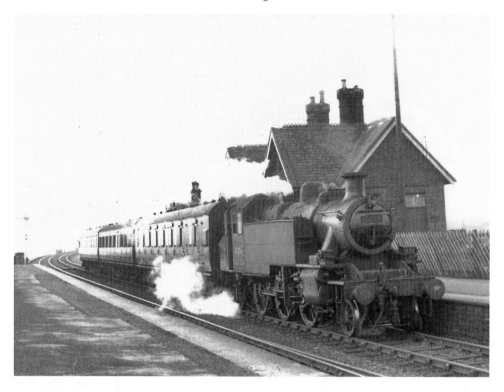

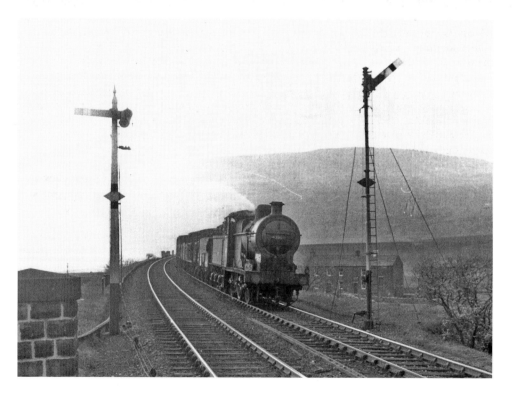

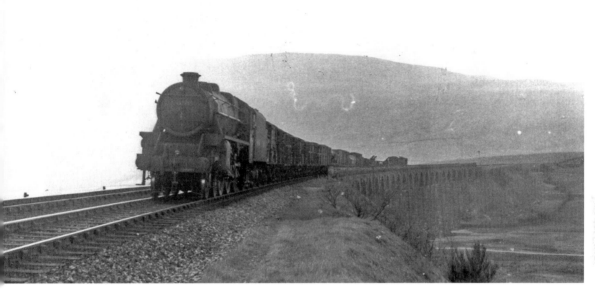

Above: On the same day, ex-LMS Black Five 4-6-0 No. 44795 is just leaving Ribblehead Viaduct with a southbound freight. The Ribblehead Viaduct is, perhaps, the most famous structure on the whole of the line and was built between October 1870 and October 1874. Its red brick-lined limestone viaduct stands 105 feet high and has twenty-four arches. Neglect by British Rail in the 1980s to try and bring about closure of the Settle–Carlisle line forced reduction from two tracks to one as the viaduct began to suffer, although the structure is 'listed', along with many others on the line, and cost of maintenance was becoming prohibitive. However, closure was refused and the Ribblehead Viaduct was brought back up to a good standard. However, the line across the viaduct is still single. (H. Casserley)

Opposite above: Waiting at Ribblehead station on 30 May 1951 is ex-LMS 2-6-2T No. 41206 with the 4.25 p.m. train from Hawes to Hellifield. This is one of the two Ivatt engines allocated to Hellifield locoshed at this time. (H. Casserley)

Opposite below: Approaching Ribblehead station after leaving Ribblehead Viaduct, visible in the background, on 30 May 1951 is ex-LMS 4F 0-6-0 No. 43999 with a southbound freight train. (H. Casserley)

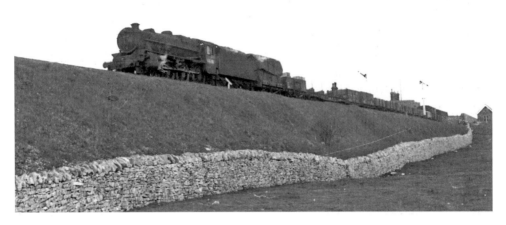

Another freight train, headed by ex-LMS Black Five 4-6-0 No. 44790, is approaching Ribblehead station on 30 May 1951, heading north for Carlisle. (H. Casserley)

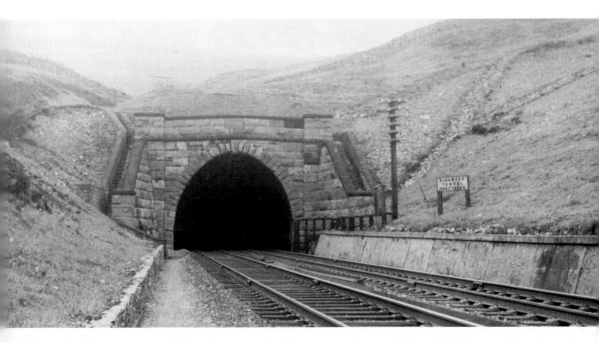

After crossing Ribblehead Viaduct, the line passes close to Whernside before entering Blea Moor Tunnel, the north end of which is seen here on 30 May 1951. The line is now in mountain country, rising to its peak of 1,050 feet, and the tunnel is some 500 feet long under the moor. (H. Casserley)

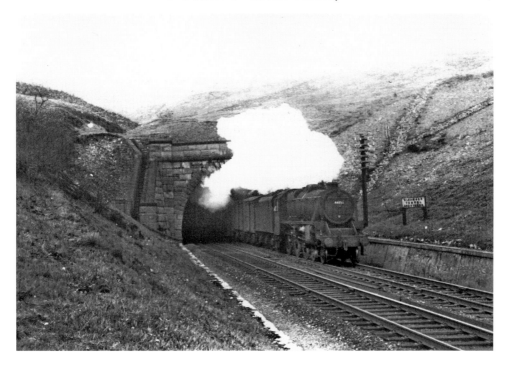

Leaving Blea Moor Tunnel on 30 May 1951 is ex-LMS Black Five 4-6-0 No. 44856 at the head of a northbound fitted freight train. (H. Casserley)

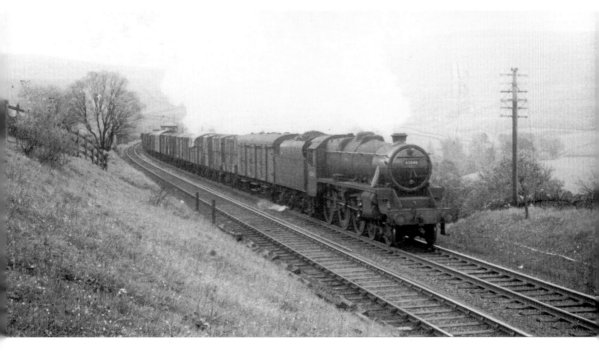

Another Black Five 4-6-0, No. 45050, heads another fitted freight north after leaving Blea Moor Tunnel and is running through some very attractive country some 200 feet above the young River Dee, which itself is some 80 feet above sea level, at Dent Dale. (H. Casserley)

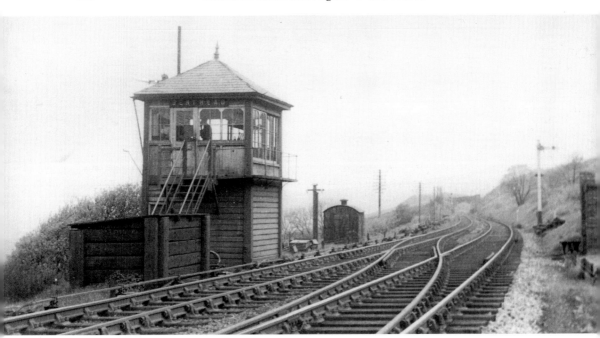

A typical Midland signal box at Dent Head in 1951; this view is looking north towards Dent station and Dent Viaduct. (H. Casserley)

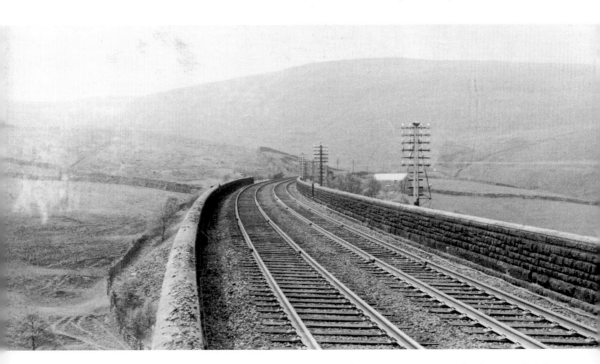

Approaching Dent station is Dent Head Viaduct, seen here on 30 May 1951 looking south. The viaduct was built of blue limestone and is some 100 feet high and 1,150 feet above sea level. Blea Moor can be seen in the background. (H. Casserley)

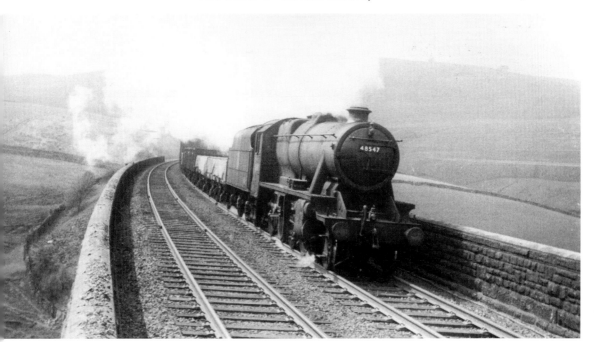

On 30 May 1951, ex-LMS 8F 2-8-0 No. 48547 heads a freight train across Dent Head Viaduct heading north. (H. Casserley)

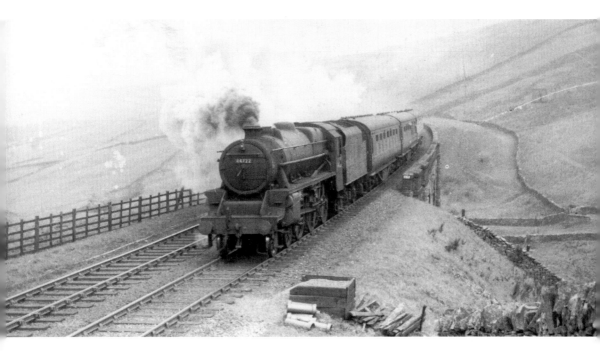

Crossing Dent Head Viaduct on the same day is yet another Black Five 4-6-0, No. 44722, at the head of the 10.23 a.m. Carlisle–Hellifield train. (H. Casserley)

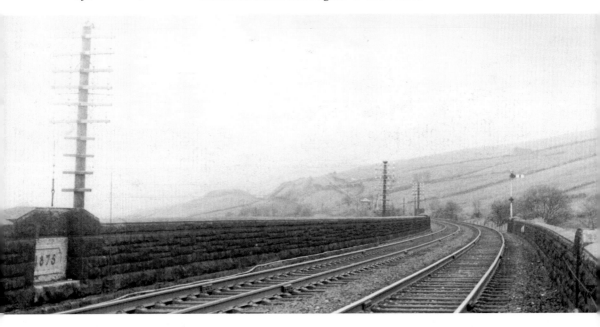

Another view of Dent Head Viaduct, facing north, on 30 May 1951. (H. Casserley)

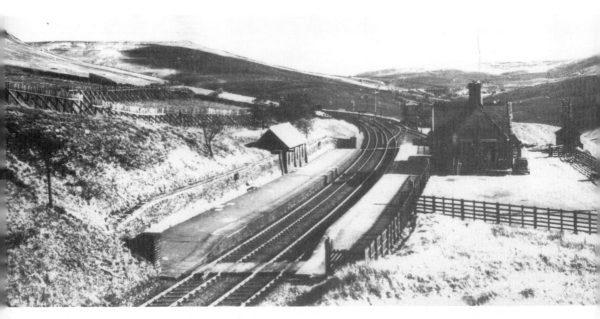

Shortly after leaving Dent Head Viaduct and heading north, the line enters Dent station, seen in this snowy view at the end of the nineteenth century. Dent itself was originally a small village and was settled by Norsemen in the tenth century, but was largely ignored by other invaders. Dent also escaped the attention of the Normans, their castle being at Sedburgh. Development of turnpike roads between Kirkby Stephen and Greta Bridge, along with one from Askrigg to Kendal, led to a further decline of Dent, so much so that when the Settle–Carlisle line was built, the MR built Dent station around 4 miles and 700 feet above the town. (LOSA)

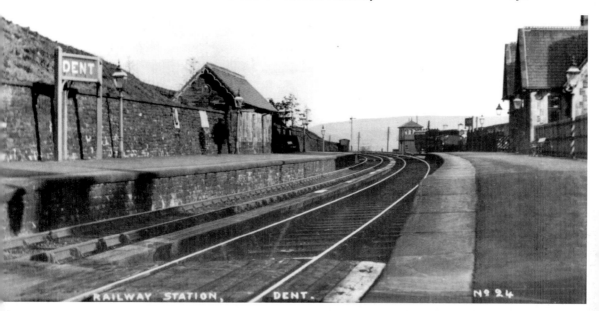

The station at Dent in Midland Railway days, showing the main station building and the waiting shelter on the opposite platform, all built of local stone, with the MR signal box in the distance. (LOSA)

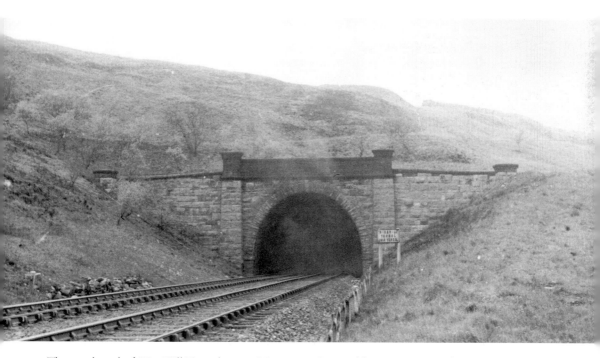

The south end of Rise Hill Tunnel on 30 May 1951. Situated between Dent and Garsdale, the tunnel is 110 feet above sea level, the line emerging on a ledge south of Garsdale station, some 300 feet above the River Clough, which runs across the A684, the old Askrigg–Kendal turnpike road. (H. Casserley)

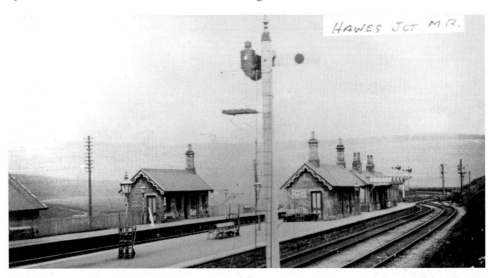

Hawes Junction station, later renamed Hawes Junction & Garsdale and Garsdale for Hawes, before becoming just Garsdale. Garsdale became the junction with the Hawes branch which was opened in October 1878 and closed in 1959. The station is seen here just after opening and was the scene of a major accident on 24 December 1910. At that time, the MR, like many of the railway companies, were reluctant to spend money on safety equipment, despite such devices having been invented. Many railways had adopted some simple safety devices, an example being mechanical collars that signalmen were required to place on signal levers as a back-up system to prevent improper clearance of signals. The MR did not adopt such a device as they placed the onus on its employees to maintain a safe railway; in other words, the MR put profit above safety, and this policy would haunt them following this accident.

The immediate cause of the accident was that the signalman forgot that he had moved two light engines to the Down line which were waiting there to proceed to Carlisle. He later improperly cleared the Down line signals without checking that the line was clear. The two light engines set off when the signal went to 'clear' for the Scotch Express and into the same block section. The light engines were travelling at low speed from a stand at Hawes Junction and the following express was running at high speed and a collision was inevitable. The express caught up with the light engines just after Moorcock Tunnel, not far north of the station, near Ais Gill summit in Mallerstang, and was totally derailed. The wooden coaches telescoped together and ruptured gas pipes which supplied the lighting in the carriages, the gas being ignited by coal from the locomotive's firebox, causing a massive fire which could be seen for miles around and caused the deaths of twelve people, some of whom were trapped in the wreckage and burned to death. When the signalman became aware that he had allowed the two trains to pass he telephoned Ais Gill box to ascertain whether the two light engines had passed. When the signalman at Ais Gill informed him that they had not, he told his relief signalman to inform the stationmaster that he had wrecked the Scotch Express. There were errors on both sides; the signalman should have checked that the Down line was clear and the engine driver should have whistled that the engines were there. The driver did say that he had whistled, but it was likely that stormy weather prevented the signalman from hearing this whistle. As the engines had been stationary for some twenty minutes, the fireman should have gone to the signal box to inform the signalman that he was there. The situation was not helped due to MR policy of using small engines, many trains having to be double-headed, causing a lot of train movements at places like Hawes Junction, where engines were often turned before returning to Carlisle, pilot engines often being used for the climb to Ais Gill summit. The Railway Inspectorate advised that track circuiting, which had been invented in the 1870s, would have prevented this accident and the MR rapidly installed it here and at 900 other locations on the network in an effort to prevent such a catastrophe happening again. (LOSA)

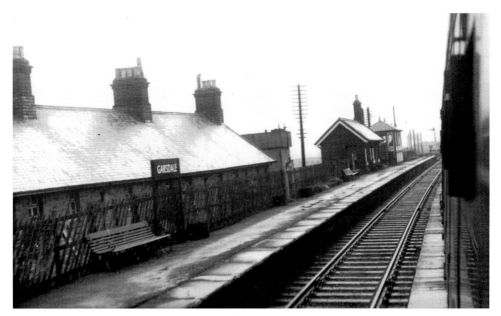

Garsdale station looking towards Carlisle as it appeared on 13 June 1963. The small waiting room is situated on the platform, with the goods shed and water tower behind the fence. (H. Casserley)

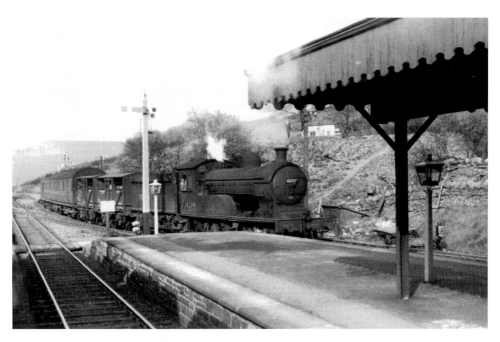

Ex-NER and LNER Class D20 4-4-0 is seen entering Garsdale station at the head of a local train, made up of two cattle trucks and a single coach, which has come from Northallerton and along the Wensleydale branch. The loco itself is probably allocated to Northallerton shed. (H. Casserley)

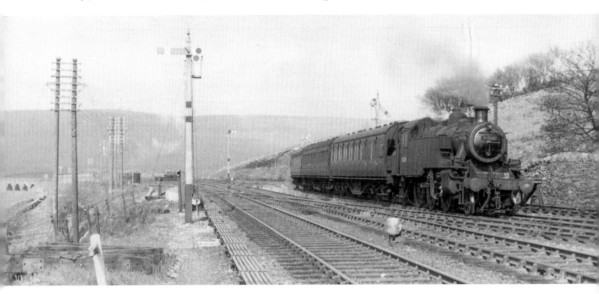

On the same day, 30 May 1951, ex-LMS Ivatt 2-6-2T No. 41206 of Hellifield shed arrives at Garsdale station with the 4.25 p.m. Hawes–Hellifield local service, the train connecting with local services along the Wensleydale branch at Hawes station. (H. Casserley)

Water troughs just outside Garsdale as they appeared in 1951. After such a long climb, water would be low in the tenders of locomotives and they could be refilled here without the need to stop at Garsdale station. After leaving Hawes Junction, the Settle–Carlisle line turns north almost 90 degrees and crosses Dandry Mire Viaduct before heading towards the Eden Valley, cutting through glacial drifts at Moorcock Tunnel and then over Lunds Viaduct, then through to Ais Gill summit. The line in this area passes through some mountainous country, which includes peaks at Wild Boar Fell (708 feet), High Seat (688 feet), and Great Shunner Fell (716 feet) before reaching Ais Gill. The line then passes through Mallerstang Common before entering Birkett Tunnel, thence to Kirkby Stephen West. (H. Casserley)

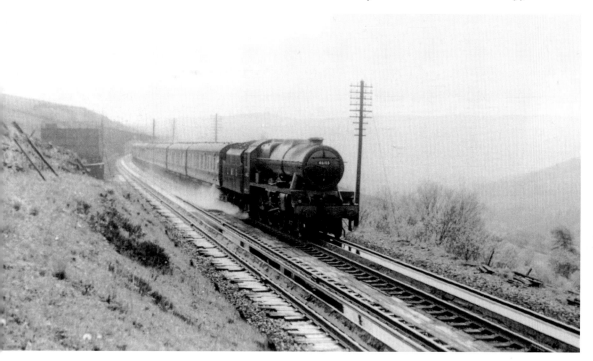

Heading north and over the troughs at Garsdale is rebuilt Stanier Royal Scot Class 4-6-0 No. 46103 *Royal Scots Fusilier*, as yet without smoke deflectors, carrying its new BR number but with the LMS legend on the tender, on the 'Thames–Clyde Express' on 30 May 1951. (H. Casserley)

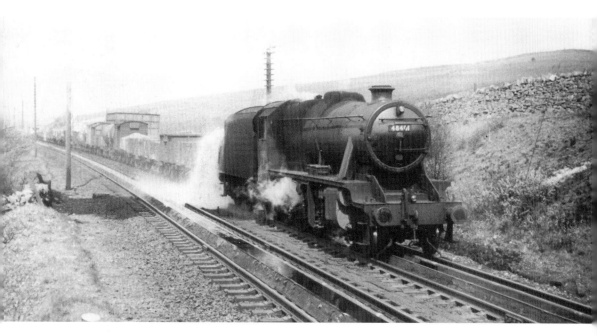

On the same day, ex-LMS Stanier 8F 2-8-0 No. 48401 picks up water on Garsdale troughs as it heads south with a long freight train. (H. Casserley)

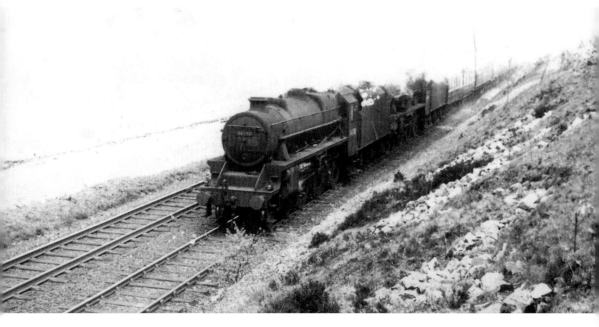

Heading the 10.05 a.m. Edinburgh to St Pancras express through Garsdale on 30 May 1951 is ex-LMS Black Five 4-6-0 No. 44790 piloting ex-LMS Jubilee 4-6-0 No. 45569 *Tasmania*. (H. Casserley)

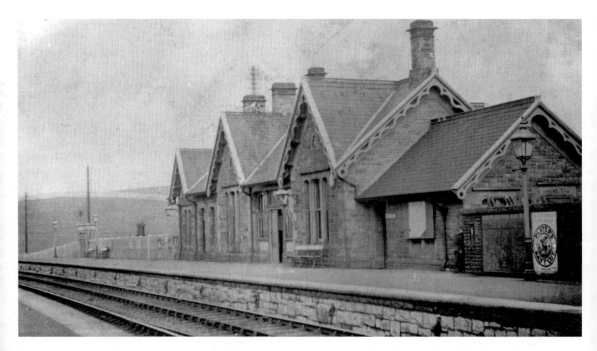

Kirkby Stephen West in Midland Railway days, showing the main building in typical MR style. The station is set at the far-western end of the Eden Valley. From here, the line strikes north, the river disappears and from here the line runs through various earthworks and tunnels. (LOSA)

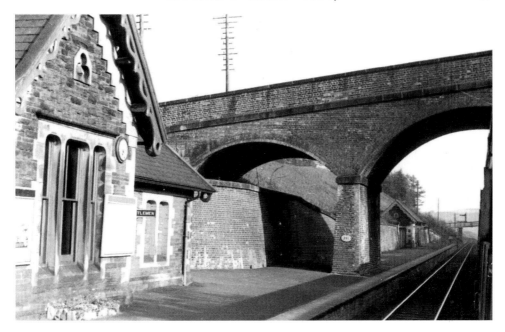

Between Kirkby Stephen West and Crosby Garrett station, seen here in May 1951, looking south, the line crosses Smardale Viaduct, Crosby Garrett Viaduct and Crosby Garrett Tunnel. (H. Casserley)

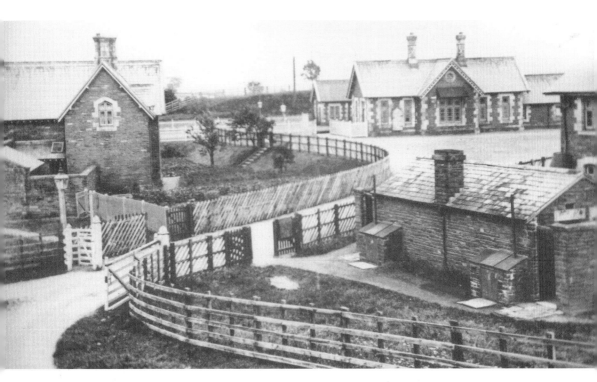

From Crosby Garrett the line then crosses Griseburn Viaduct and Helm Tunnel before entering Ormside station, the exterior of which can be seen here in MR days. (LOSA)

Ormside station looking south with the little waiting room in view on the Up platform. (H. Casserley)

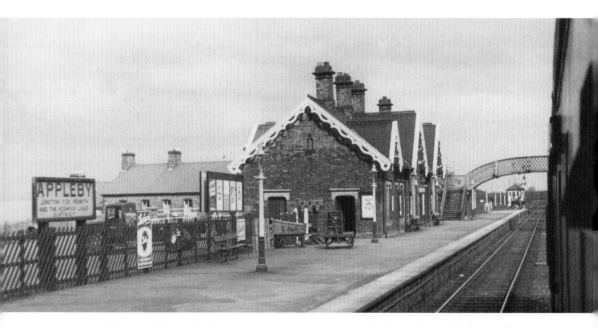

On leaving Ormside station, the line heads north and crosses Ormside Viaduct before entering Appleby station, seen here, looking north, on 30 May 1951. Appleby was once the county town of Westmoreland and, until local government reorganisation in 1974, laid claim to being the smallest county town, with a history dating back to the Norman Conquest and having had a corporation since 1201. (H. Casserley)

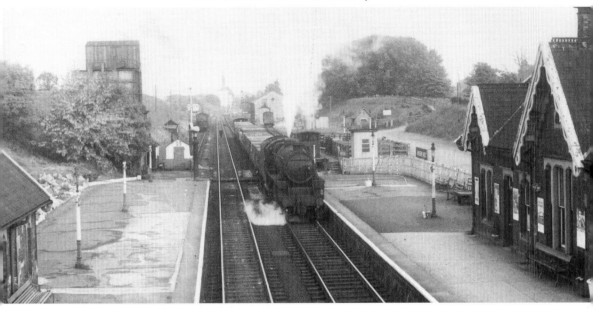

Appleby station on 12 June 1964, with ex-LMS Black Five 4-6-0 No. 44886 at the head of a train for Carlisle. Appleby station was unusual for the line, having been built of brick instead of stone, but still retains its MR style of 'Derby Gothic'. The station itself stands 100 feet above the River Eden and faces the Norman castle which holds the high ground above river's meander. (H. Casserley)

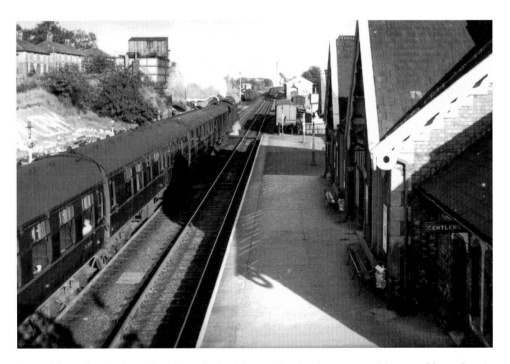

A southbound train is racing through Appleby station in the 1950s with a northbound train approaching. The station name is also seen carved on the embankment on the left. (LOSA)

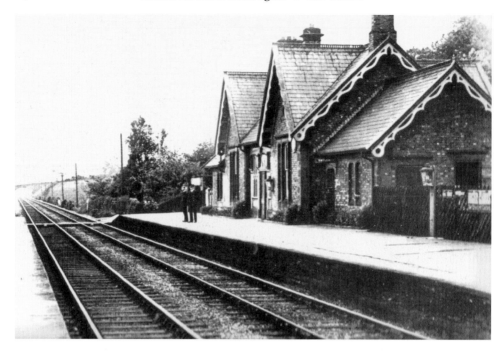

From Appleby, the line passes through the Vale of Eden, which is greener and much softer than the mountain country to the south. The next station north was Long Marton, which closed in 1970. The main MR station building, of local stone, can be seen in this late nineteenth-century view. (LOSA)

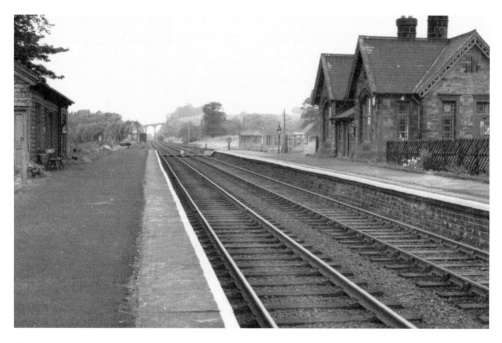

The next station north was at Newbiggin, its main building seen here in this 1950s view. Again, this was one of the 1970 closures. (LOSA)

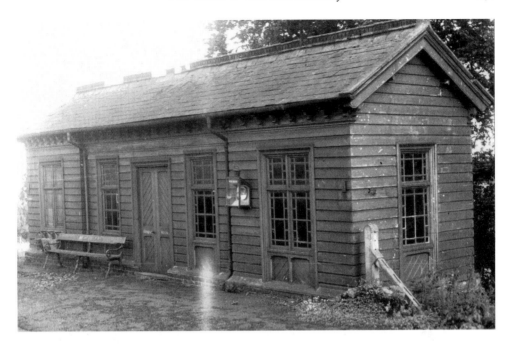

Unusually for the Midland Railway, the waiting room on the southbound platform at Newbiggin station was of timber construction, as can be seen in this view of 12 June 1964. (H. Casserley)

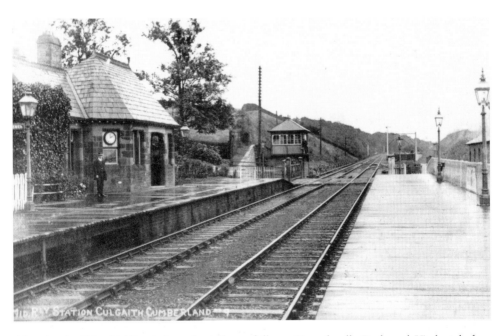

After leaving Newbiggin station, the railway follows Crowdundle Beck and Viaduct before entering Culgaith station. The simple structure, with wooden platforms on the Up side, is seen here at the beginning of the twentieth century. (LOSA)

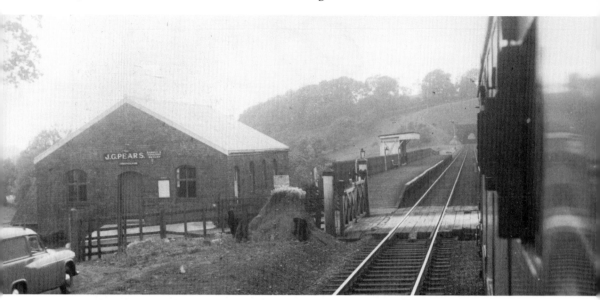

Approaching Culgaith station from the south on 12 June 1964. (H. Casserley)

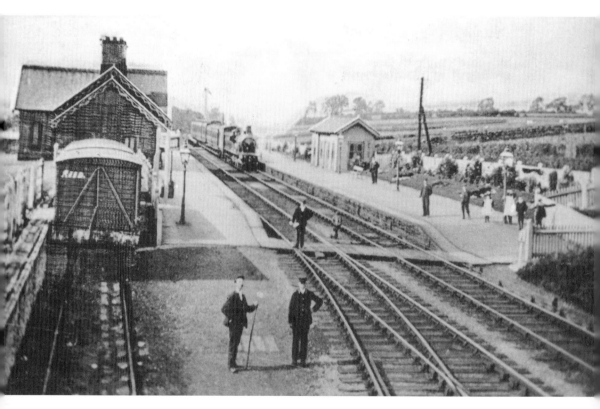

From Culgaith station, the line enters Culgaith Tunnel and Wastebank Tunnel shortly afterwards before entering Langwathby station, seen here in MR days with a local train approaching. Although officially closed, the station was used as part of a Dalesrail scheme in the 1990s. (LOSA)

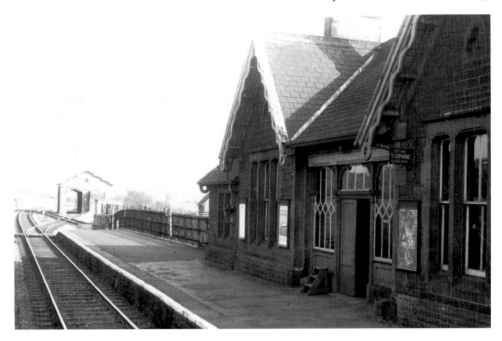

The main station building at Langwathby as it appeared in June 1964. (H. Casserley)

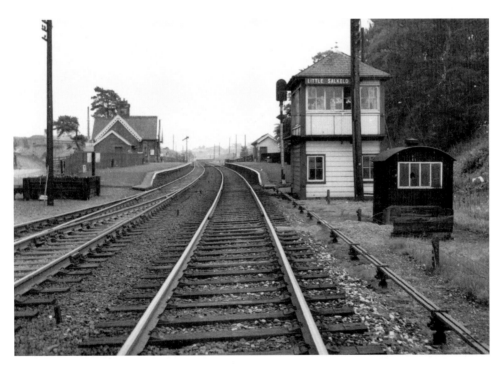

Between Langwathby and Little Salkeld, the line runs over Little Salkeld Viaduct before entering the station. The little station and its signal box, all looking neat and tidy, can be seen in this 1950s view. (LOSA)

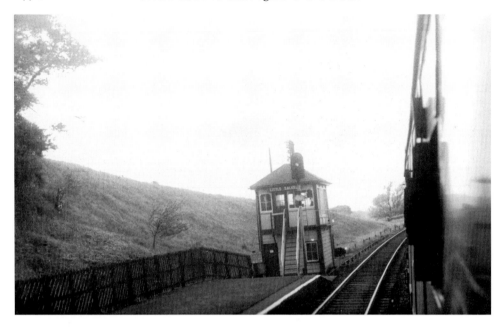

The signal box at Little Salkeld, looking towards Carlisle, in June 1964. The station was one of those closed in 1970. (H. Casserley)

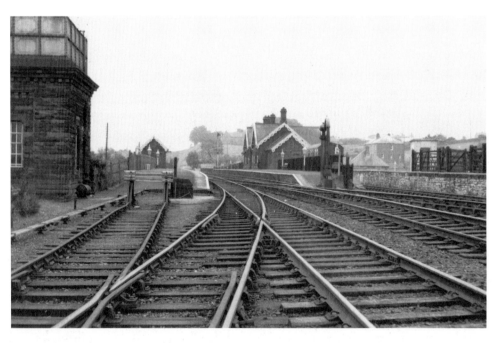

From Little Salkeld, the line crosses the Long Meg (Eden Lacy) Viaduct and then Lazonby Tunnel before arriving at Lazonby station, seen here in this 1950s view. Although the station was closed in 1970, it has been used for Dalesrail services. The station here looks in good condition with its cattle dock (showing the change of character in the area as farming has changed from sheep south of the line to cattle in the more lush north), neat little water tower and main station building. (LOSA)

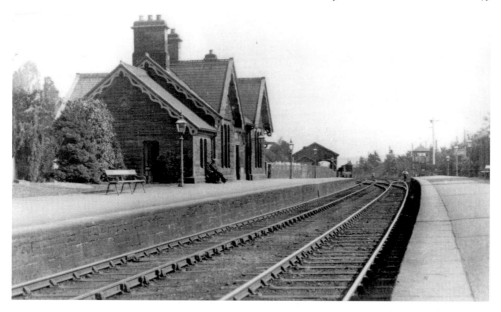

From Lazonby, the railway runs parallel with the River Eden all the way to Cotehill, entering Baron Wood No. 1 and No. 2 tunnels, Armathwaite Viaduct and Tunnel on its way to Armathwaite station, its main building seen here in the 1950s. The station has been used for Dalesrail trains and occasional steam excursions which operate over the Settle–Carlisle line. (LOSA)

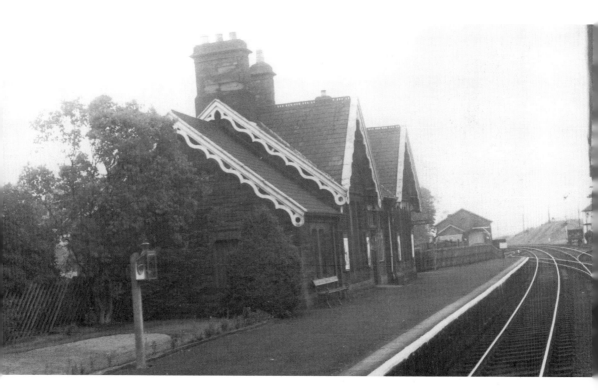

Another view of the main building, on the Down platform, at Armathwaite station in June 1964. (H. Casserley)

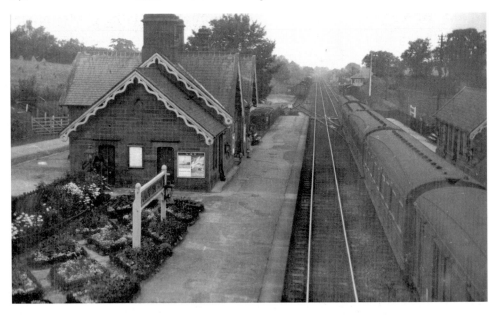

After leaving Armathwaite station, the line crosses Dry Beck Viaduct and High Stand Viaduct before passing through Cotehill station and then on to Cumwhinton station, its main building visible on the left and the small waiting room on the right. (LOSA)

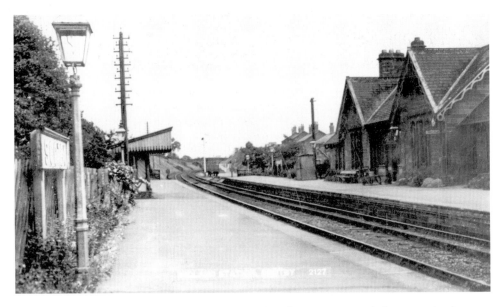

The last station before joining the old NER main line for access to Carlisle was at Scotby, seen here in Midland Railway days. Like several at this northern end of the line, it was closed in 1970. (LOSA)

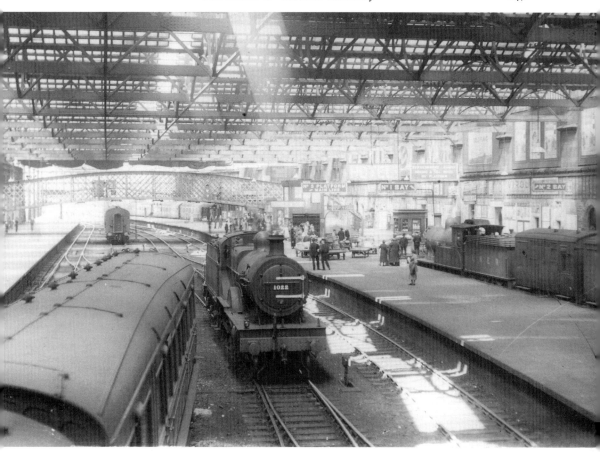

Carlisle station on 14 May 1936, with an ex-MR 4P Compound 4-4-0 No. 1022 in LMS crimson lake livery, probably having just brought in a train from the Settle–Carlisle line. To the right is ex-NER D17 4-4-0 at the buffers. When the red engines of the MR arrived at Carlisle, the station having been extended in 1875/76 to accommodate Settle–Carlisle trains, it added to the colours of engines which appeared regularly at the station. There were mid-green engines of the Glasgow & South Western Railway, the brown/green locos of the North British Railway, the green engines of the Maryport & Carlisle, the green of the North Eastern Railway, the blue of the Caledonian Railway, and the blackberry black of the LNWR. Coaching stock also provided even more colour, from the Midland red, the purple and cream of the LNWR, the brownish red of the Caledonian, and the various reds of the GWSR and NBR and the green and cream of the ancient Maryport & Carlisle Railway coaches. (H. Casserley)

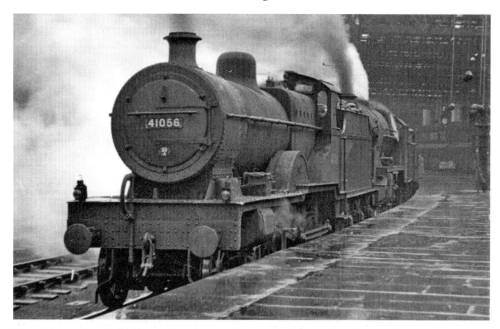

Just about to depart from Carlisle with the up 'Thames–Clyde Express' on 16 April 1953 is ex-MR/LMS 4P Compound 4-4-0 No. 41056 piloting an unidentified rebuilt Royal Scot. Carlisle station was built in 1847 by the Lancaster & Carlisle Railway, which was absorbed into the LNWR in 1859. (H. Casserley)

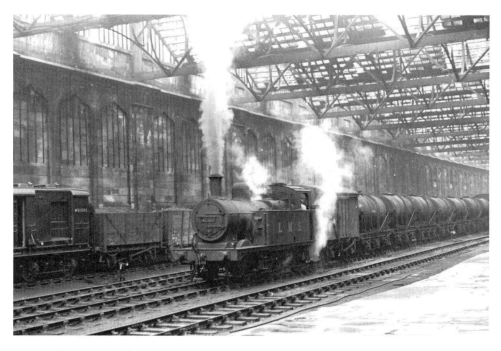

Passing through Carlisle with a train of tank wagons is 0-6-0 Jinty tank loco No. 47326, still retaining its LMS legend on its tank sides, on 27 April 1949. (H. Casserley)

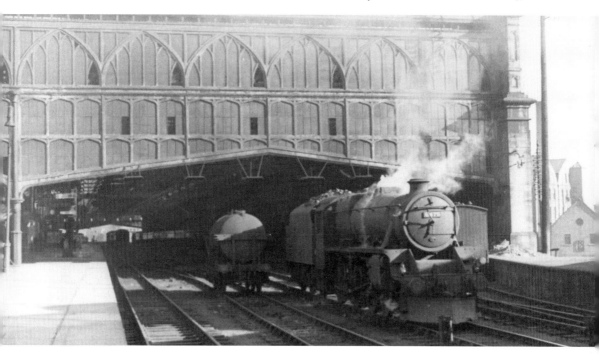

On 8 April 1946, LMS Black Five 4-6-0 No. 5475 awaits its turn of duty at Carlisle station. (H. Casserley)

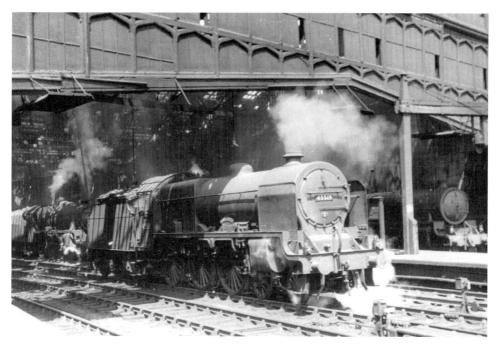

Waiting to take over the 6.25 a.m. Aberdeen–Manchester train at Carlisle on 31 May 1951 is ex-LMS Patriot Class 4-6-0 No. 45519 *Lady Godiva*. (H. Casserley)

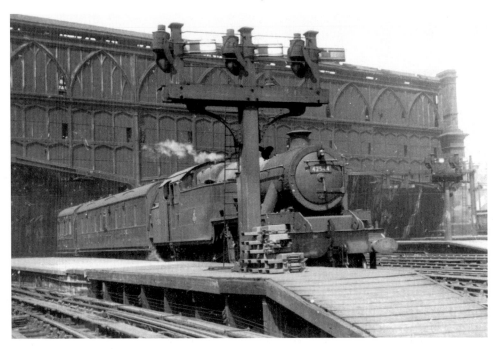

On the same day, ex-LMS Stanier 2-6-4T No. 42544 is about to depart with the 1.25 p.m. from Carlisle to Whitehaven. (H. Casserley)

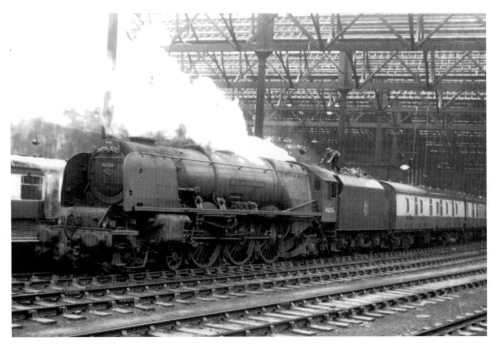

Waiting at Carlisle station on 16 April 1953 with the 10.00 a.m. from Glasgow to Euston is Princess Coronation Pacific No. 46256 *Sir William A Stanier FRS*; the fireman is seen pushing coal forward while awaiting departure. (H. Casserley)

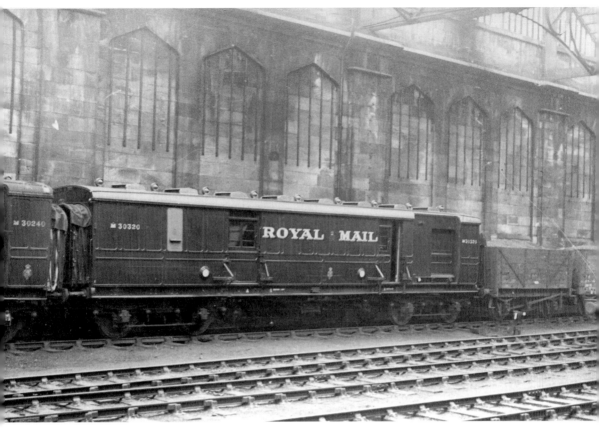

A Royal Mail coach, built at Wolverton in 1900, is standing in the sidings at Carlisle station on 27 April 1949. (H. Casserley)

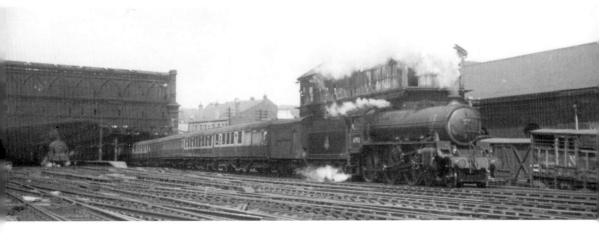

As well as the West Coast, trains from the East Coast also ran services to Carlisle. Here, ex-LNER Thompson B1 Class 4-6-0 No. 61013 is seen leaving Carlisle with the 1.05 p.m. train to Newcastle-on-Tyne. (H. Casserley)

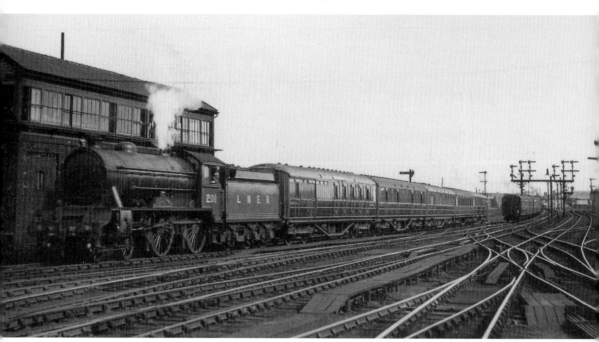

Entering Carlisle station on 14 May 1936 is LNER Gresley D49 4-4-0 No. 201 at the head of the 3.20 p.m. from Newcastle complete with Gresley teak coaches, buffet car No. 24079 leading. (H. Casserley)

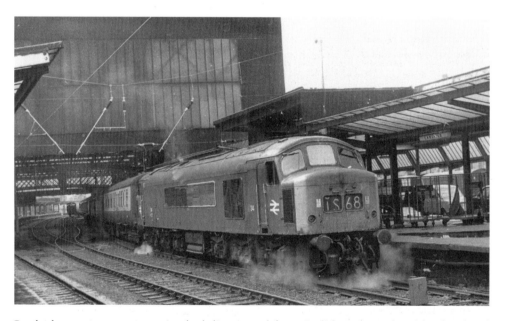

By the late 1960s, steam traction had disappeared from Carlisle to be replaced by diesel and electric traction on the WCML and diesels on the Settle–Carlisle line. Here, on 17 September 1973 Peak diesel-electric locomotive No. D34, in new blue livery, heads an express through a modernised station. (H. Casserley)

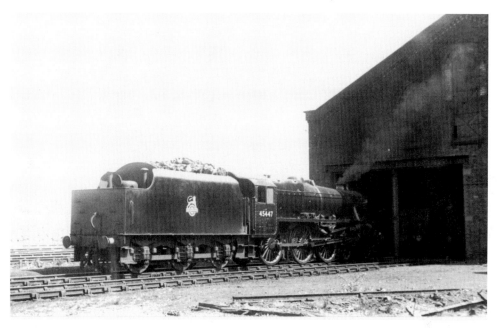

The MR had a locoshed at Carlisle Durran Hill to serve its trains over the Settle–Carlisle line and it was situated just south of the junction with the former NER at Petteril Bridge. The shed was closed in December 1936 and was subsequently used as a coaling and turning point only, the ex-MR trains now moving to Carlisle Kingmoor under LMS auspices. Here, on 1 June 1951, ex-LMS Black Five No. 45447, in very clean condition and sporting the new British Railways coat of arms, awaits its turn of duty outside Durran Hill shed. (H. Casserley)

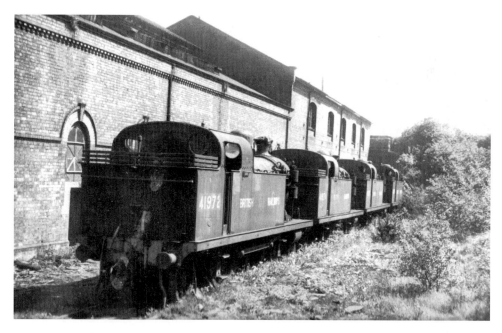

Awaiting their fate at Durran Hill on 1 June 1951 are four ex-LT&SR 0-6-2T locos, Nos 41972, 41974, 41973, and 41971. (H. Casserley)

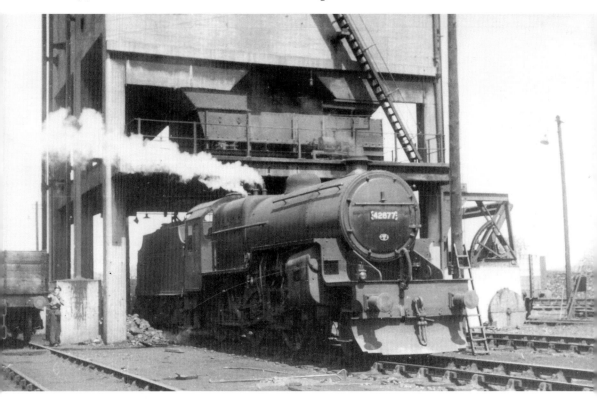

Above: Standing under the coaling stage at Kingmoor is Crab 2-6-0 No. 42877, one of the shed's allocation, on 31 May 1951. (H. Casserley)

Below: Standing at Kingmoor shed on 31 May 1951 is ex-Caledonian Railway McIntosh 0-6-0T No. 56332, then allocated to the Carlisle shed. (H. Casserley)

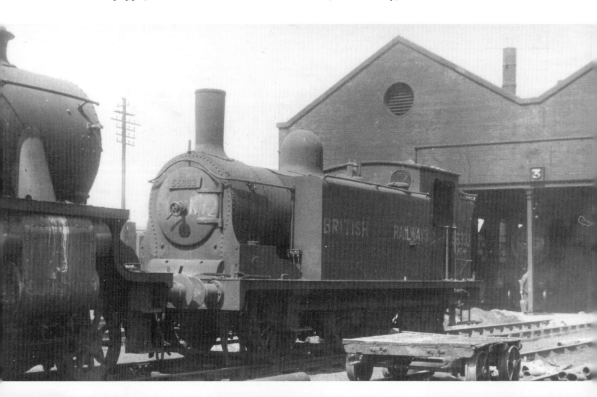

Along with Durran Hill, Carlisle had three other steam sheds, two of which were part of the LMS, Carlisle Kingmoor being the one to which ex-MR services were transferred. Here, in 1950, and coded 68A, is the shed's allocation:

Ex-MR 2P 4-4-0	40613, 40615
Ex-MR 4P 4-4-0	41139, 41140, 41141, 41142, 41143, 41146
Ex-LMS Crab 2-6-0	42748, 42749, 42751, 42752, 42757, 42793, 42802, 42803, 42831, 42832, 42833, 42834, 42835, 42836, 42837, 42875, 42876, 42877, 42881, 42882, 42883, 42884, 42905, 42906, 42907, 42913
Ex-LMS 4F 0-6-0	43922, 43973, 43996, 44001, 44008, 44009, 44016, 44181, 44183, 44189, 44199, 44315, 44324, 44326
Ex-LMS 5MT 4-6-0	44668, 44669, 44670, 44671, 44672, 44673, 44674, 44675, 44676, 44677, 44718, 44719, 44720, 44721, 44722, 44723, 44724, 44725, 44726, 44727, 44877, 44878, 44882, 44883, 44884, 44886, 44898, 44899, 44900, 44901, 44902, 44903, 44993, 44994, 45081, 45082, 45083, 45084, 45100, 45432, 45455
Ex-LMS Jubilee 4-6-0	45580 *Burma*, 45581 *Bihar and Orissa*, 45582 *Central Provinces*, 45713 *Renown*, 45714 *Revenge*, 45715 *Invincible*, 45716 *Swiftsure*, 45727 *Inflexible*, 45728 *Defiance*, 45729 *Furious*, 45730 *Ocean*, 45731 *Perseverance*, 45732 *Sanspereil*
Ex-LMS 8F 2-8-0	48464, 48472, 48536, 48612
Ex-CR 3F 0-6-0T	56231, 56248, 56266, 56316, 56317, 56327, 56332, 56333, 56340, 56354, 56355, 56373, 56374, 57632
Ex-WD 2-10-0	90751, 90773, 90774
	Total: 123

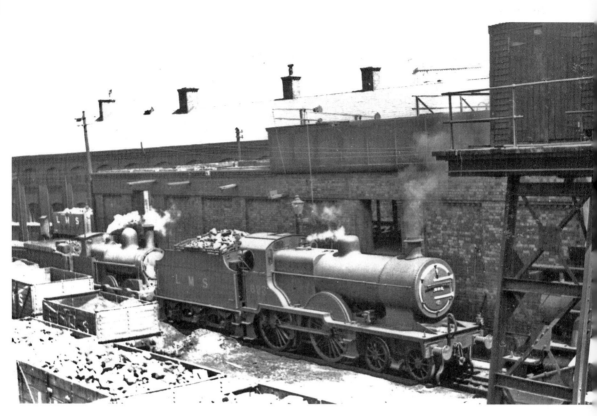

The other major shed at Carlisle was the ex-LNWR shed at Upperby, seen here with ex-MR 2P 4-4-0 as LMS No. 693, behind ex-LNWR 0-6-0 No. 8420. (H. Casserley)

In 1954, then coded 12A, the allocation was:

Ex-MR 2P 4-4-0	40356, 40448
Ex-LMS 2P 4-4-0	40582, 40652, 40699
Ex-LMS 4F 0-6-0	43896, 44060, 44081, 44121, 44346
Ex-LMS 5MT 4-6-0	44936, 44939, 45070, 45106, 45129, 45139, 45140, 45146, 45184, 45197, 45230, 45244, 45246, 45248, 45258, 45286, 45288, 45293, 45285, 45296, 45299, 45311, 45315, 45316, 45323, 45345, 45348, 45351, 45368, 45371, 45409, 45412, 45414, 45416, 45438, 45445, 45451, 45494
Ex-LMS Patriot Class 4-6-0	45502 *Royal Naval Division*, 45505 *The Royal Army Ordnance Corps*, 4508, 4512 *Bunsen*, 45526 *Morecambe and Heysham*, 45537 *Private E. Sykes VC*, 45541 *Duke of Sutherland*, 45542, 45549, 45551
Ex-LMS Jubilee Class 4-6-0	45552 *Silver Jubilee*, 45583 *Assam*, 45593 *Kolhapur* (now preserved), 45599 *Bechuanaland*, 45630 *Swaziland*, 45643 *Rodney*, 45666 *Cornwallis*, 45722 *Defence*
Ex-LMS Royal-Scot Class 4-6-0	46136 *The Border Regiment*, 46146 *The Rifle Brigade*, 46165 *The Ranger (12th London Regt)*
Ex-LMS Princess Coronation Class 4-6-2	46226 *Duchess of Norfolk*, 46228 *Duchess of Rutland*, 46238 *City of Carlisle*, 46251 *City of Nottingham*, 4625 *City of Hereford*
Ex-LMS 3F 0-6-0T	47295, 47326, 47340, 47377, 47391, 47403, 47408, 47415, 47556, 47614, 47618, 4764, 47666
0-6-0 Diesel Shunters	12081, 12082, 12083, 12087
	Total: 91

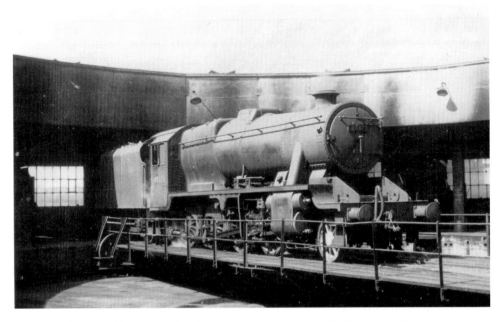

Sitting on the turntable at Upperby shed on 1 June 1951 is ex-LMS 8F 2-8-0 No. 48473. Along with the sheds mentioned, the LNER also had its own shed at Canal which had an allocation of A3 and D49 passenger engines plus a number of 0-6-0 goods engines and N15 0-6-2 tank locos. (H. Casserley)

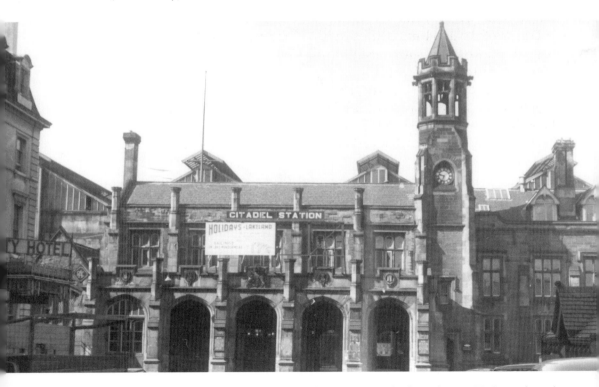

Exterior of Carlisle Citadel station in 1951. The station was built in the neo-Tudor style and designed by William Tite and is now a Grade II listed building. (H. Casserley)

ACKNOWLEDGEMENTS

Without the assistance of several people and organisations, this book would have been very difficult to complete. Special thanks go to Richard Casserley, Roger Carpenter and LOSA, who have provided photographic material used in this project. My thanks also go to Bernard Unsworth for collating shed allocations, which has saved me a lot of time, and I also thank Filey and Scarborough libraries whose books have provided me with much background material.

Details of the accidents mentioned in the manuscript have come from L. T. C. Rolt's book *Red For Danger* and Brian Hollingworth's *The Pleasure of Railways*, two very enjoyable reads.

My thanks also go to my wife, Hilary, for her continued support and constant supply of tea while I have been working and to my son, Gary, who has always been there.

Finally, may I thank anybody whom I have failed to mention. Their support has also been invaluable.

Also available from Amberley Publishing

MIKE HITCHES

STEAM

AROUND YORK &
THE EAST RIDING